MW00896652

Women's Facial Expressions - Artists Reference Images
Black and white version

Author: Paul Green

MW00896652

First published 2015

Copyright © 2015, Paul Green. All rights reserved

No part of this publication may be reproduced in any material form (including photocopying or storing in any medium by electronic means and whether or not transiently or incidentally to some other use of this publication) without the written permission of the copyright holder.

ISBN-13: 978-1508713333
ISBN-10: 1508713332

CATALOGUE OF IMAGES

This book consists of a catalogue of images portraying six different women's facial expressions.

The images show each facial expression i.e. surprised, from different camera angles around the head. The book is intended as a reference of images for an artist. The artist can refer to one of the images in a chosen facial expression and use it as a guide when drawing the character's face in his/her art work.

All of the images have been computer generated and with the aid of motion capture files, they correctly illustrate the facial expression.

All images are labelled in sequential order from 1 to 12, each image follows a stepped rotation around the character's head, to make one complete rotation of 360°.

Image number

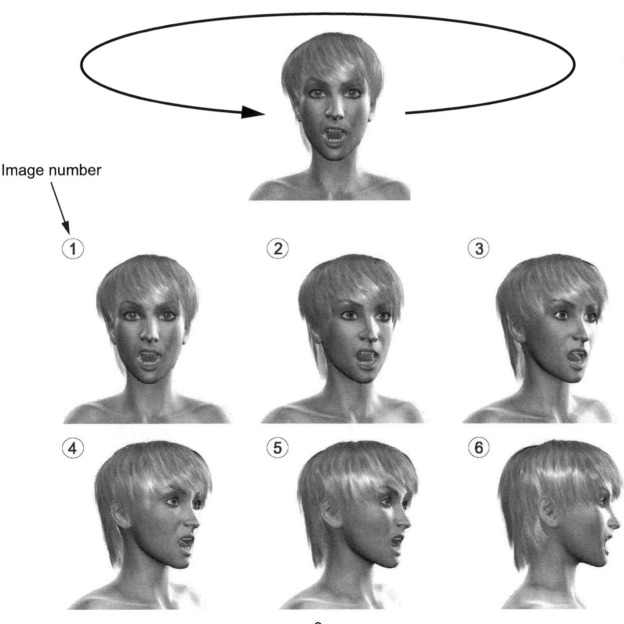

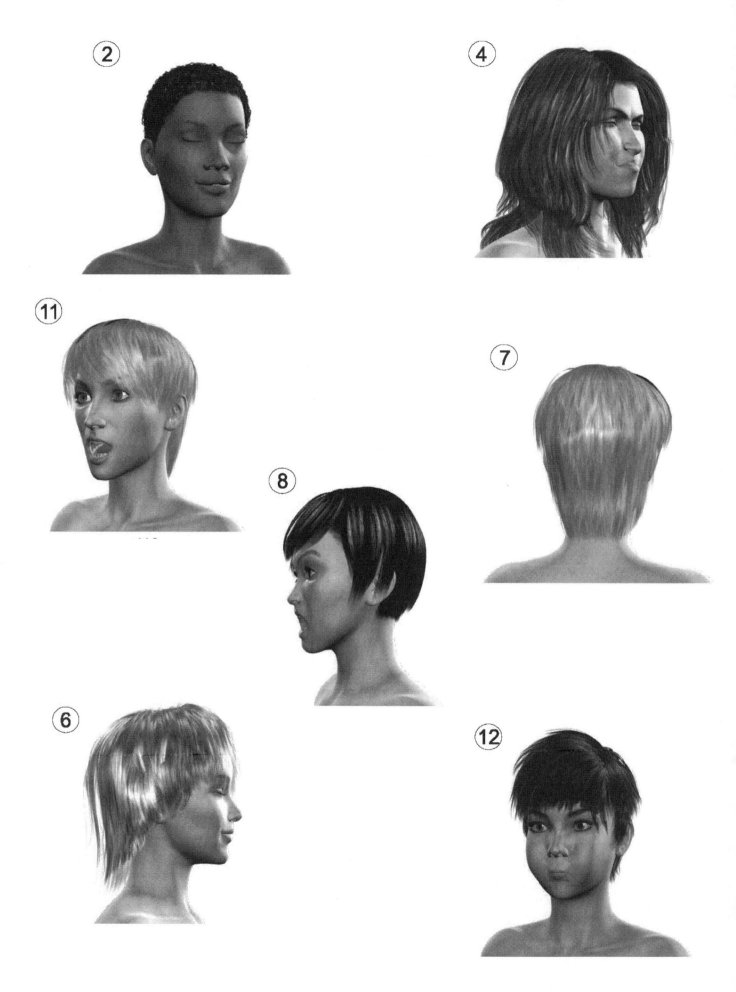

INDEX OF FACIAL EXPRESSIONS

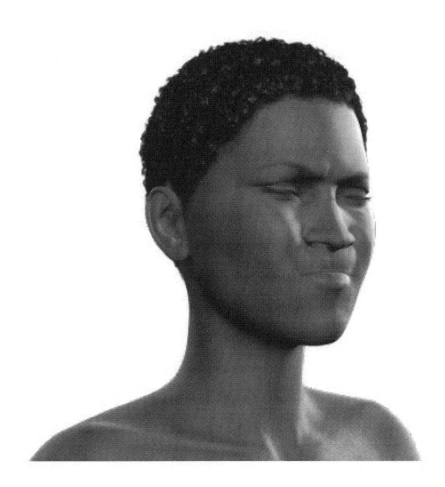

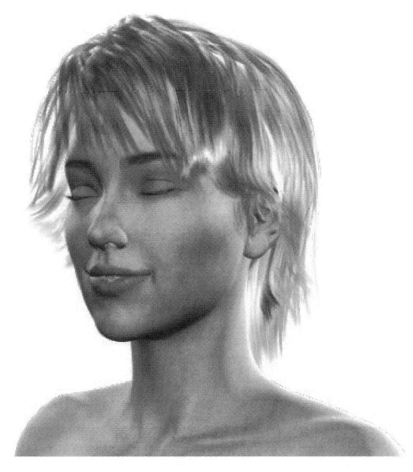

WOMEN'S FACIAL EXPRESSIONS

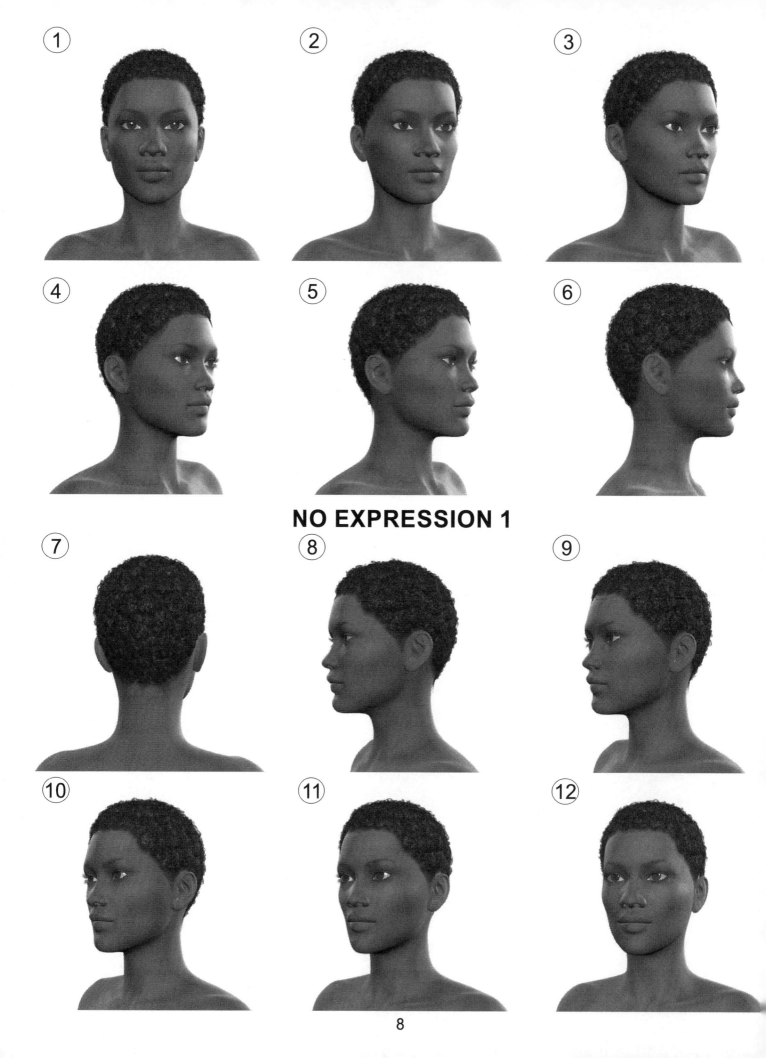

NO EXPRESSION 1

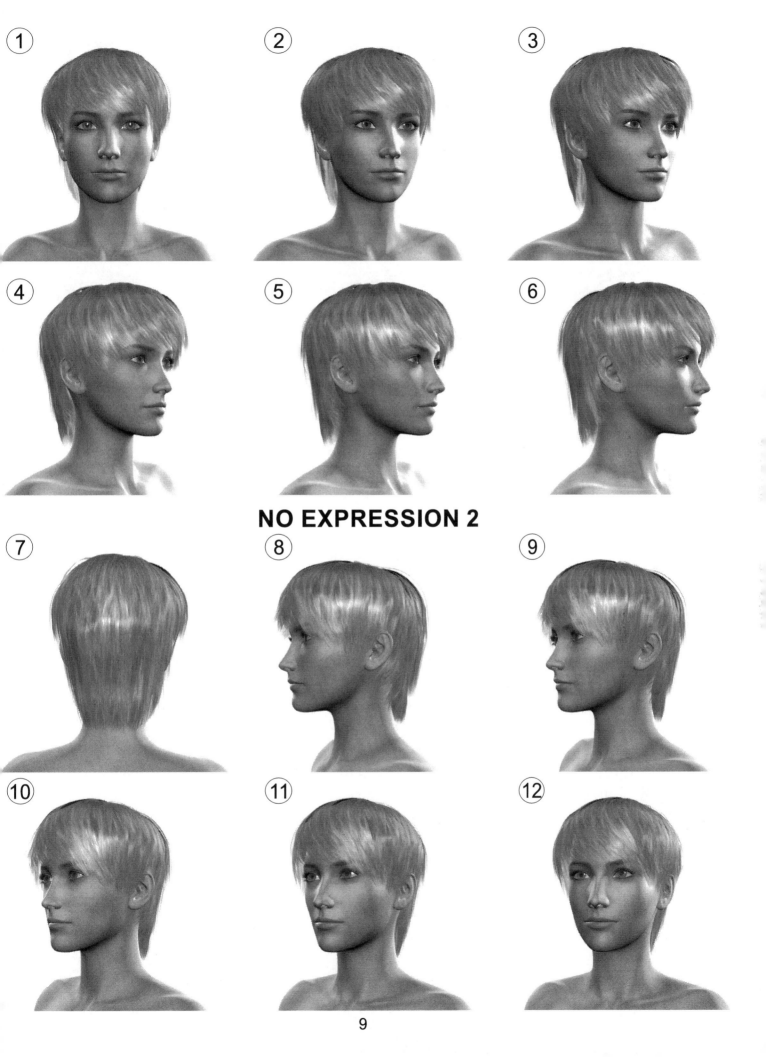

NO EXPRESSION 2

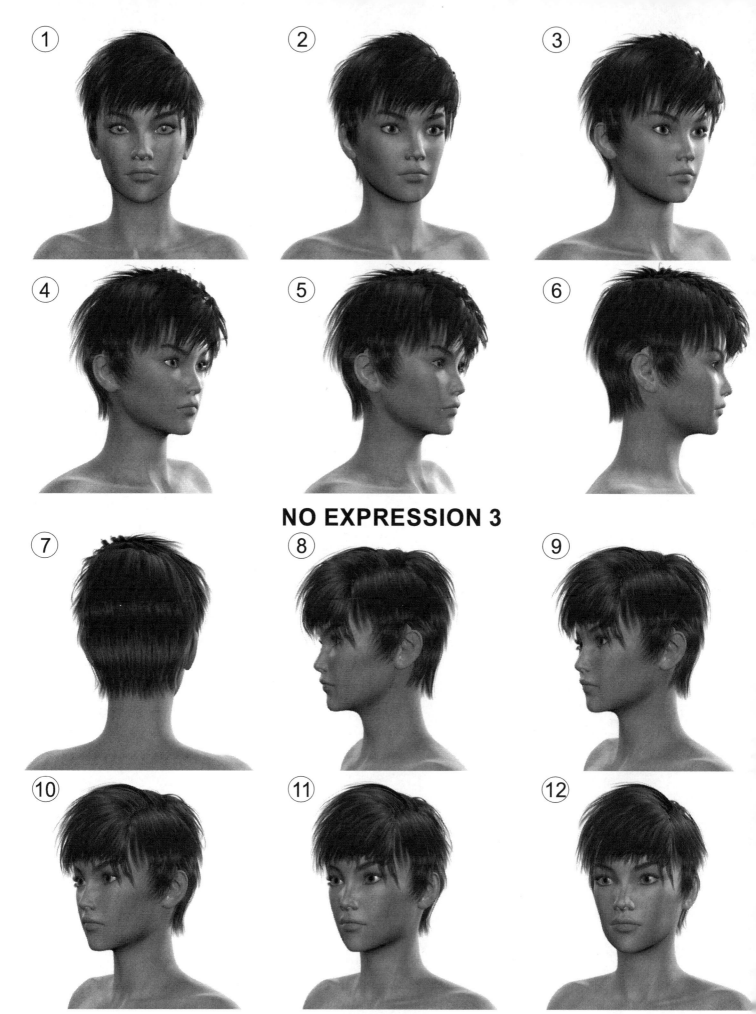

NO EXPRESSION 3

10

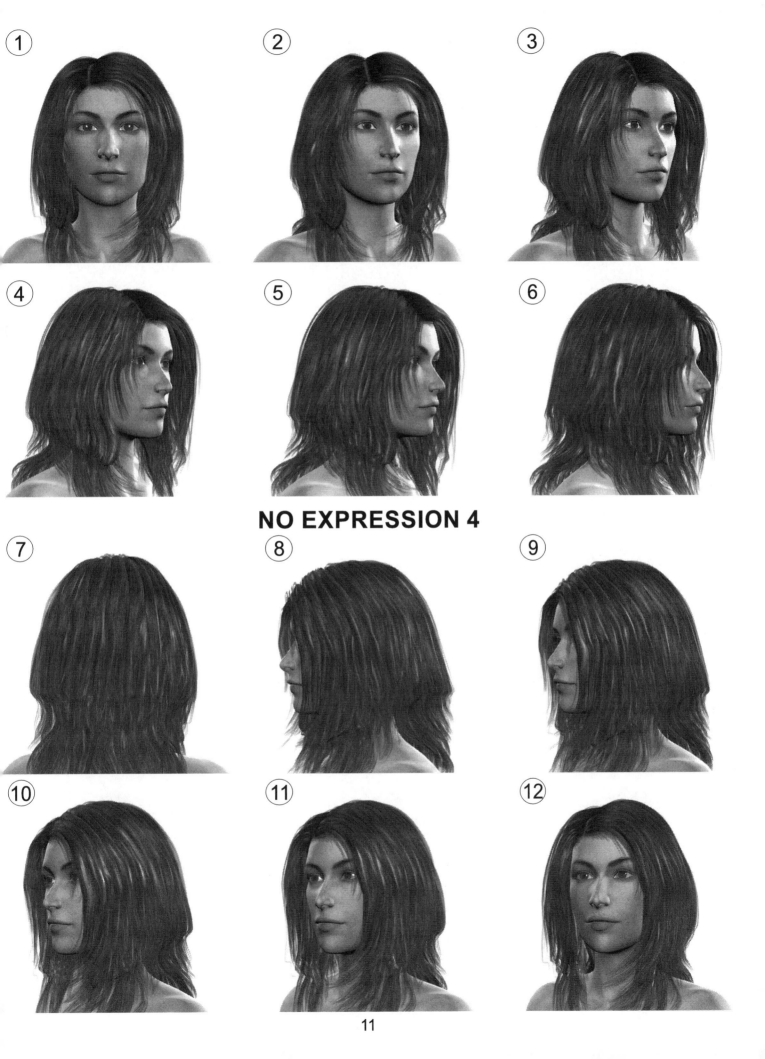

NO EXPRESSION 4

11

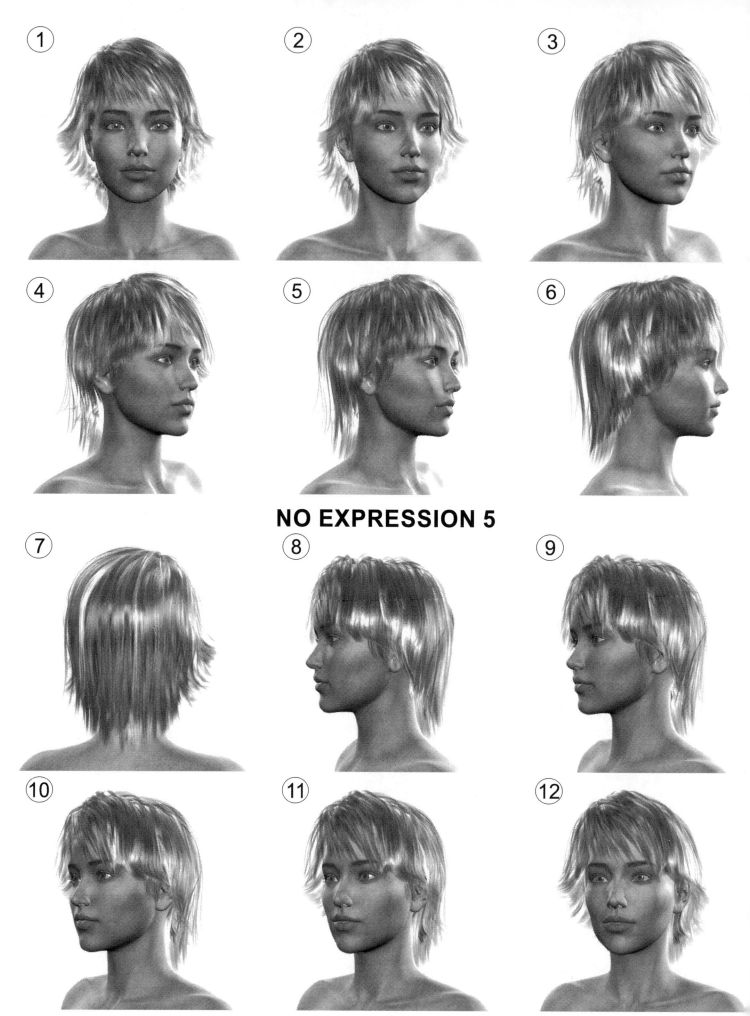

NO EXPRESSION 5

12

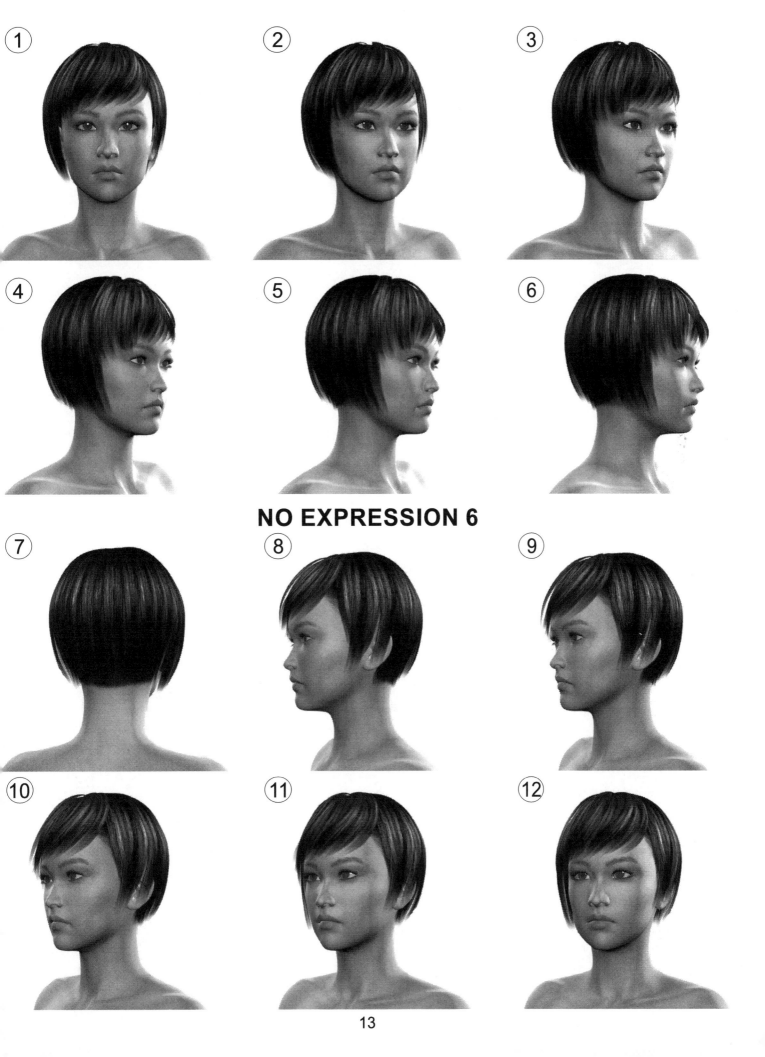

NO EXPRESSION 6

13

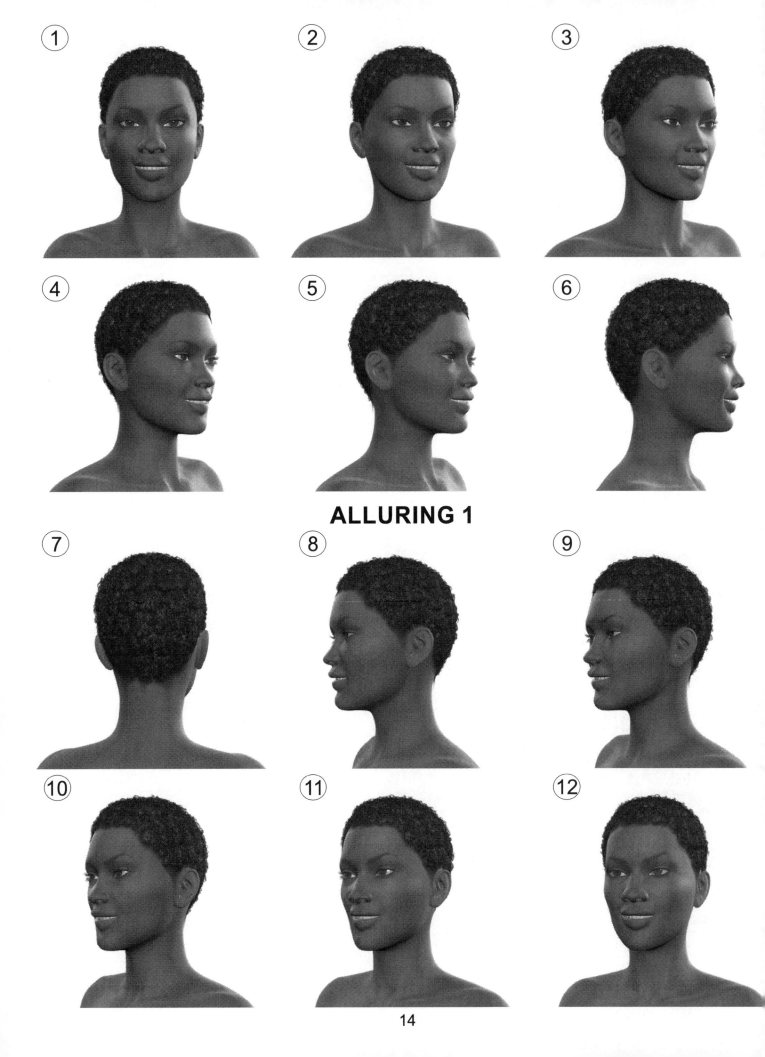

ALLURING 1

14

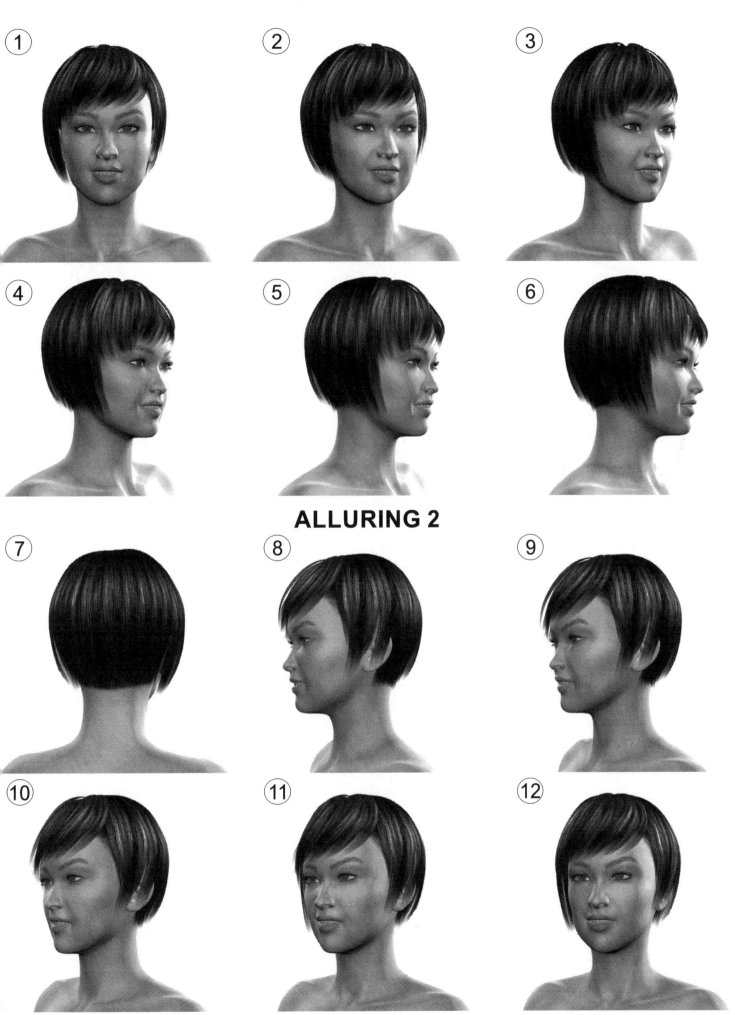

ALLURING 2

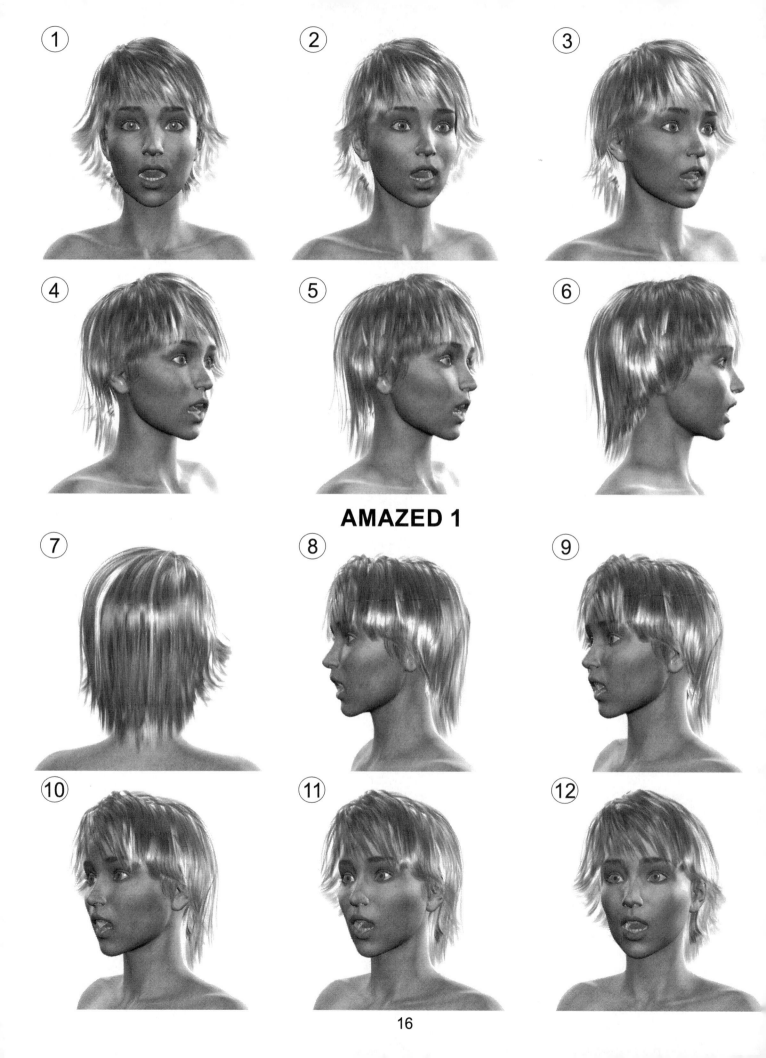

AMAZED 1

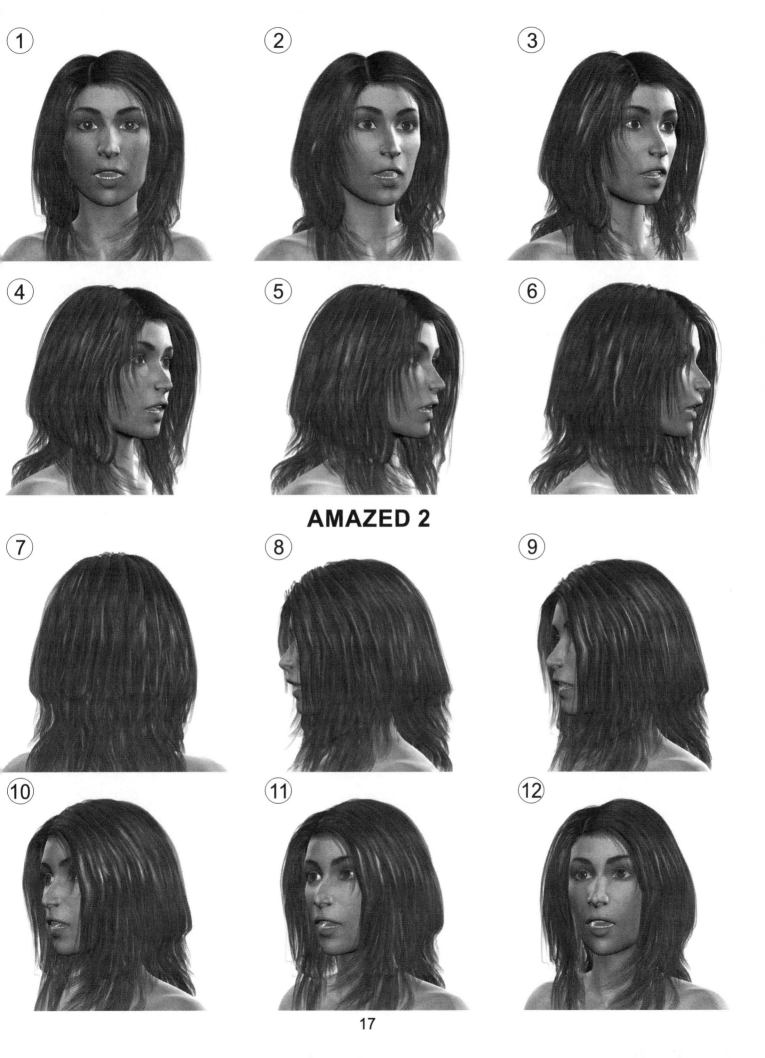

AMAZED 2

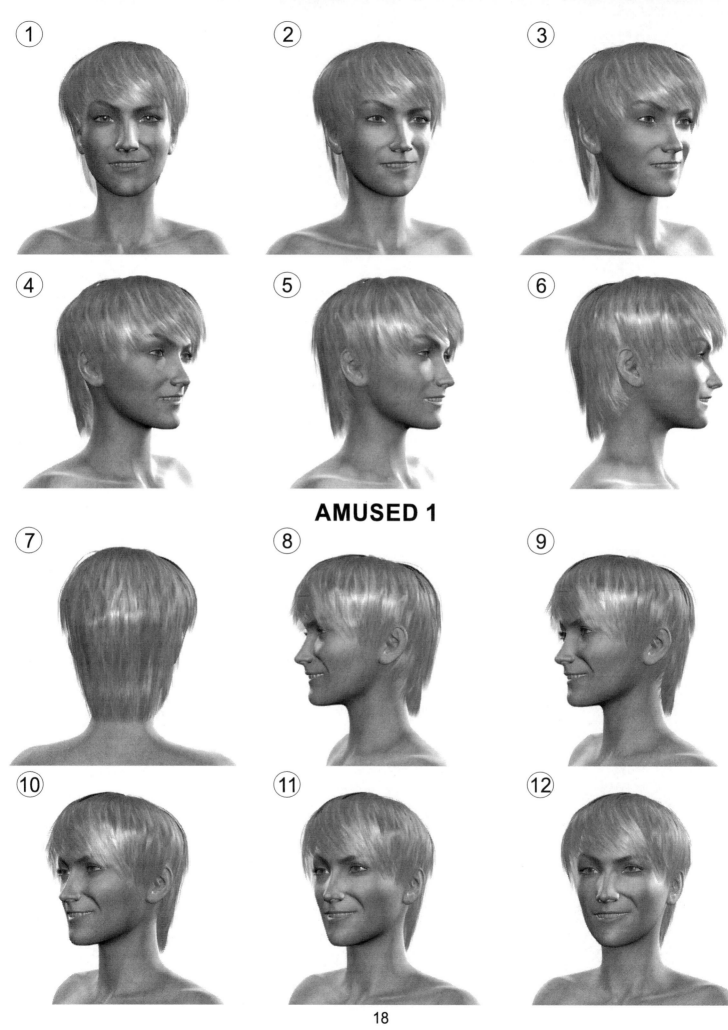

AMUSED 1

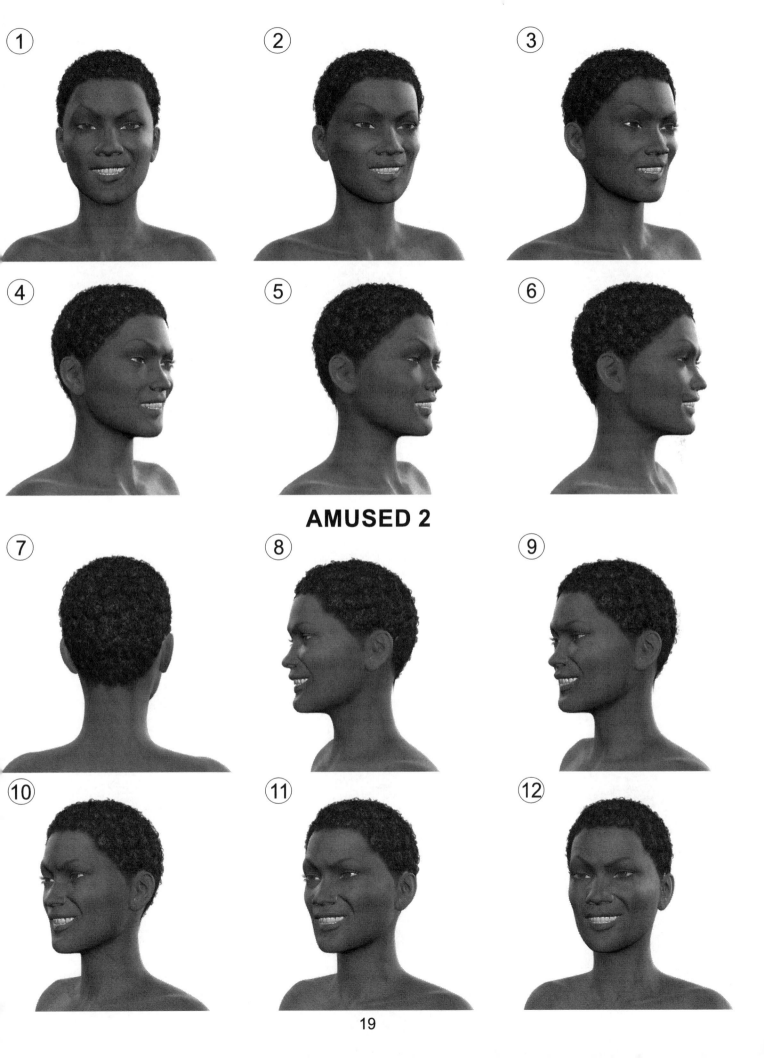

AMUSED 2

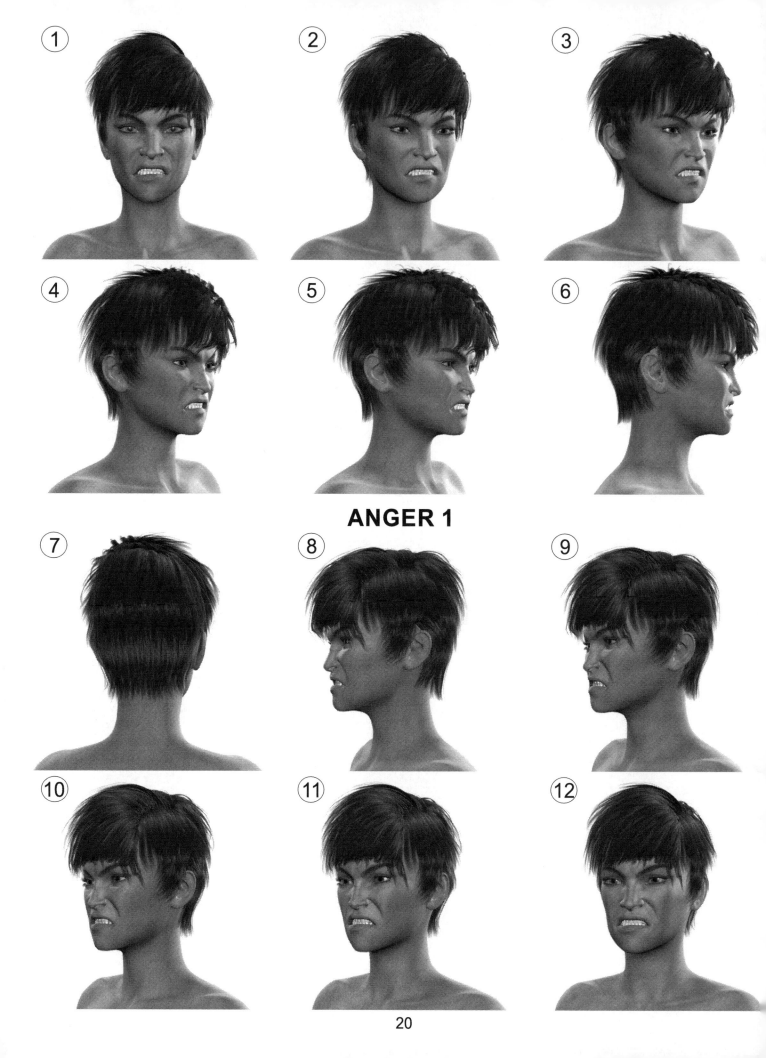

ANGER 1

20

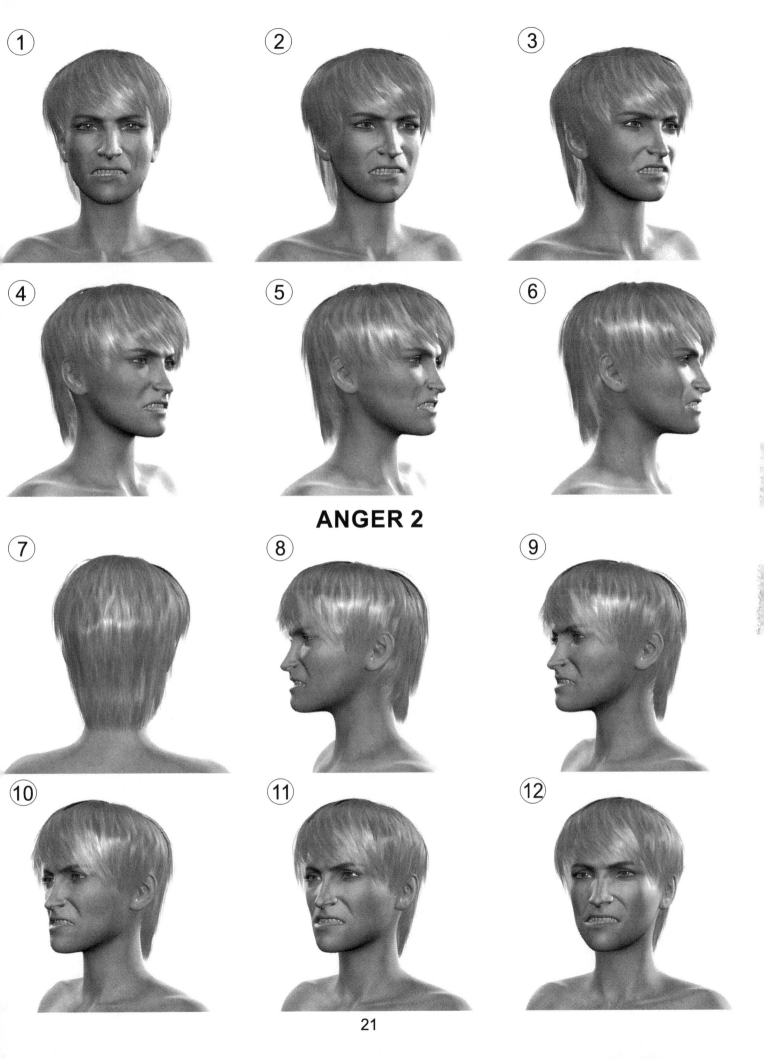

ANGER 2

21

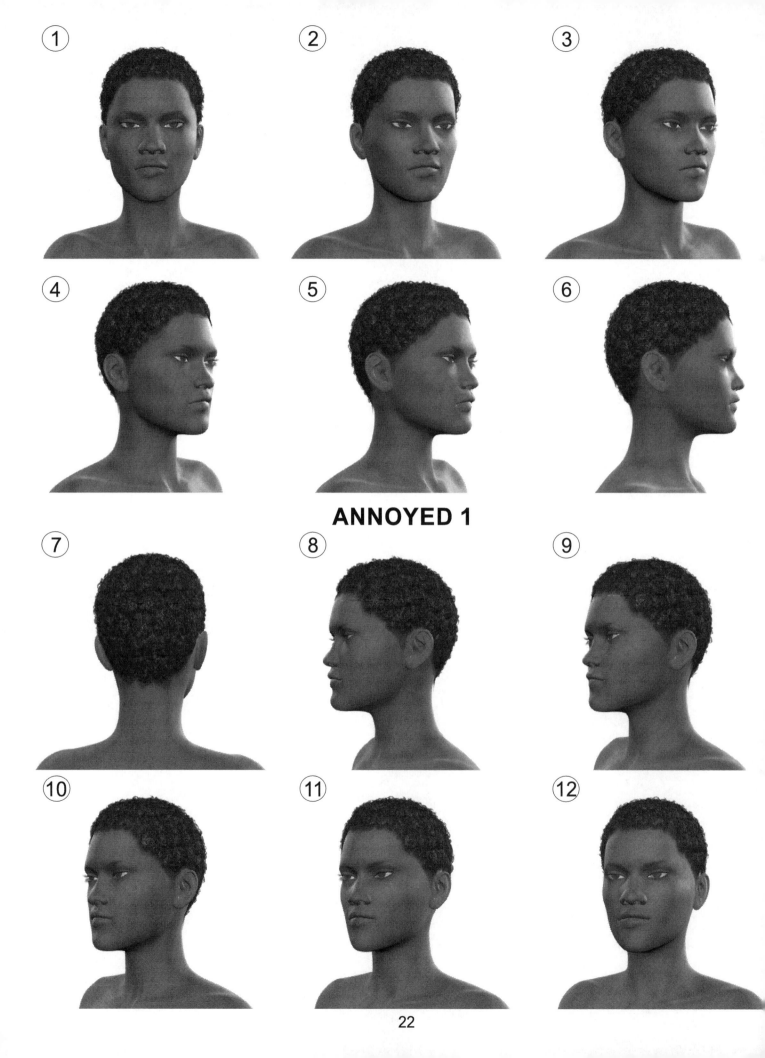

ANNOYED 1

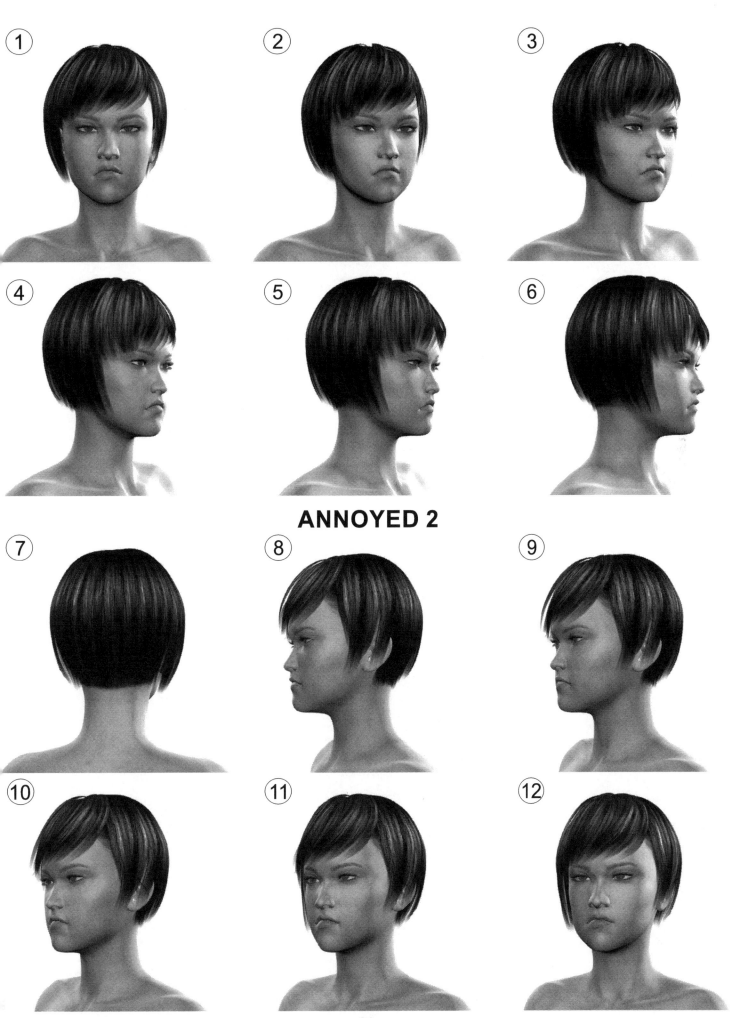

ANNOYED 2

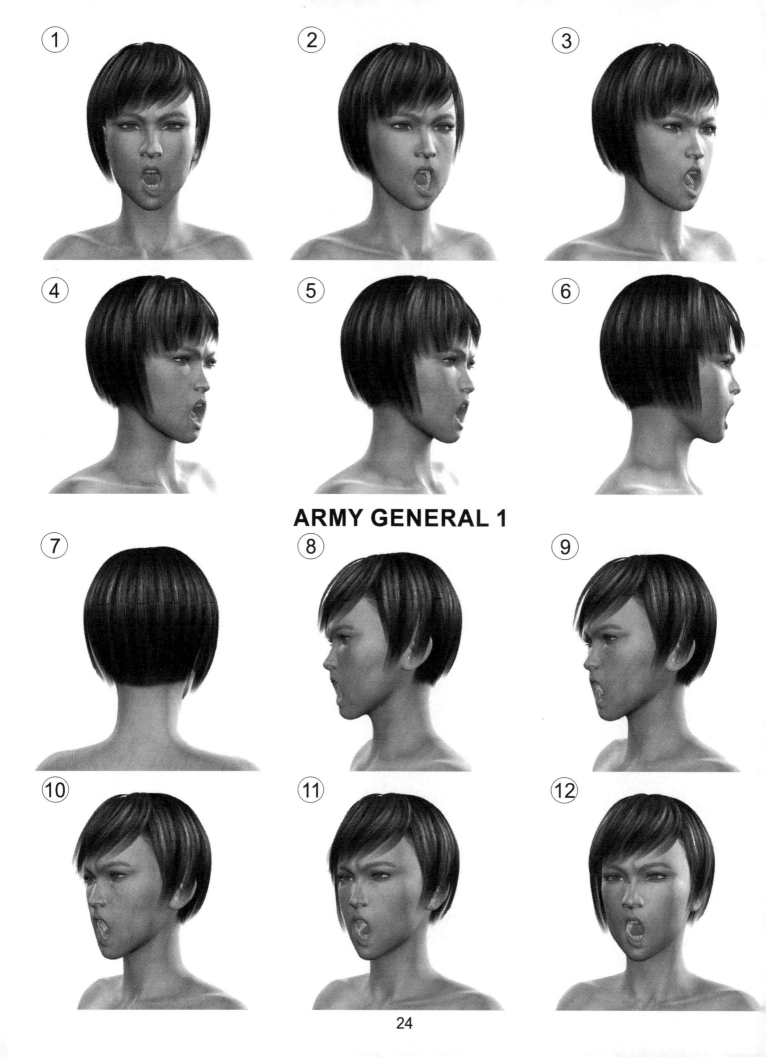

ARMY GENERAL 1

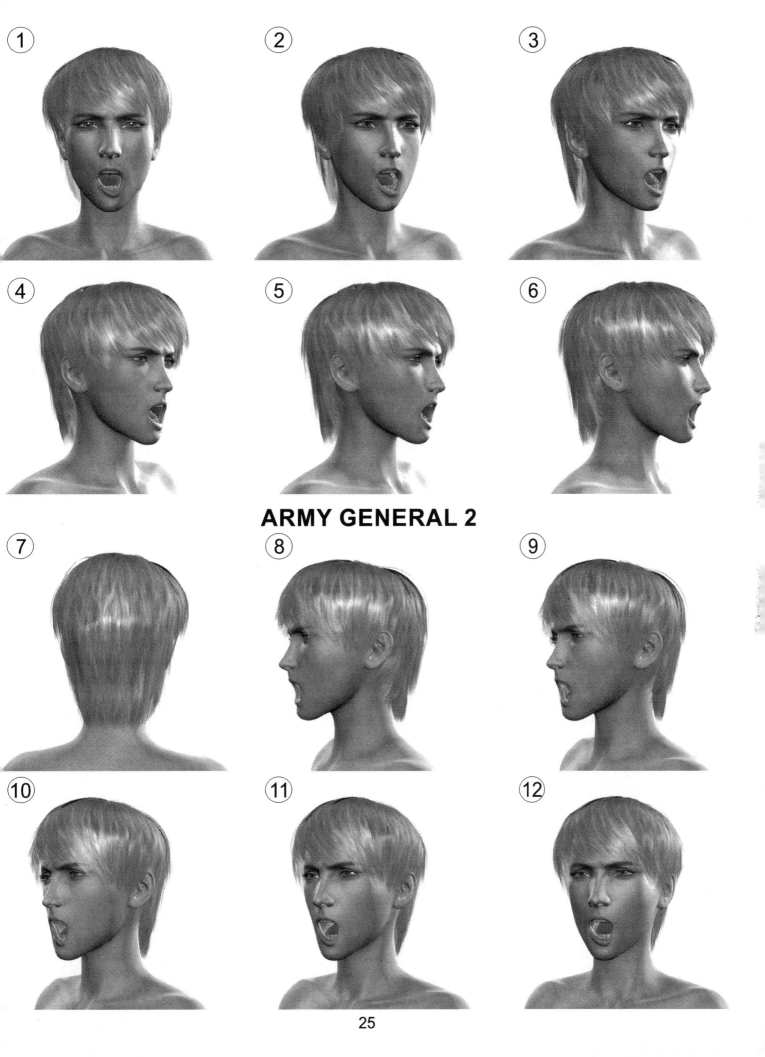

ARMY GENERAL 2

25

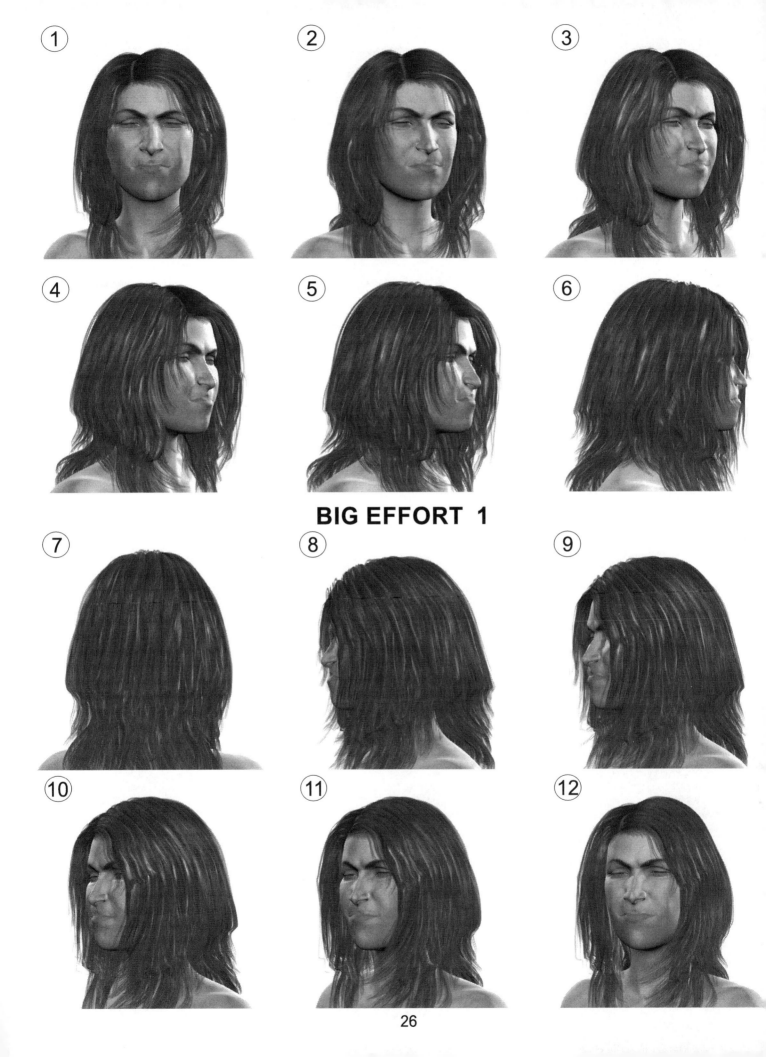

BIG EFFORT 1

26

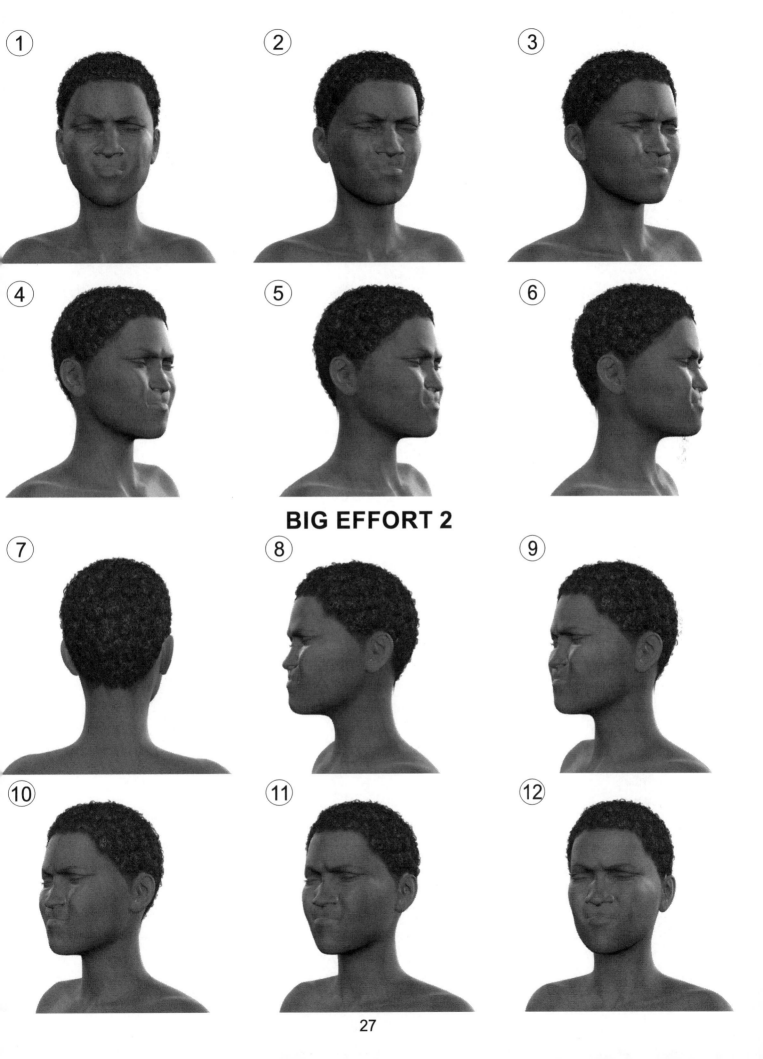

BIG EFFORT 2

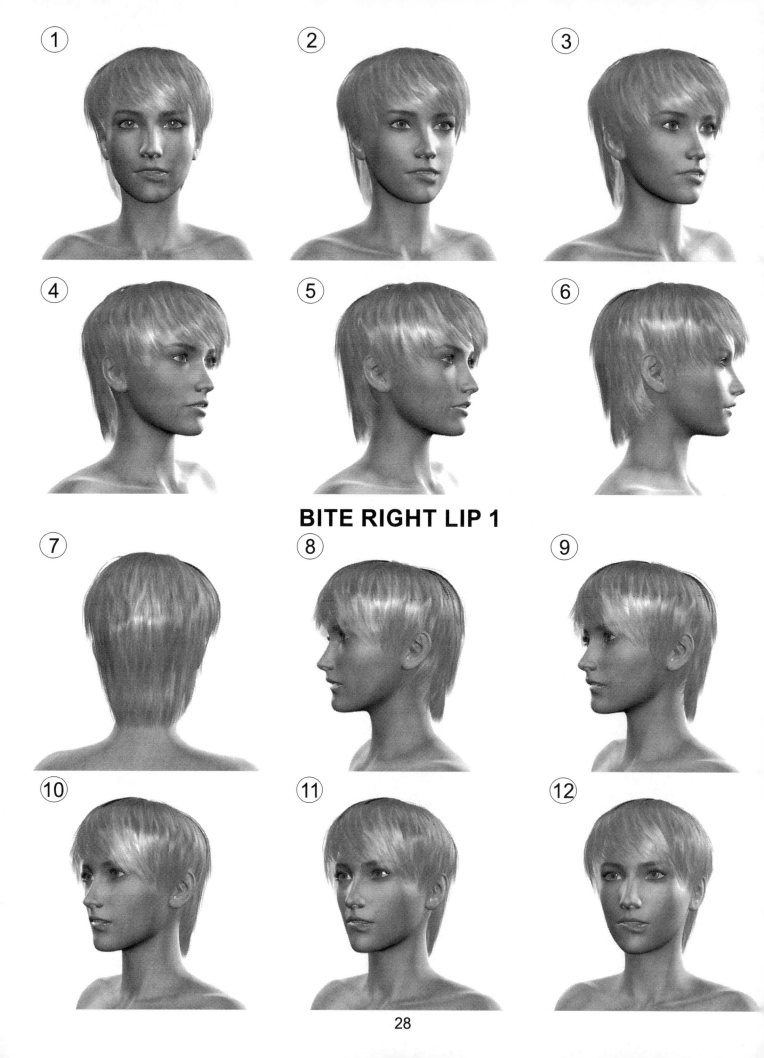

BITE RIGHT LIP 1

28

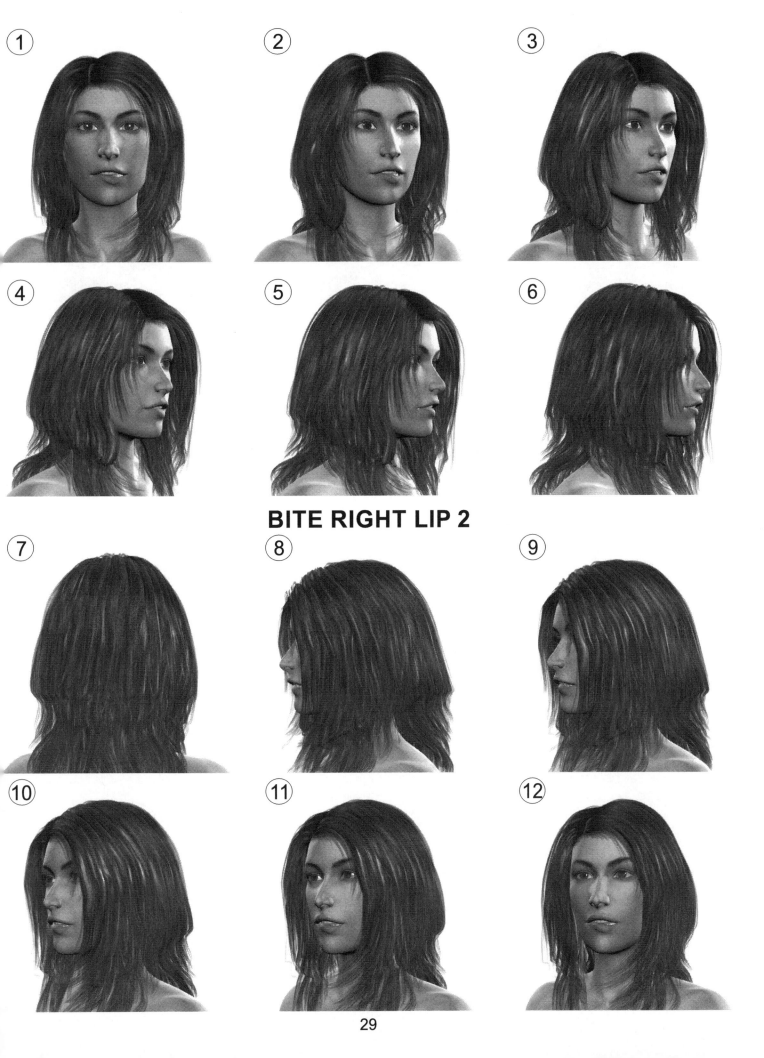

BITE RIGHT LIP 2

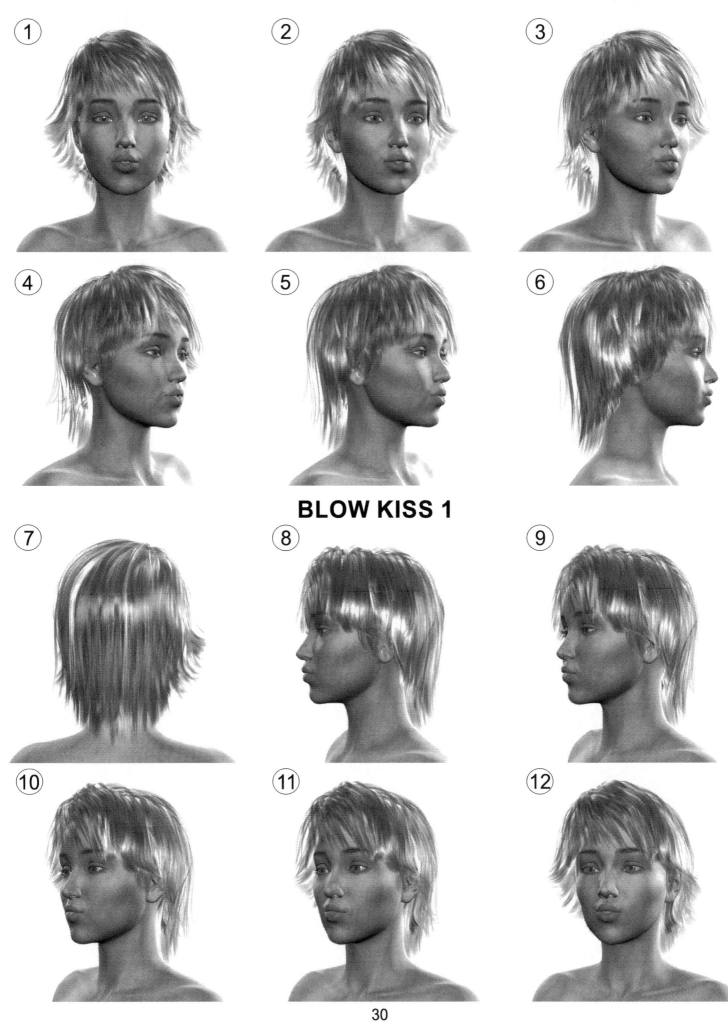

BLOW KISS 1

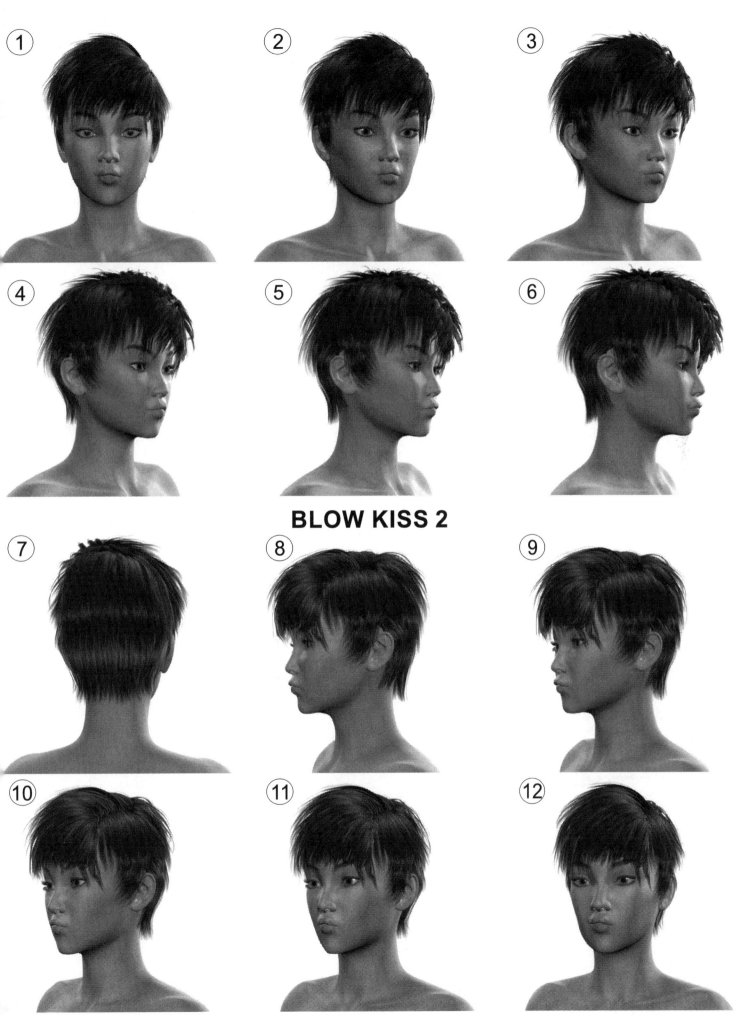

BLOW KISS 2

31

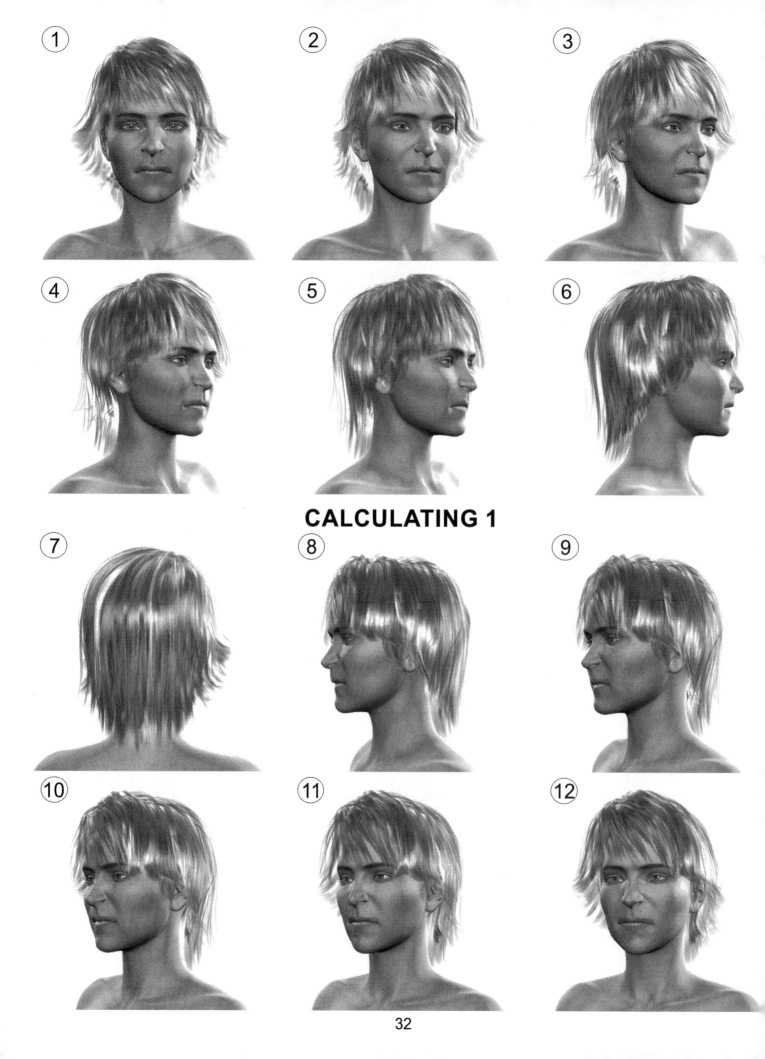

CALCULATING 1

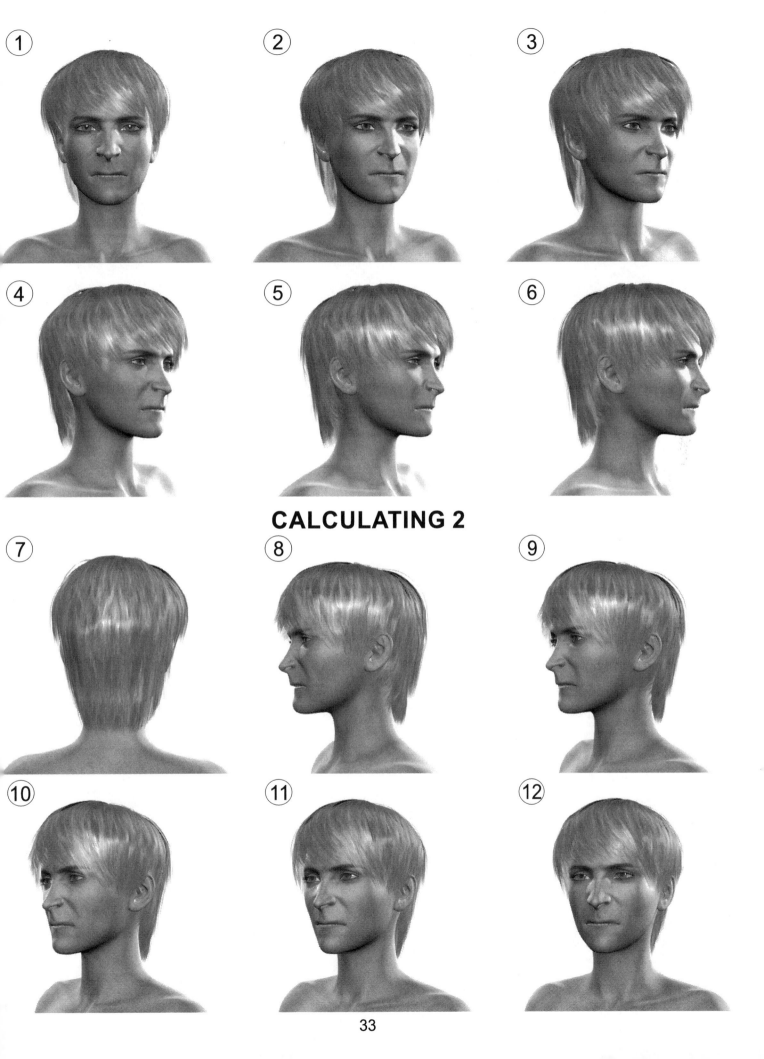

CALCULATING 2

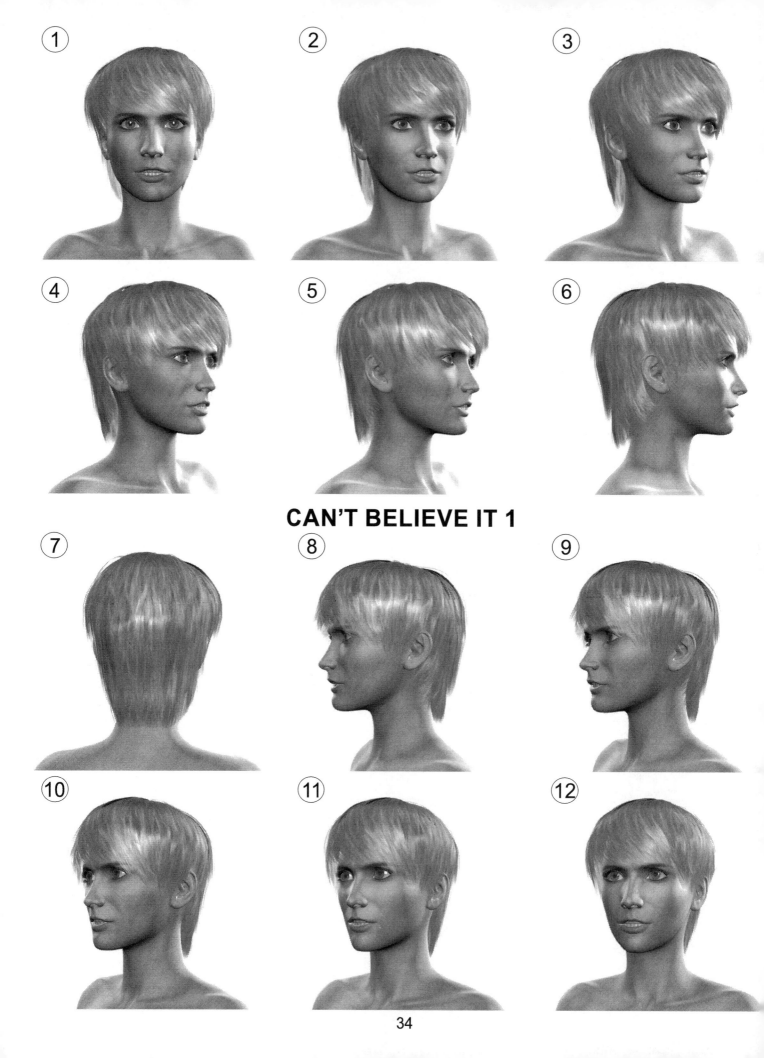

CAN'T BELIEVE IT 1

34

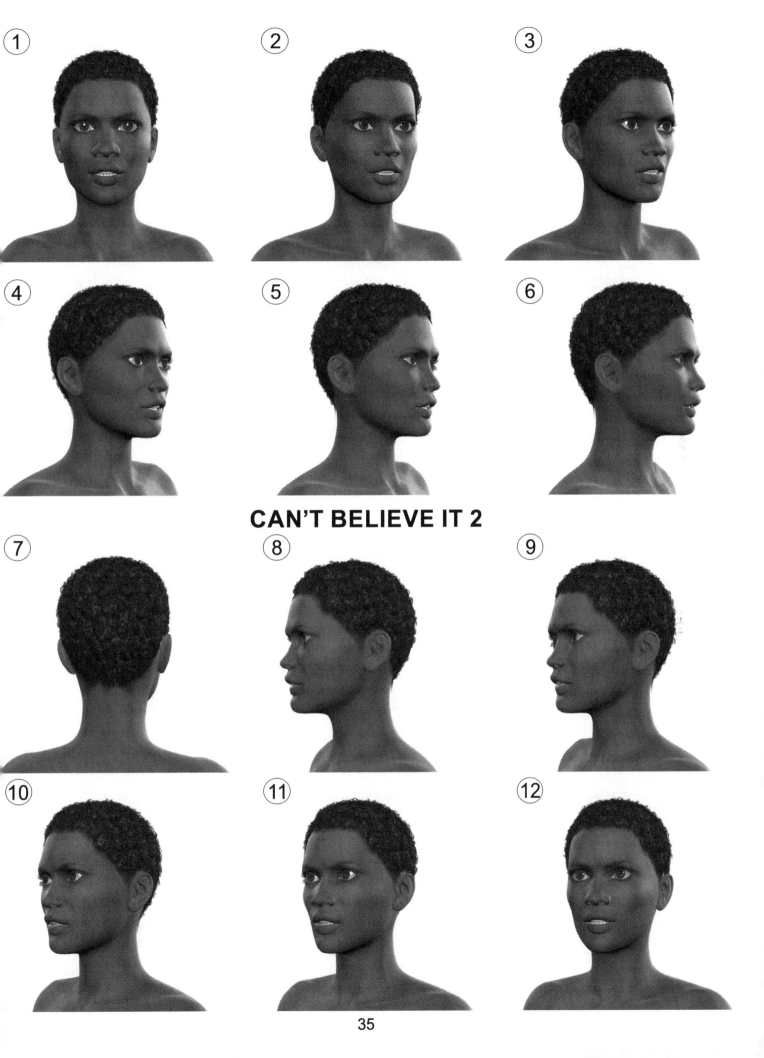

CAN'T BELIEVE IT 2

35

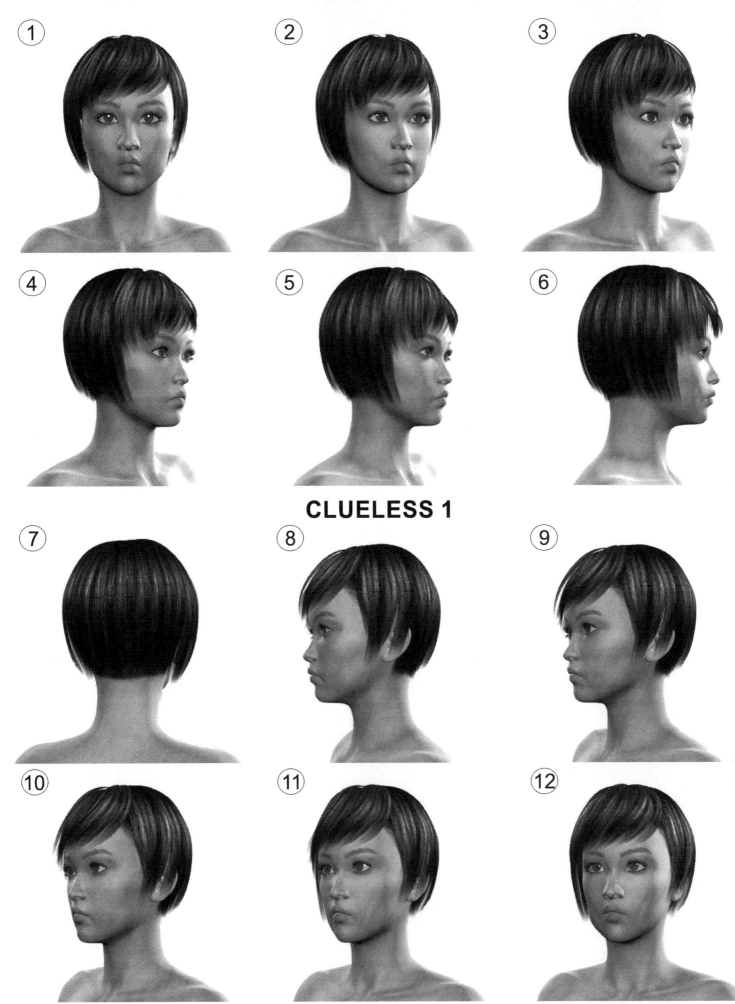

CLUELESS 1

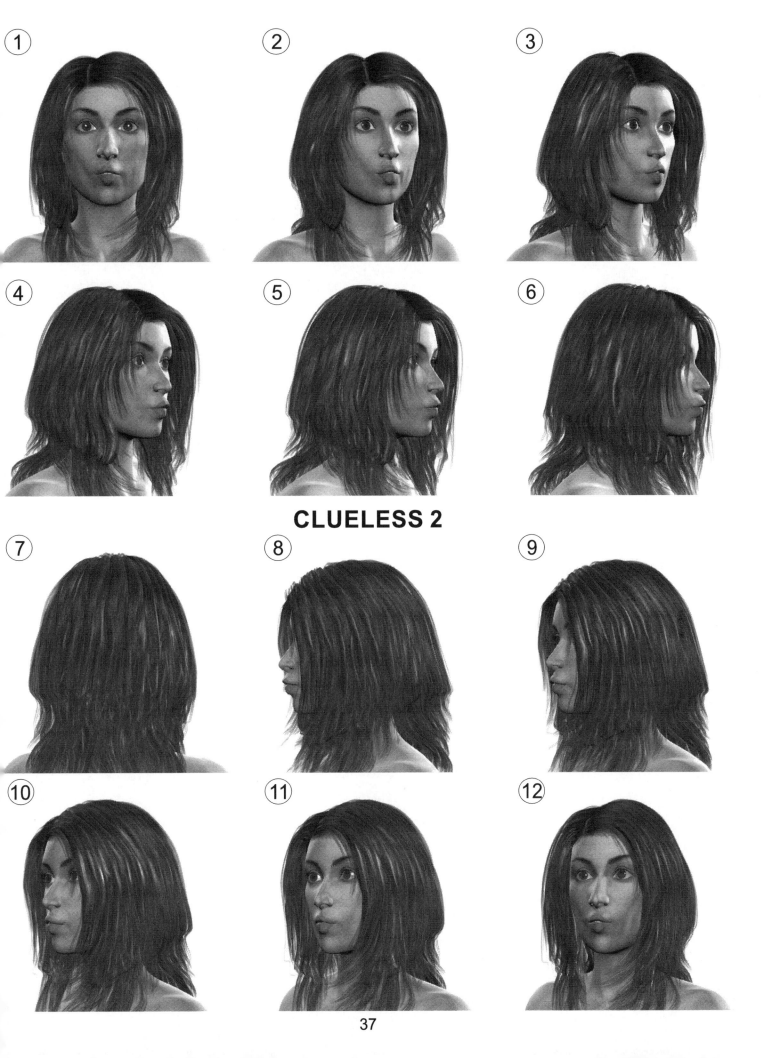

CLUELESS 2

37

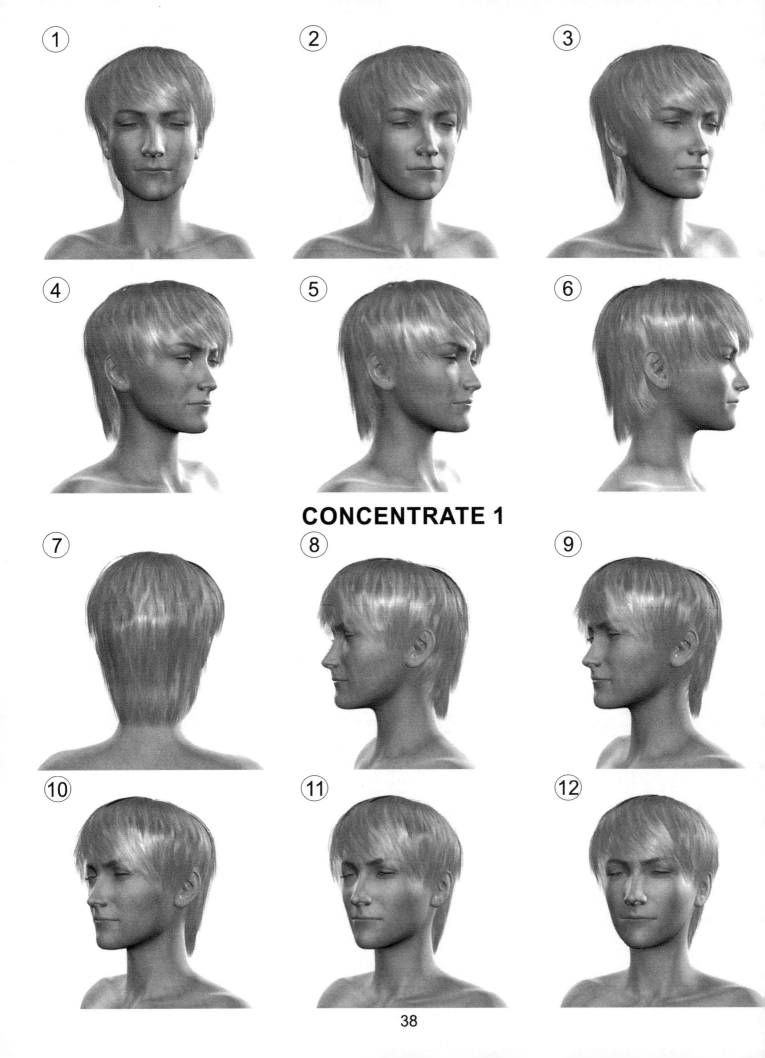

CONCENTRATE 1

38

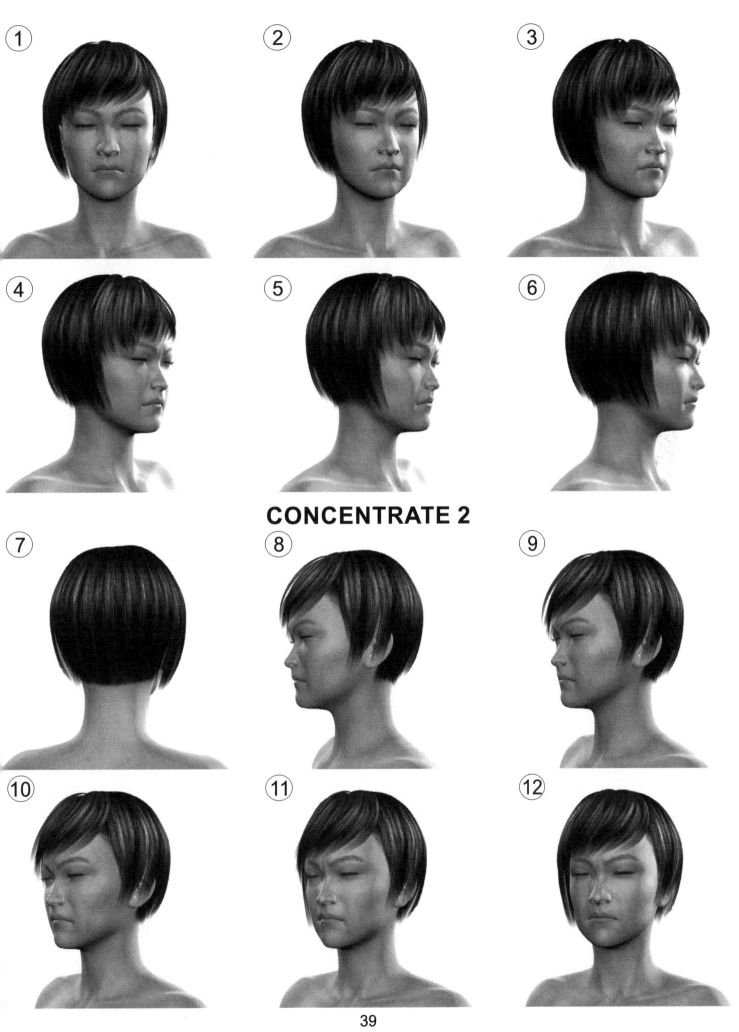

CONCENTRATE 2

39

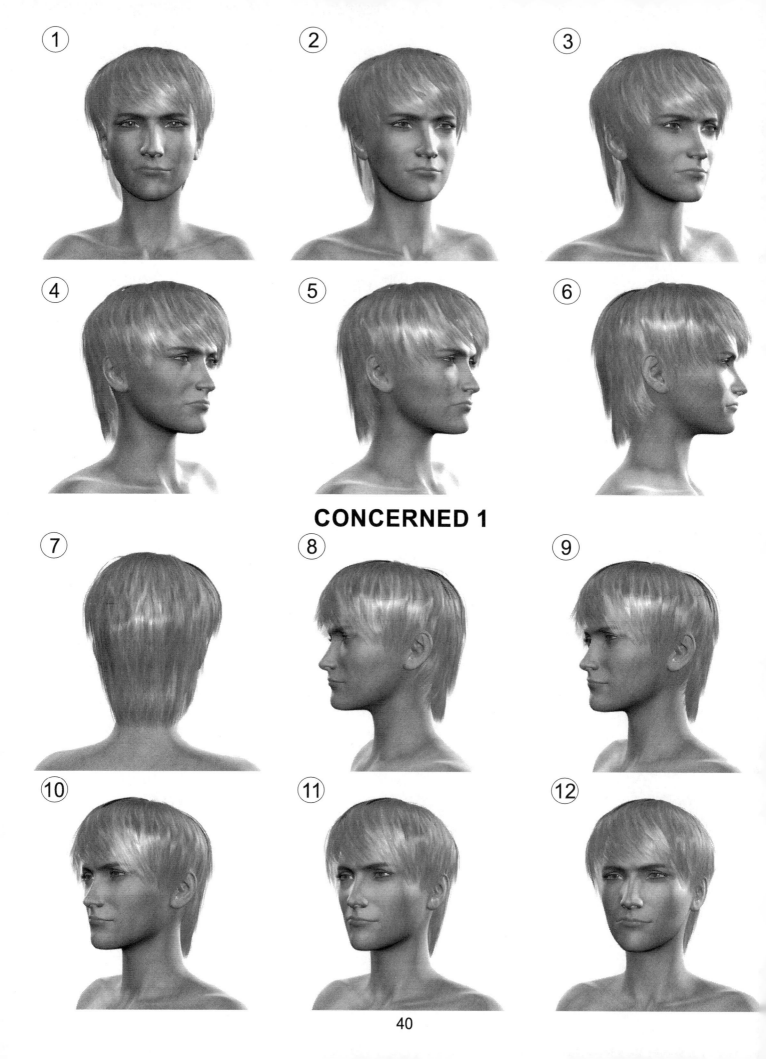

CONCERNED 1

40

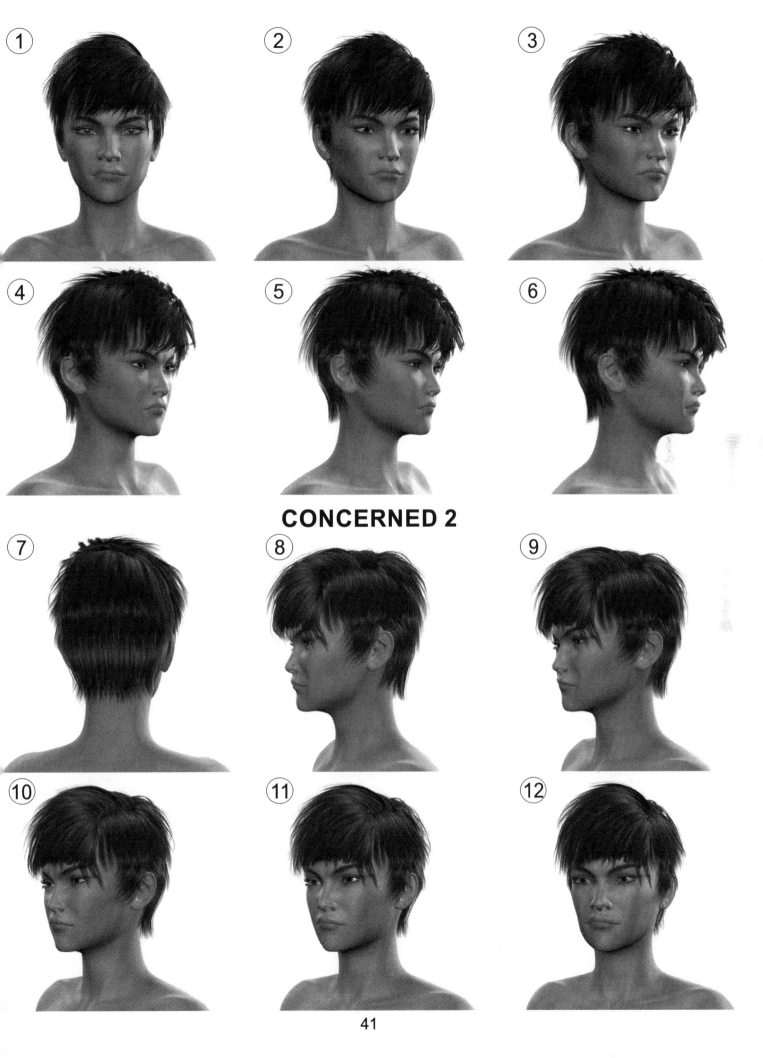

CONCERNED 2

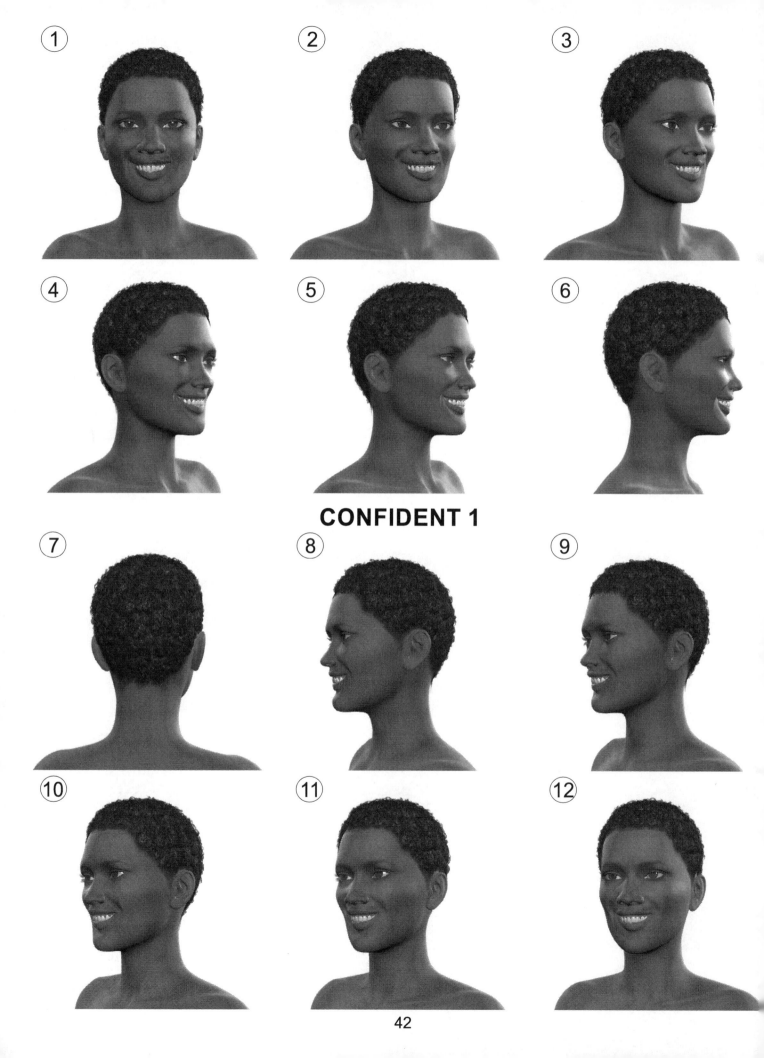

CONFIDENT 1

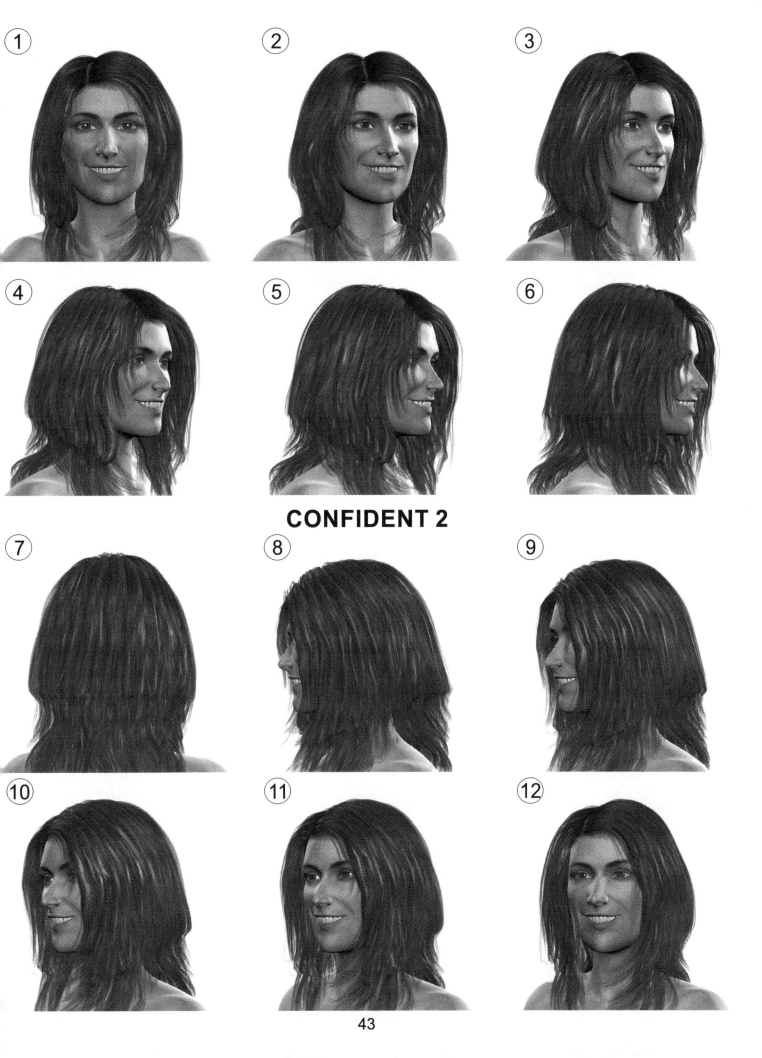

CONFIDENT 2

43

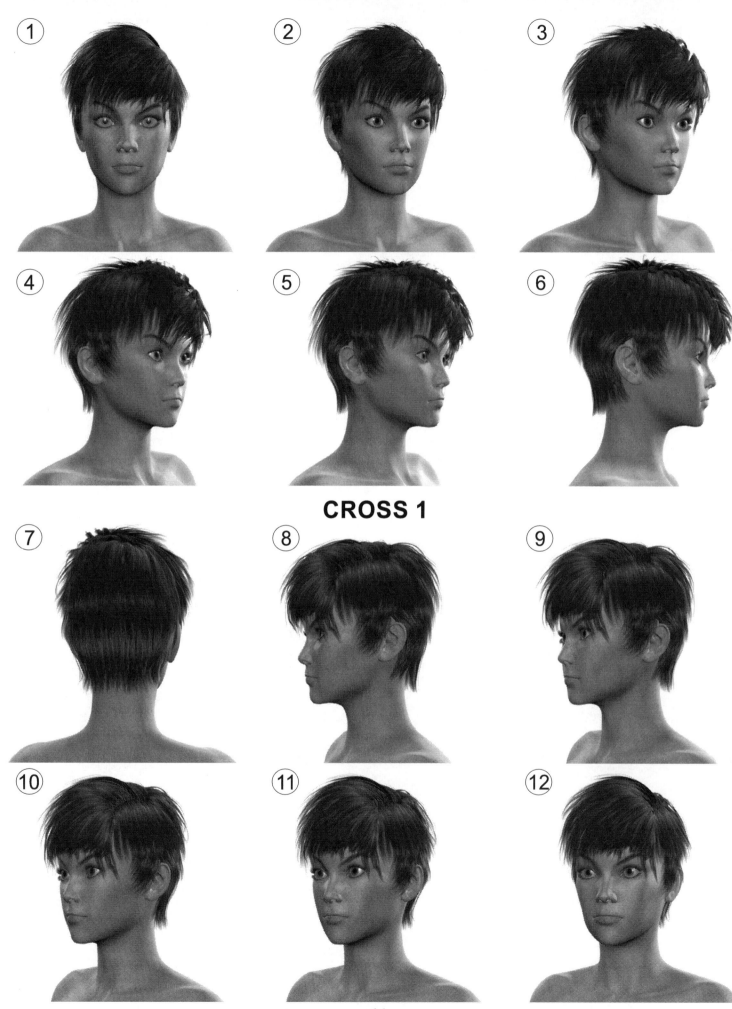

CROSS 1

44

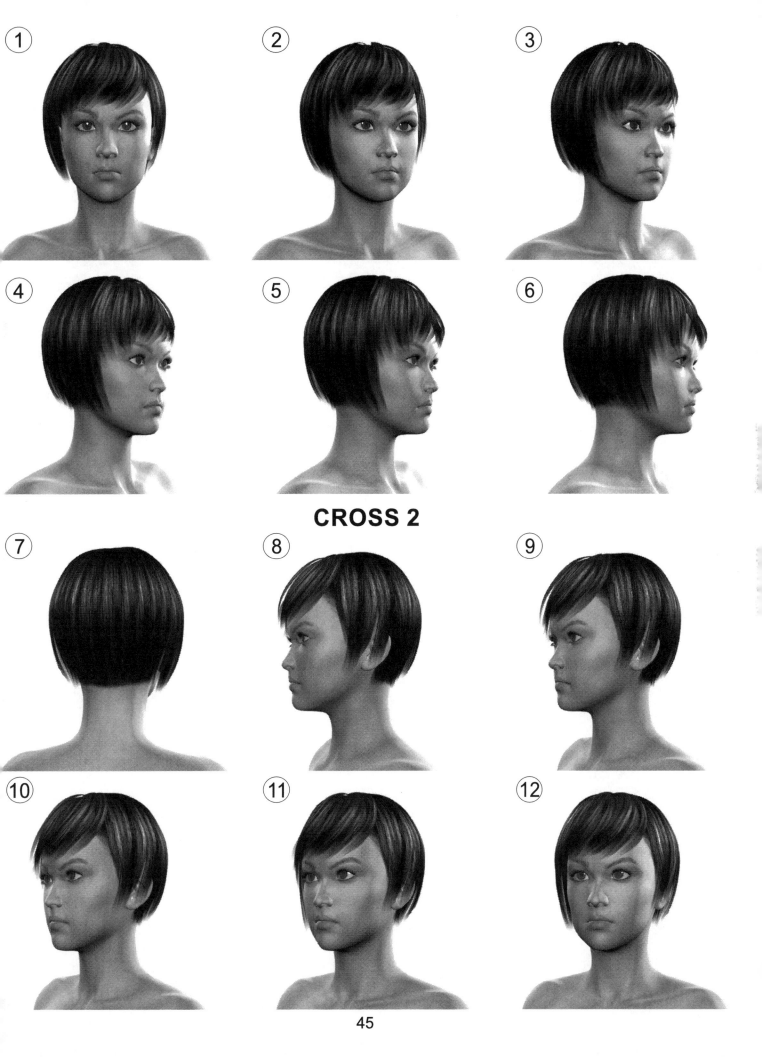

CROSS 2

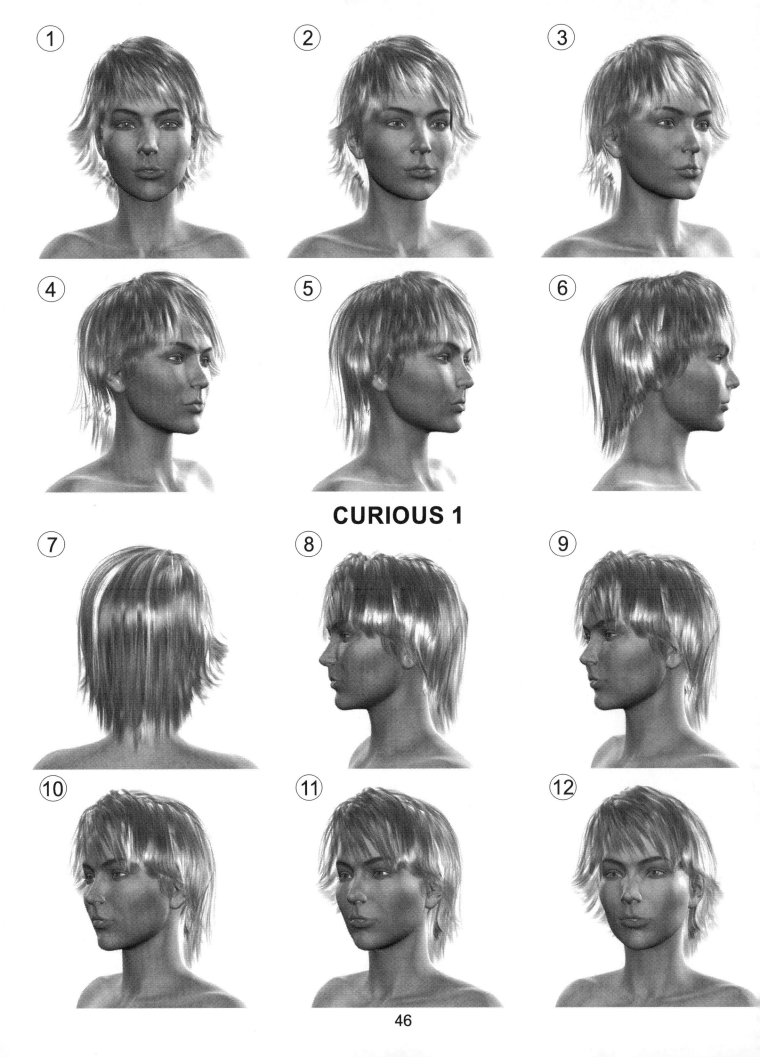

CURIOUS 1

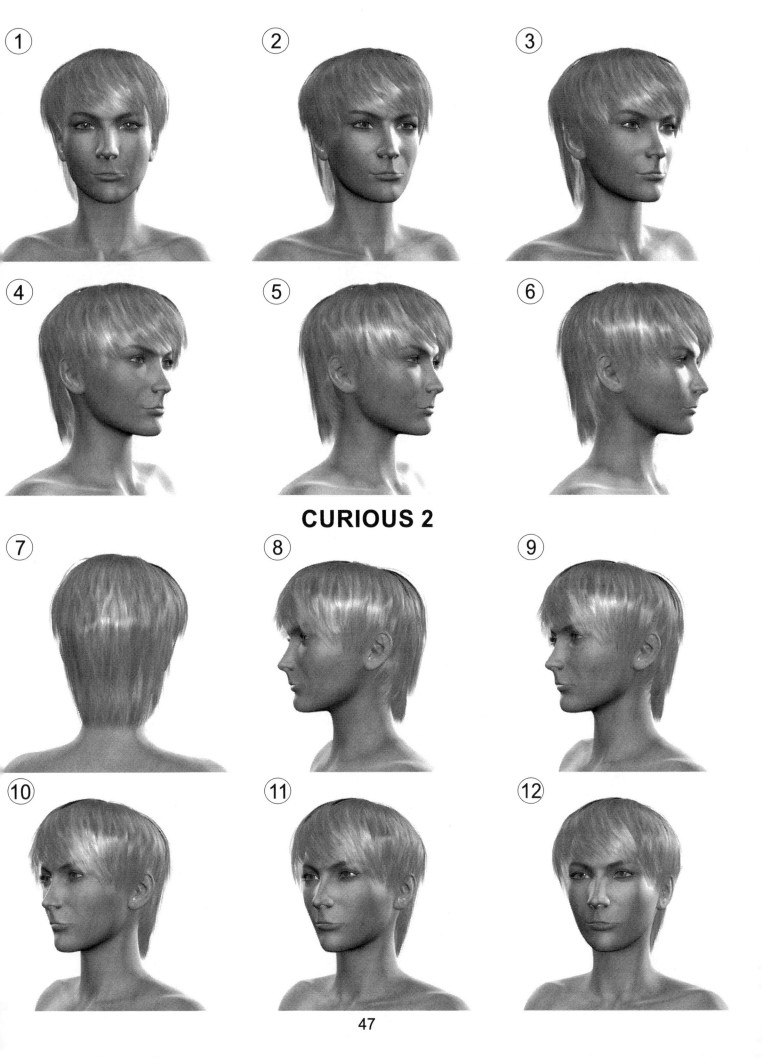

CURIOUS 2

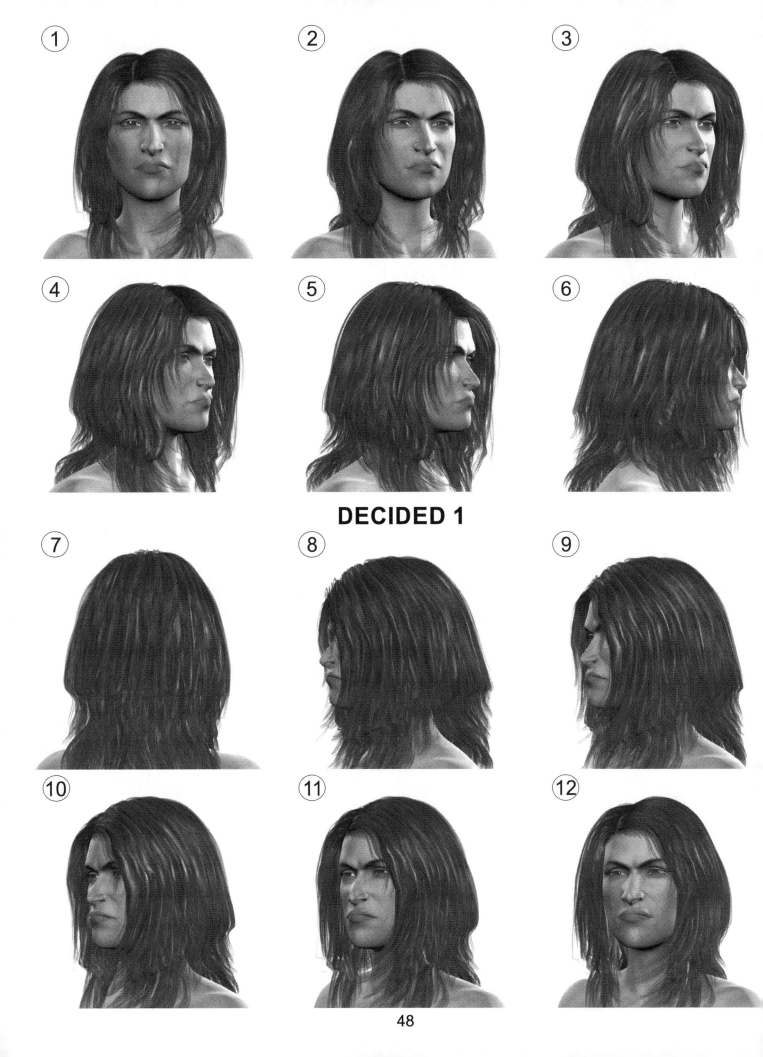

DECIDED 1

48

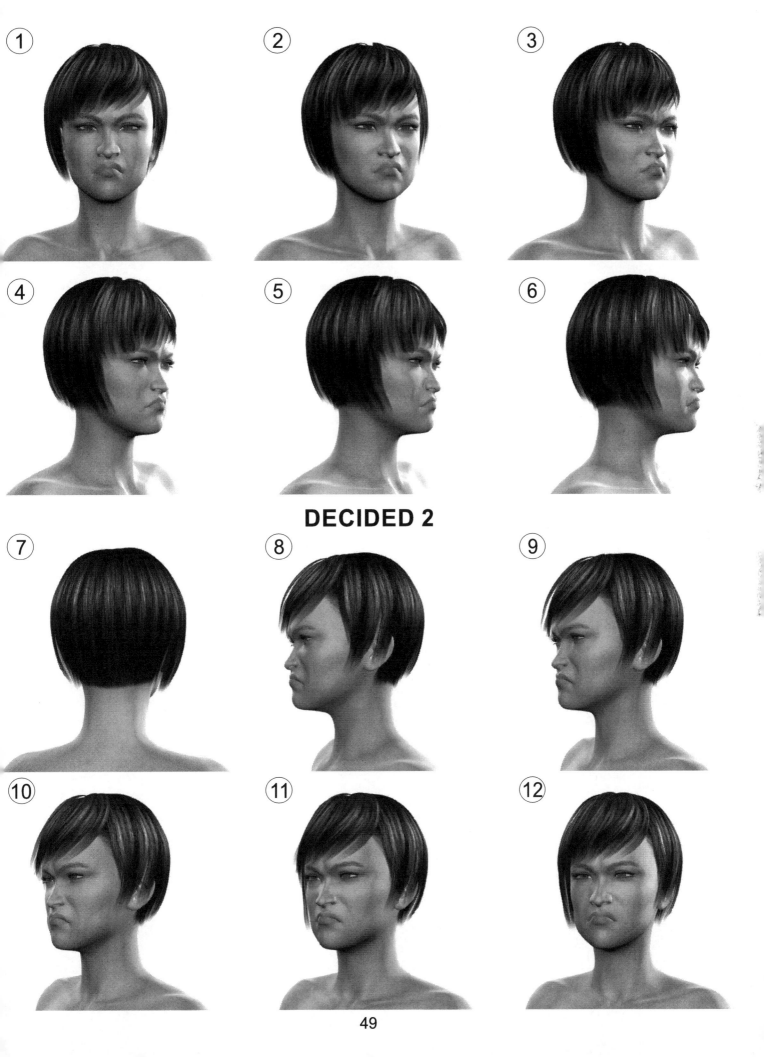

DECIDED 2

49

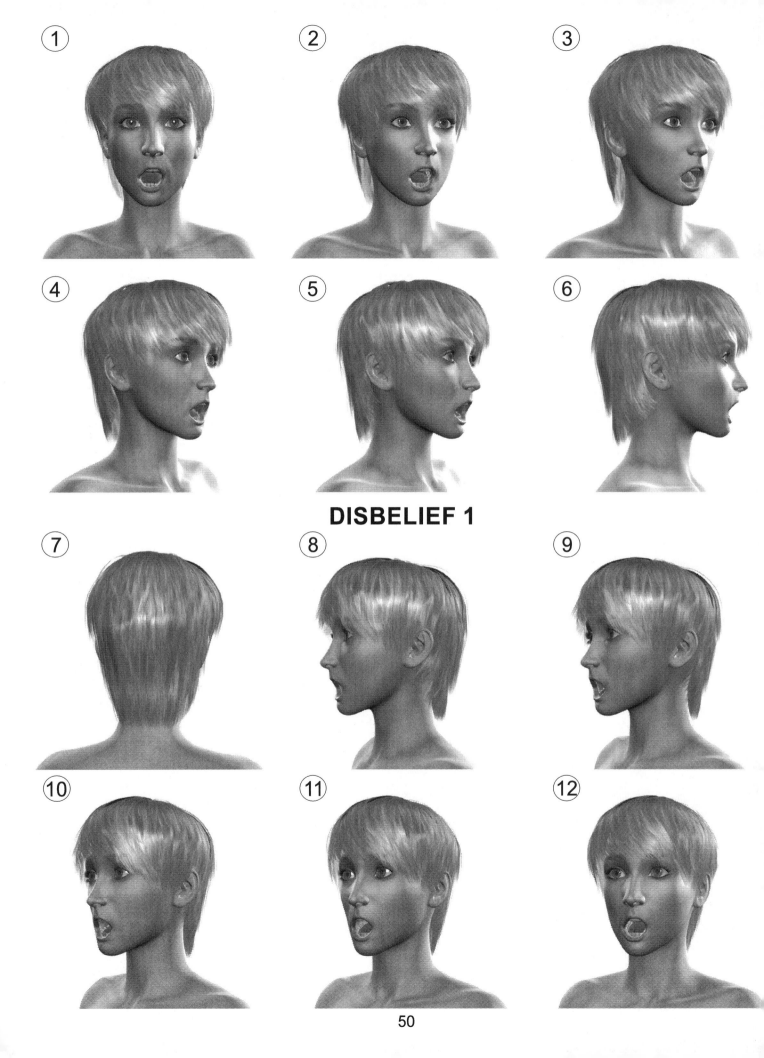

DISBELIEF 1

50

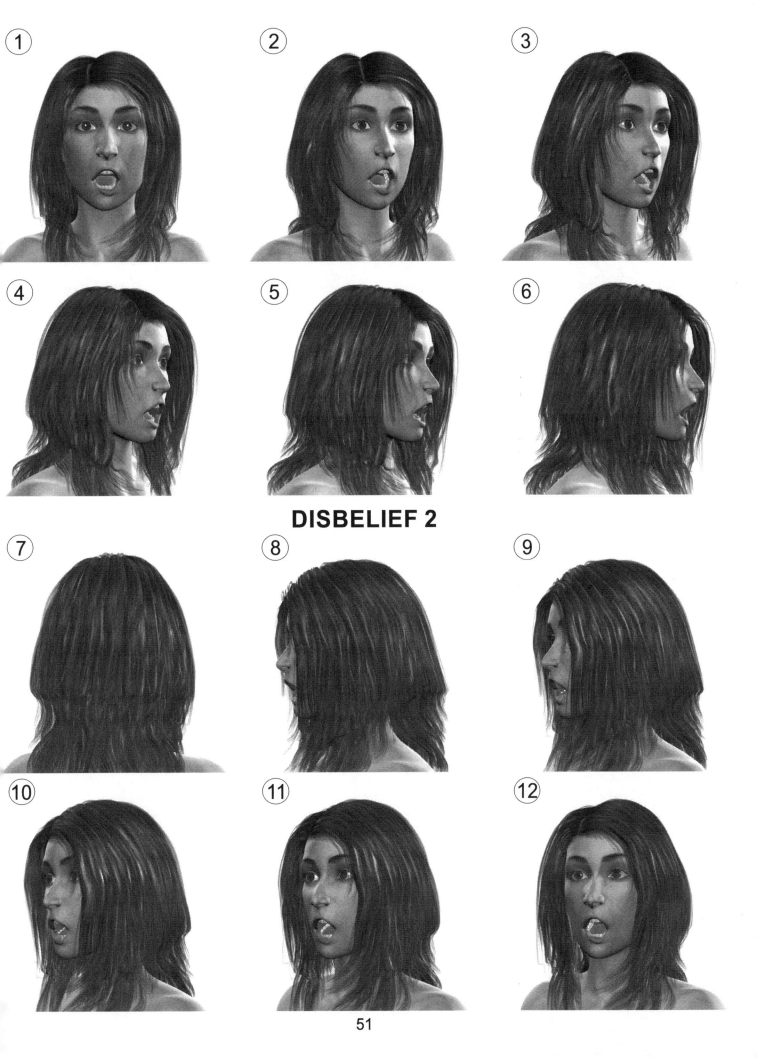

DISBELIEF 2

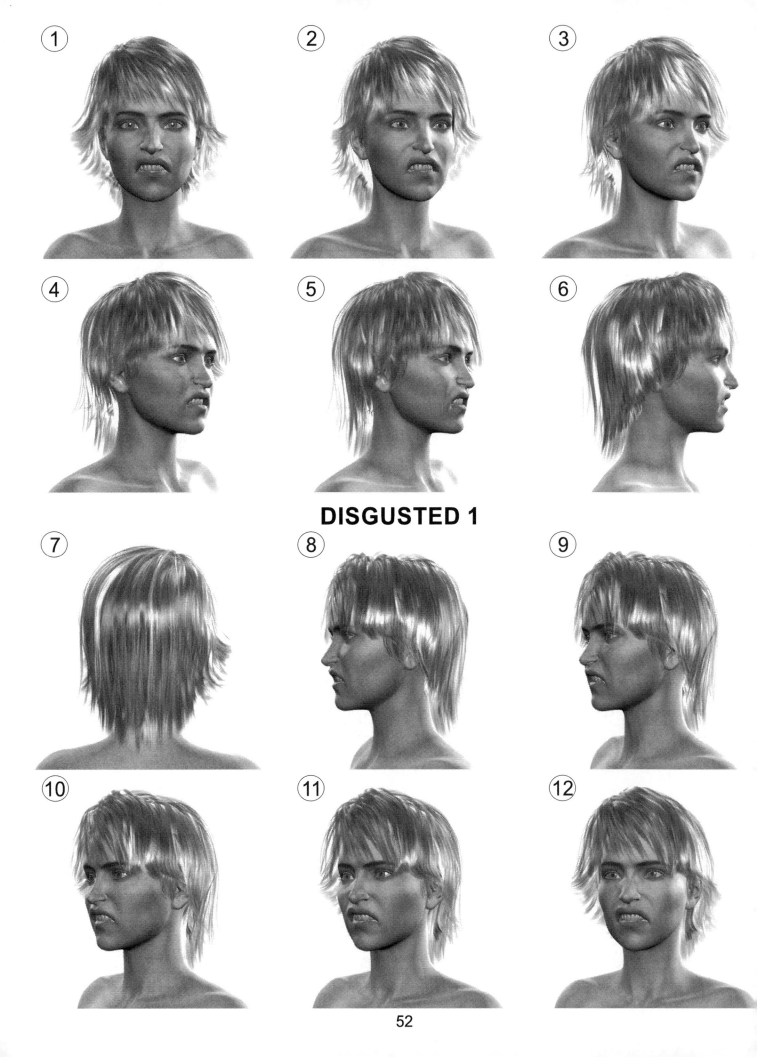

DISGUSTED 1

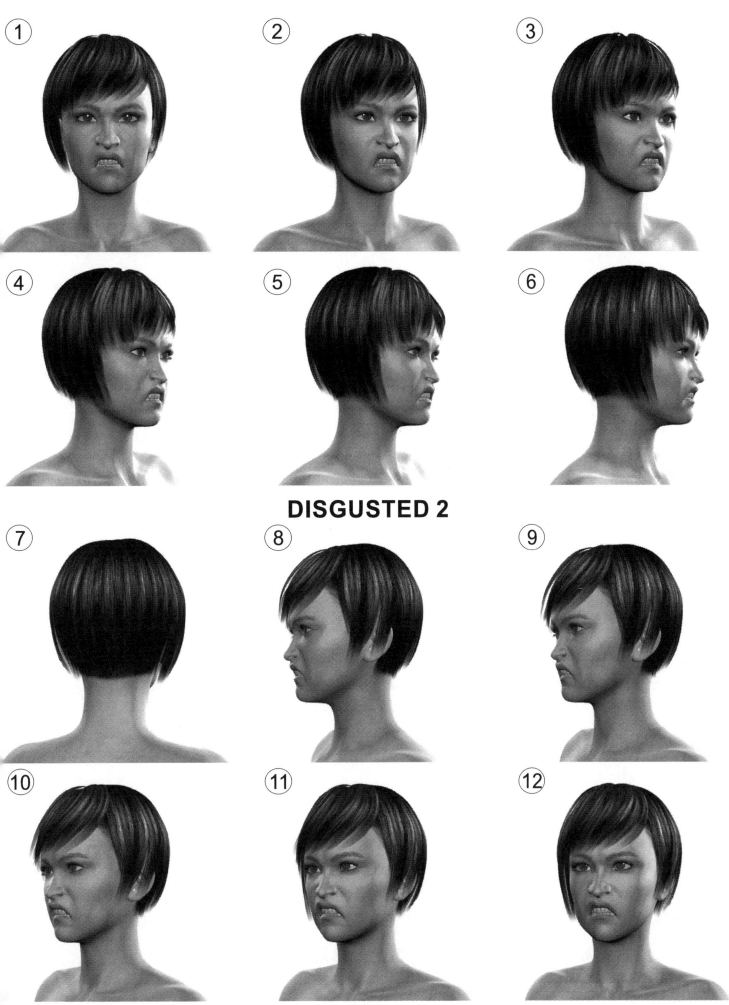

DISGUSTED 2

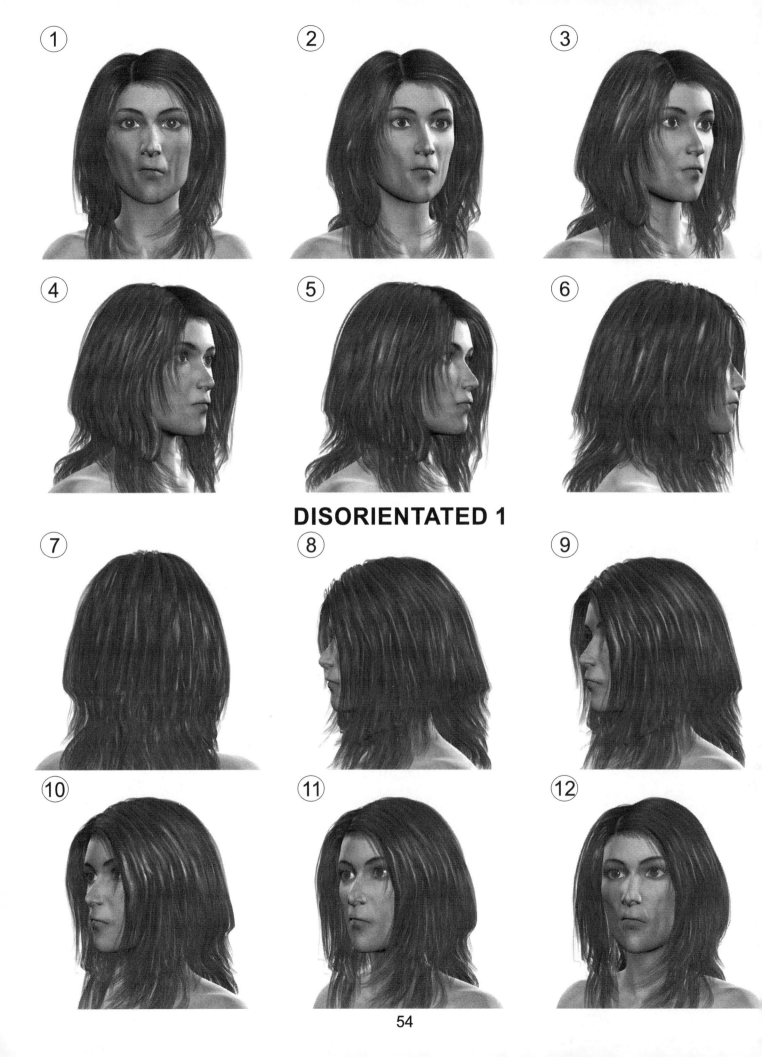

DISORIENTATED 1

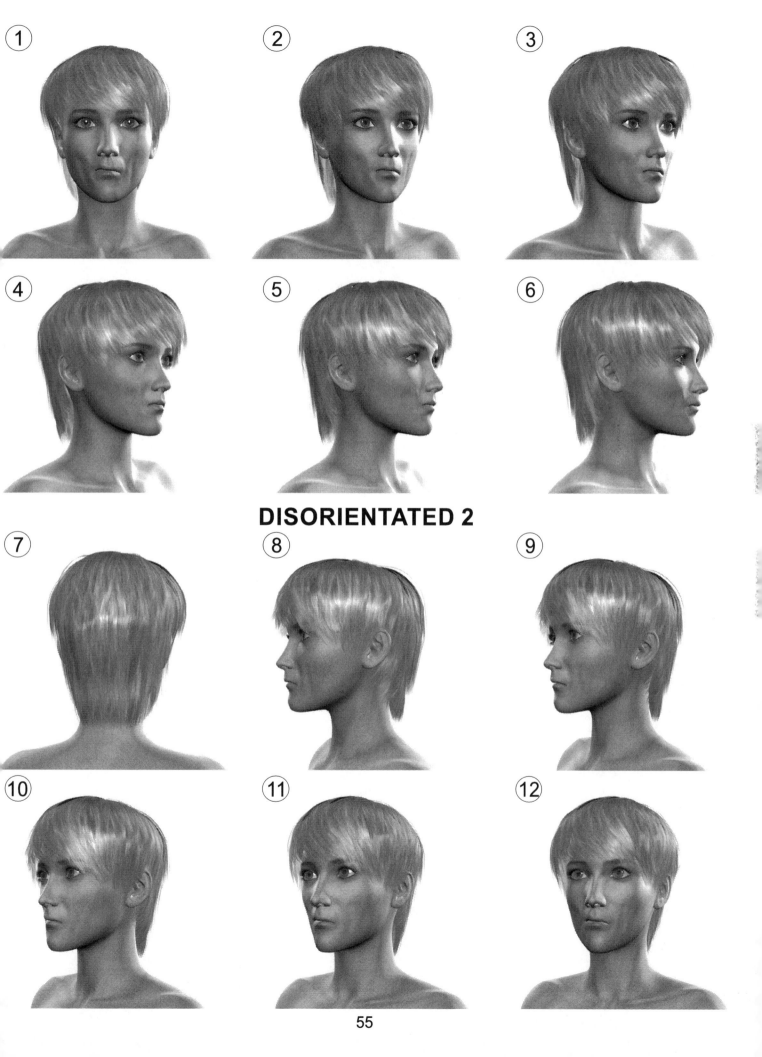

DISORIENTATED 2

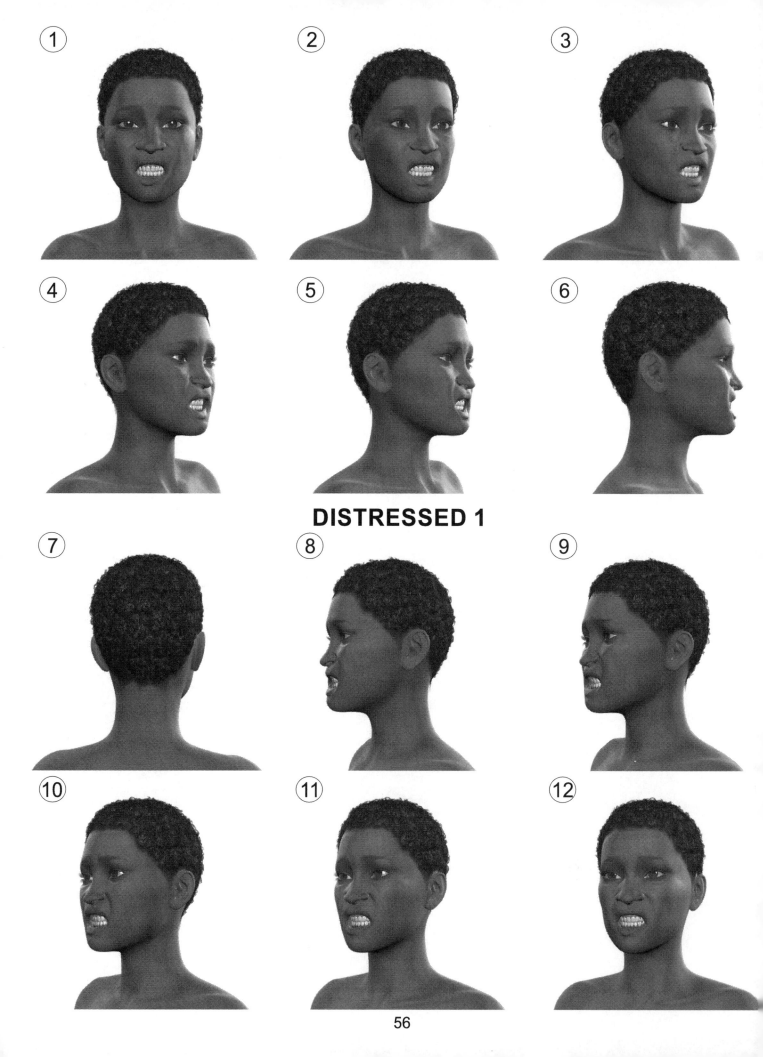

DISTRESSED 1

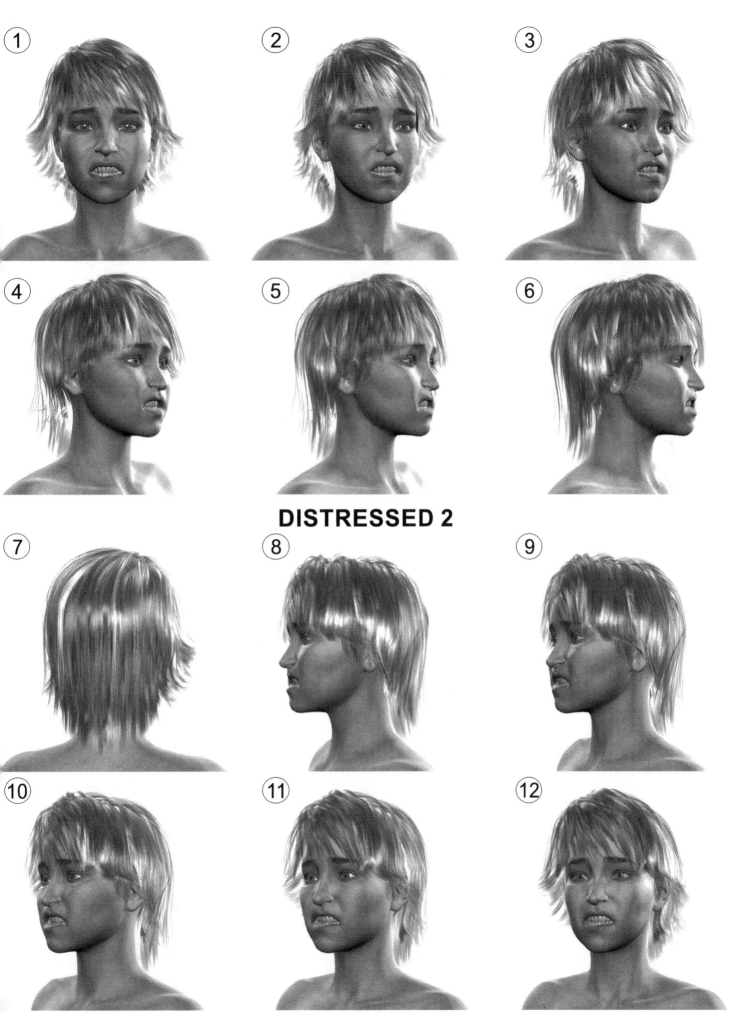

DISTRESSED 2

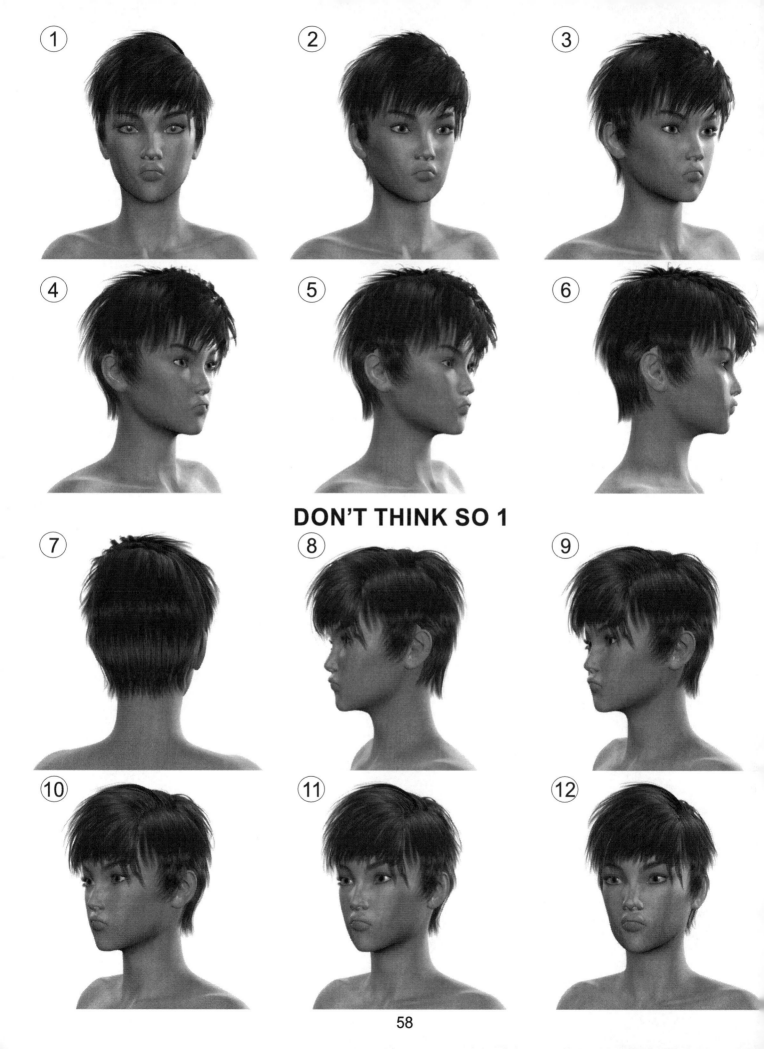

DON'T THINK SO 1

58

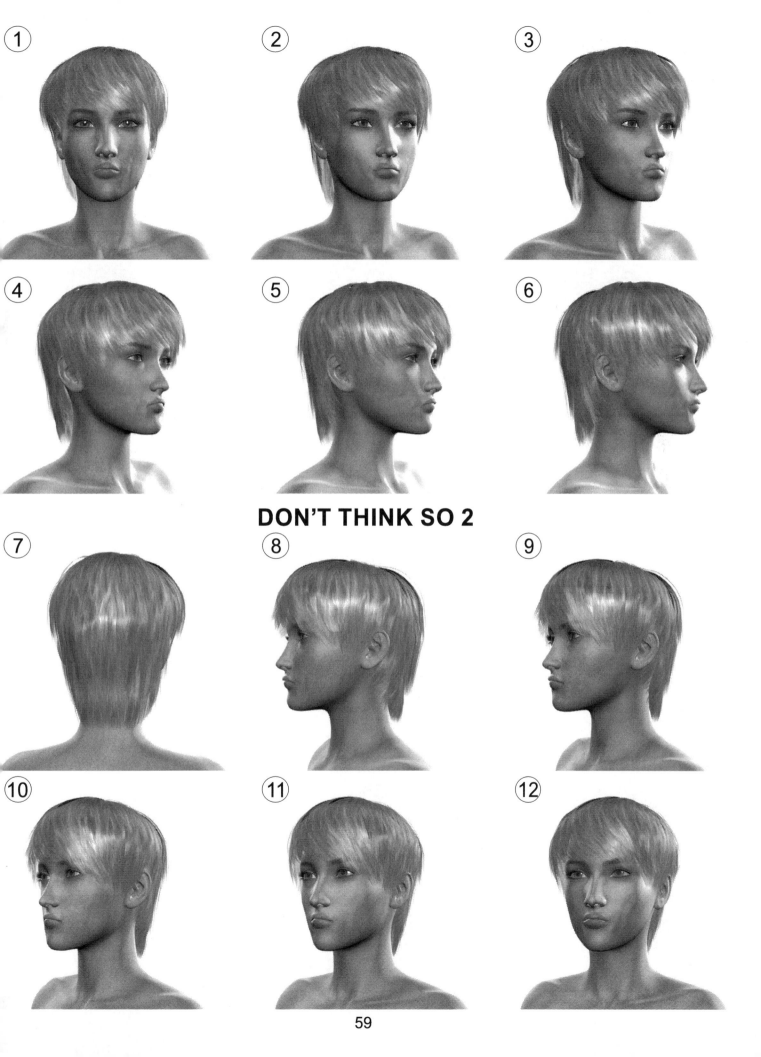

DON'T THINK SO 2

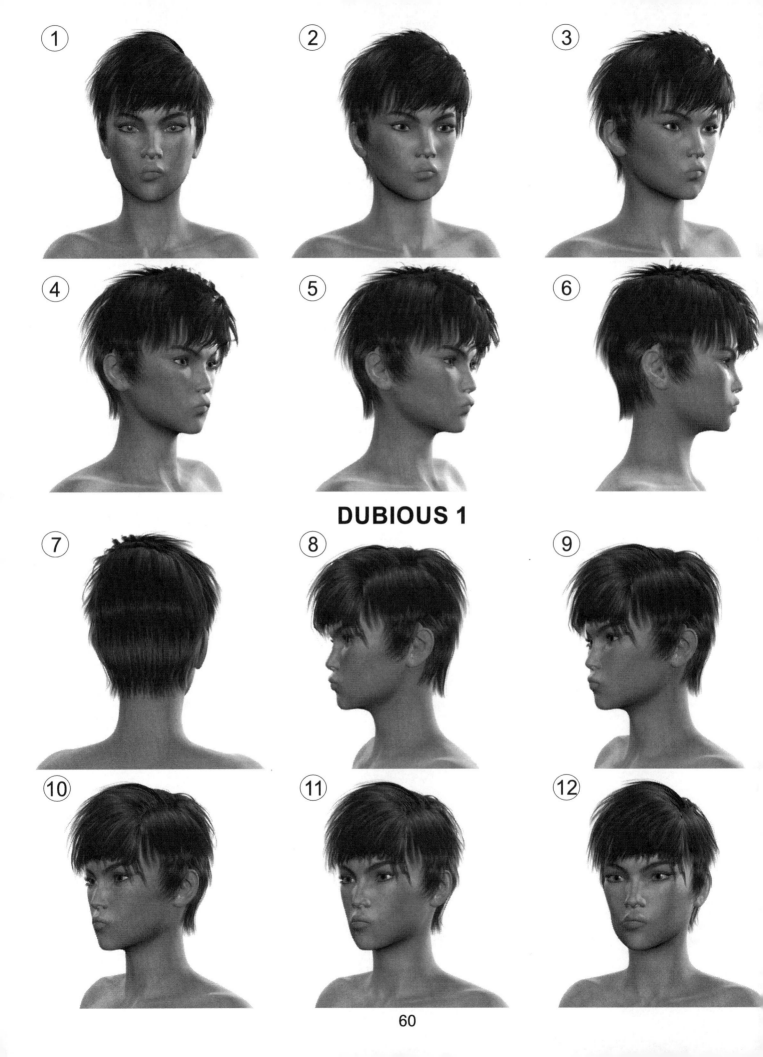

DUBIOUS 1

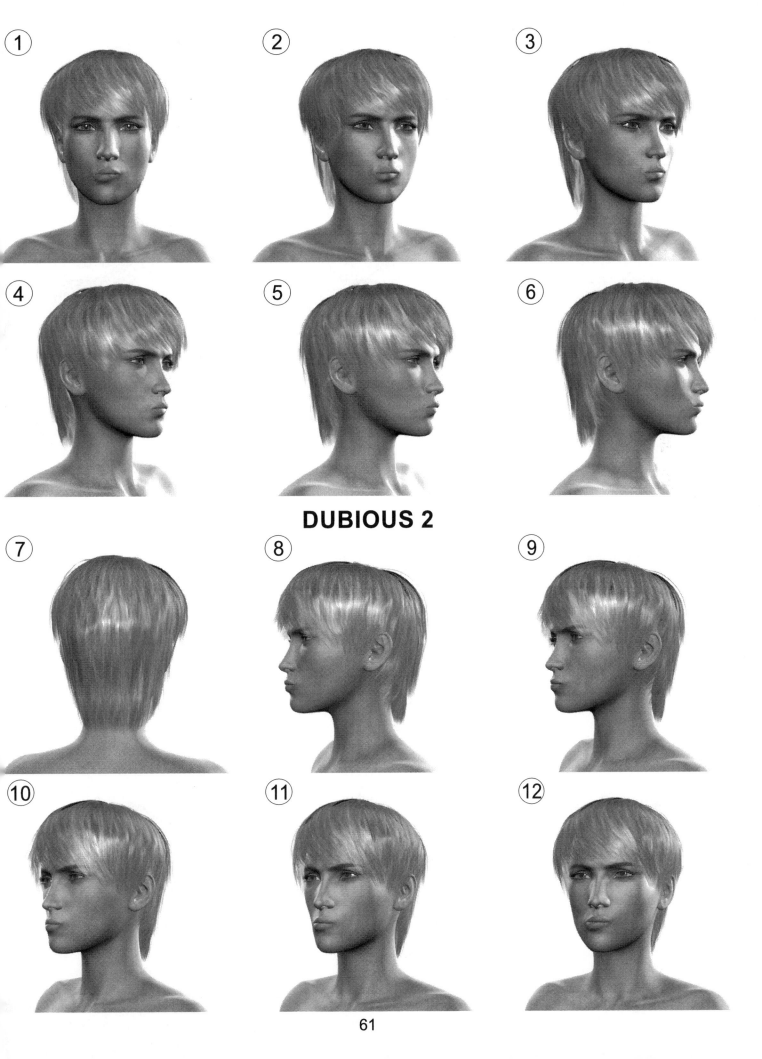

DUBIOUS 2

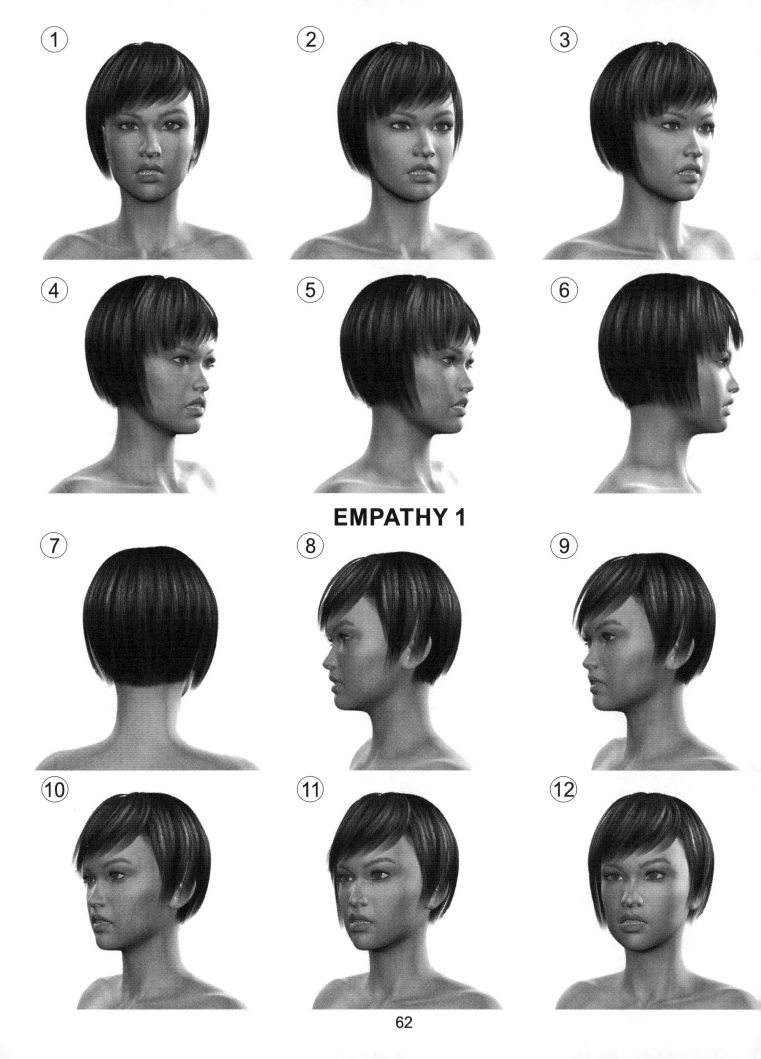

EMPATHY 1

62

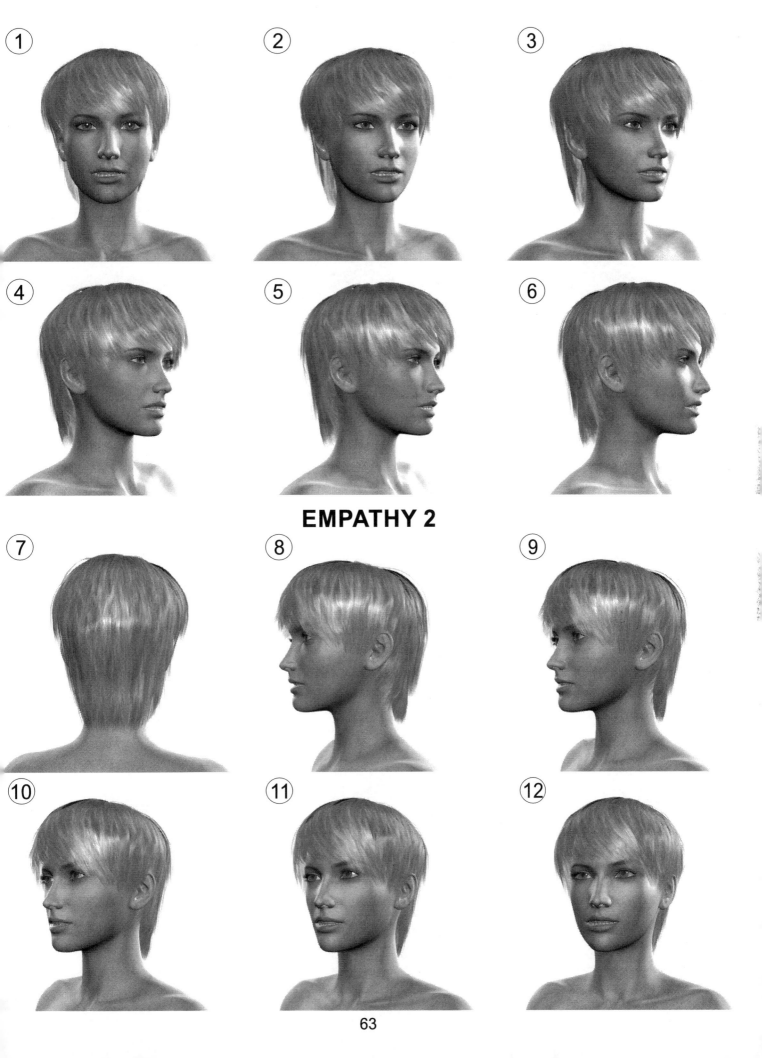

EMPATHY 2

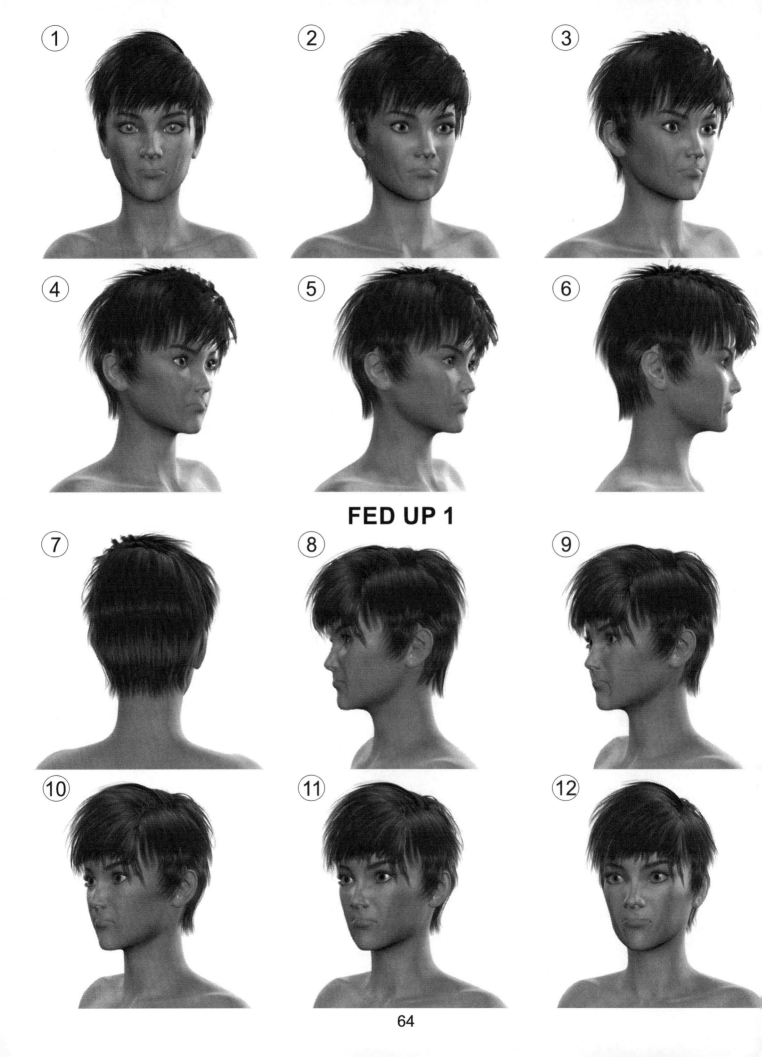

FED UP 1

64

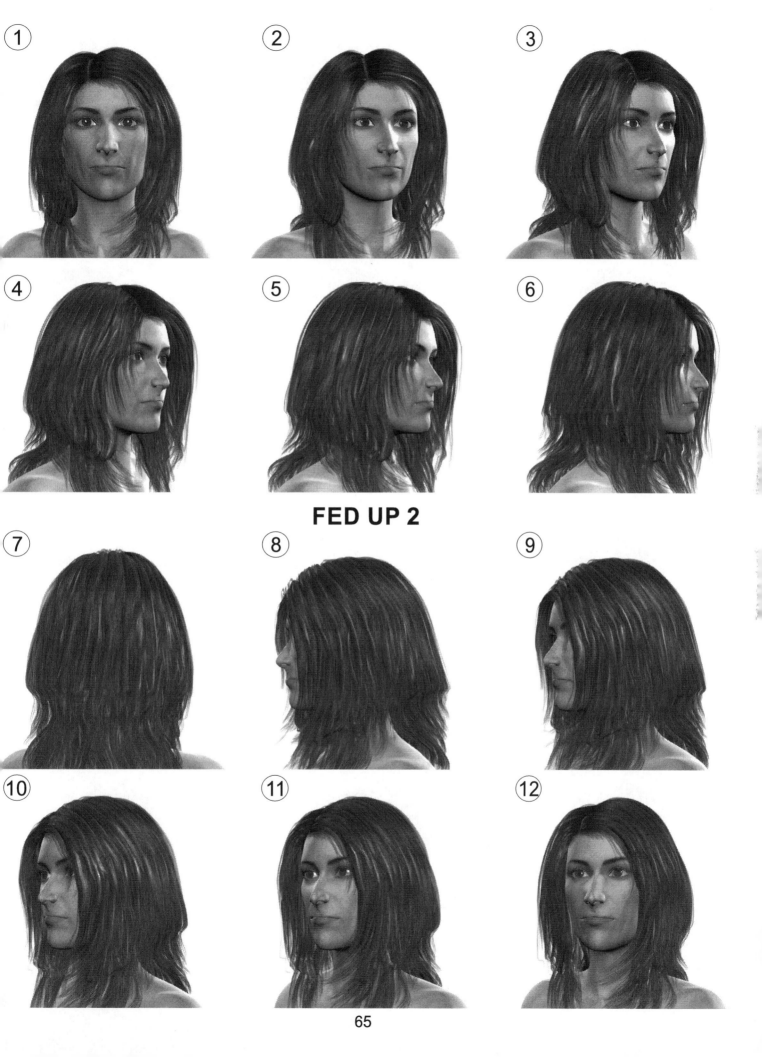

FED UP 2

65

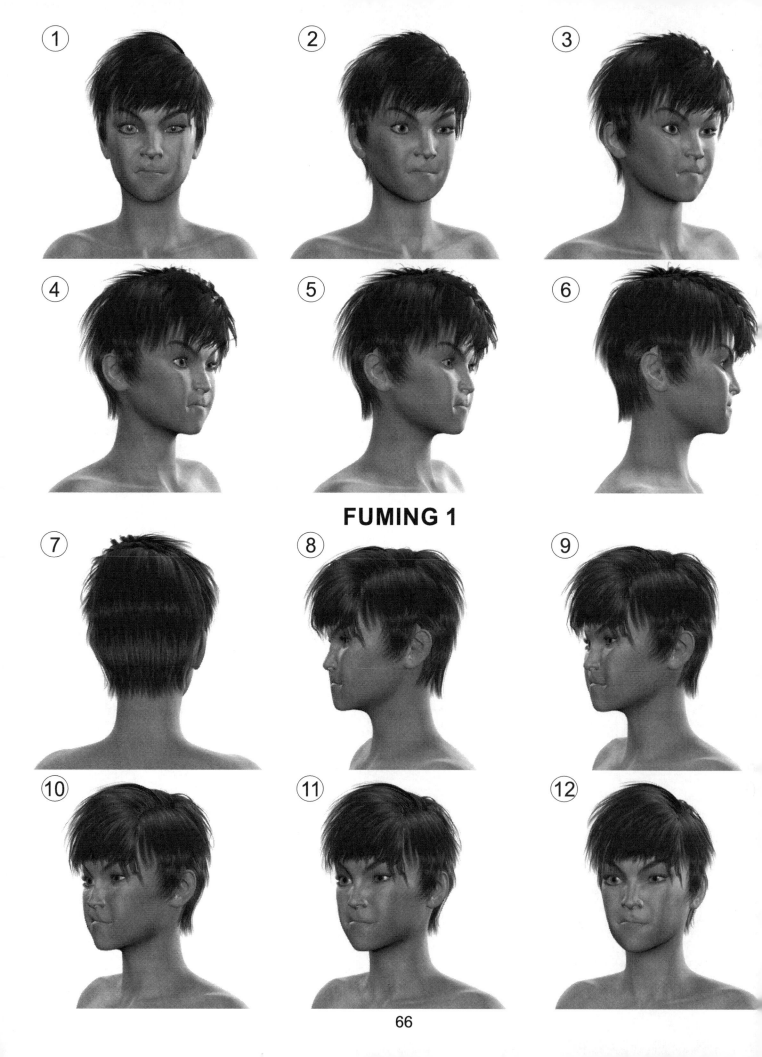

FUMING 1

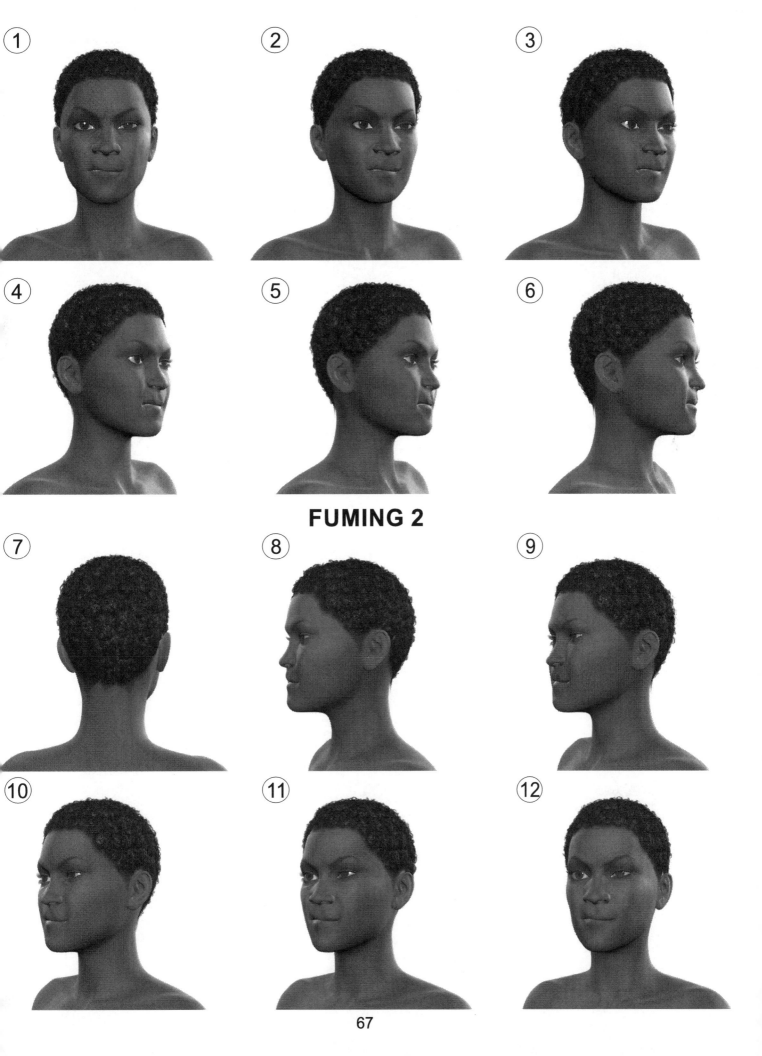

FUMING 2

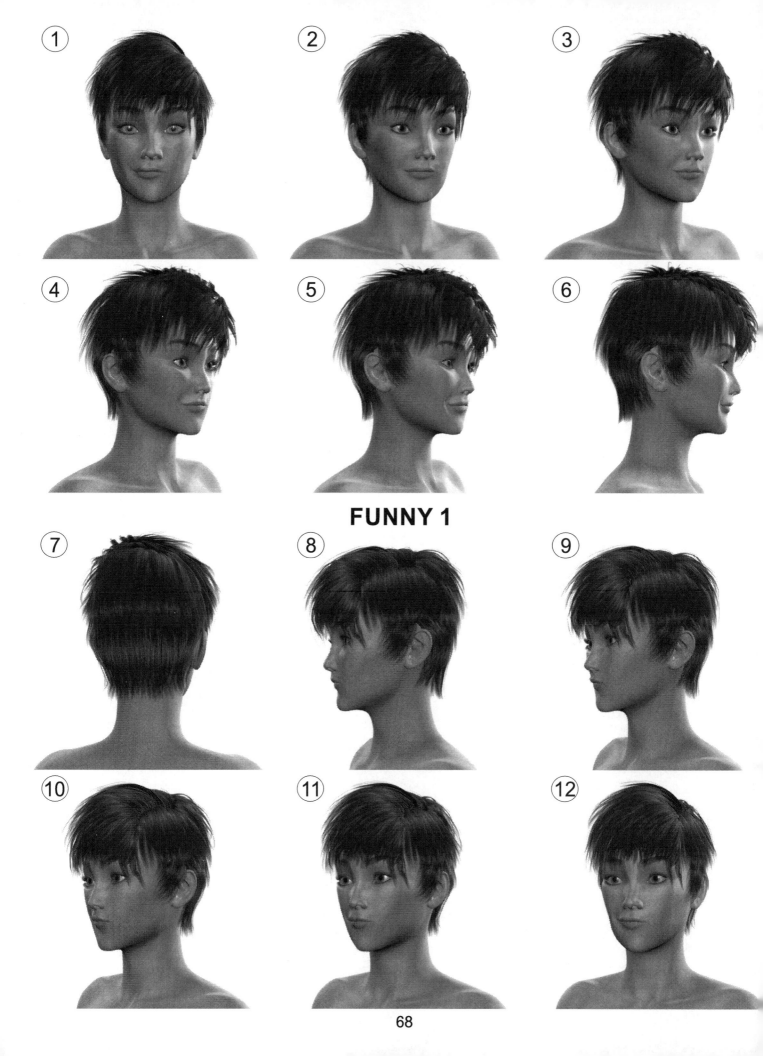

FUNNY 1

68

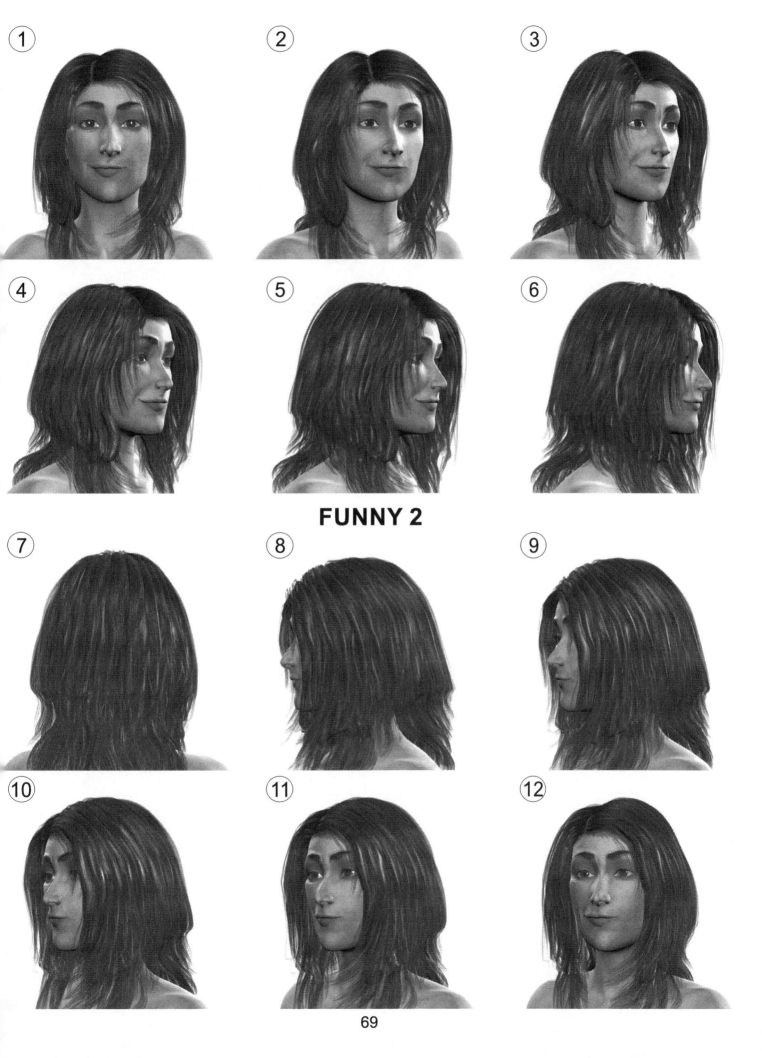

FUNNY 2

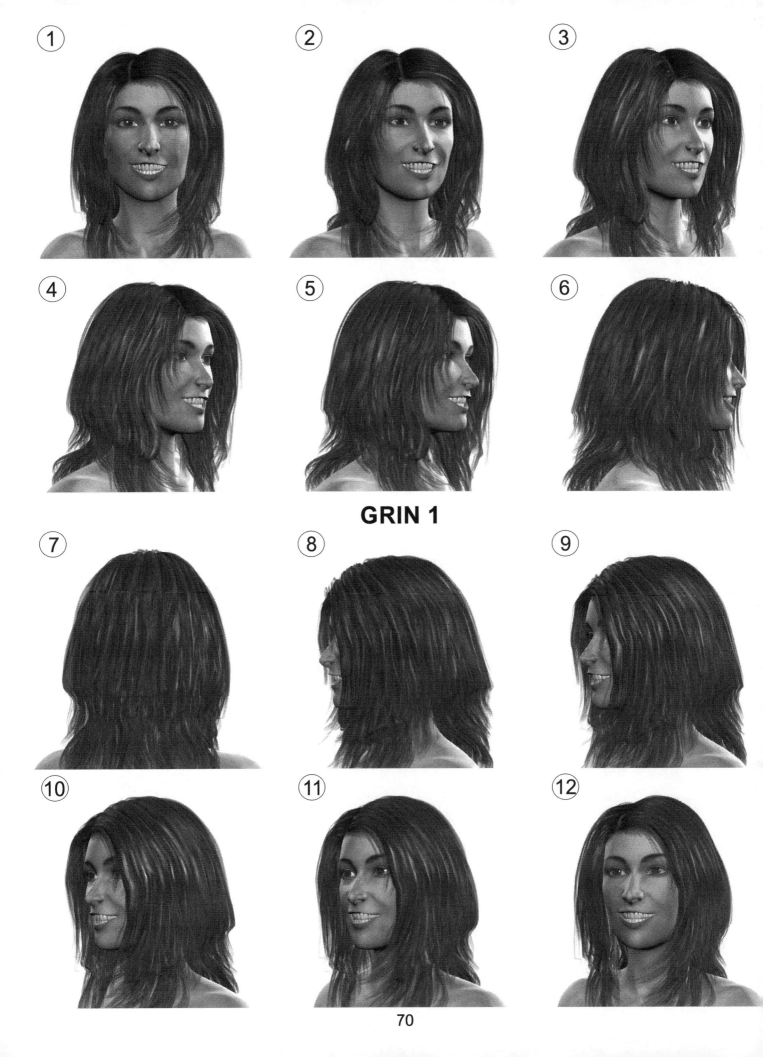

GRIN 1

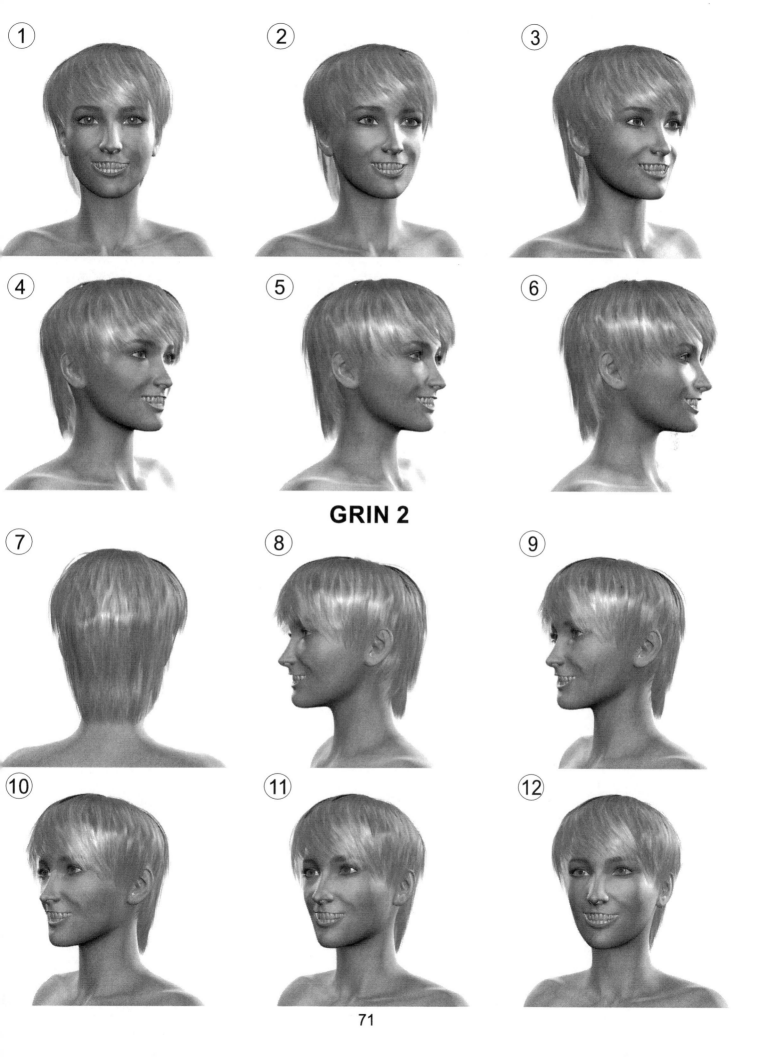

GRIN 2

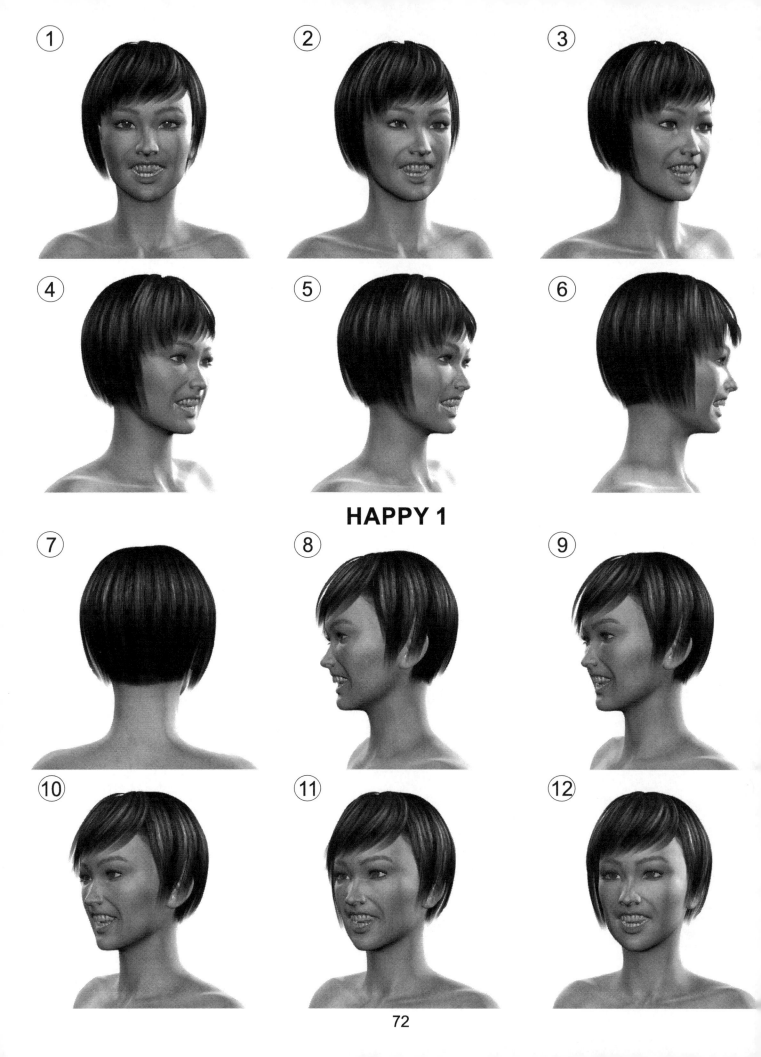

HAPPY 1

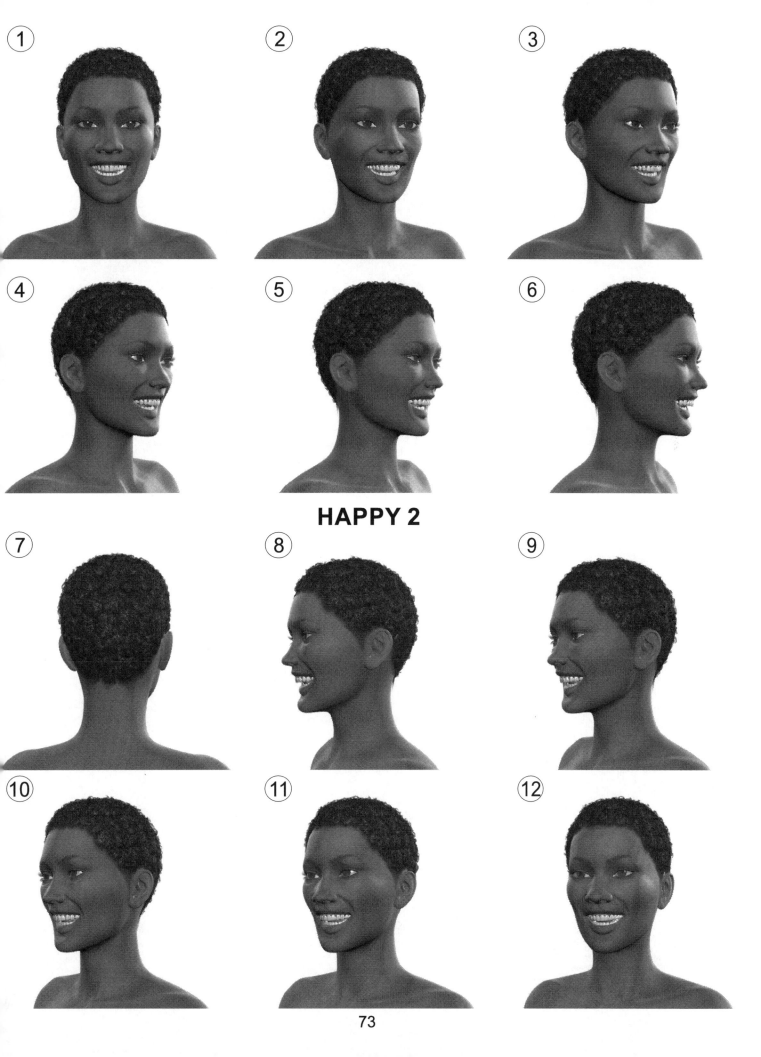

HAPPY 2

73

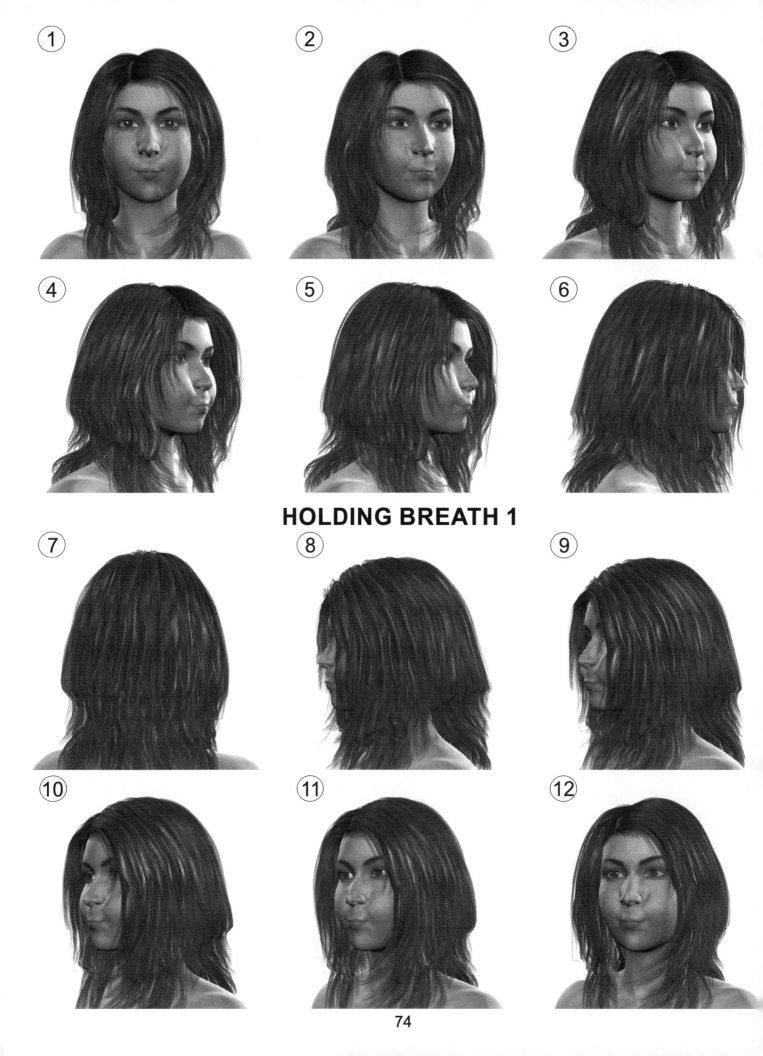

HOLDING BREATH 1

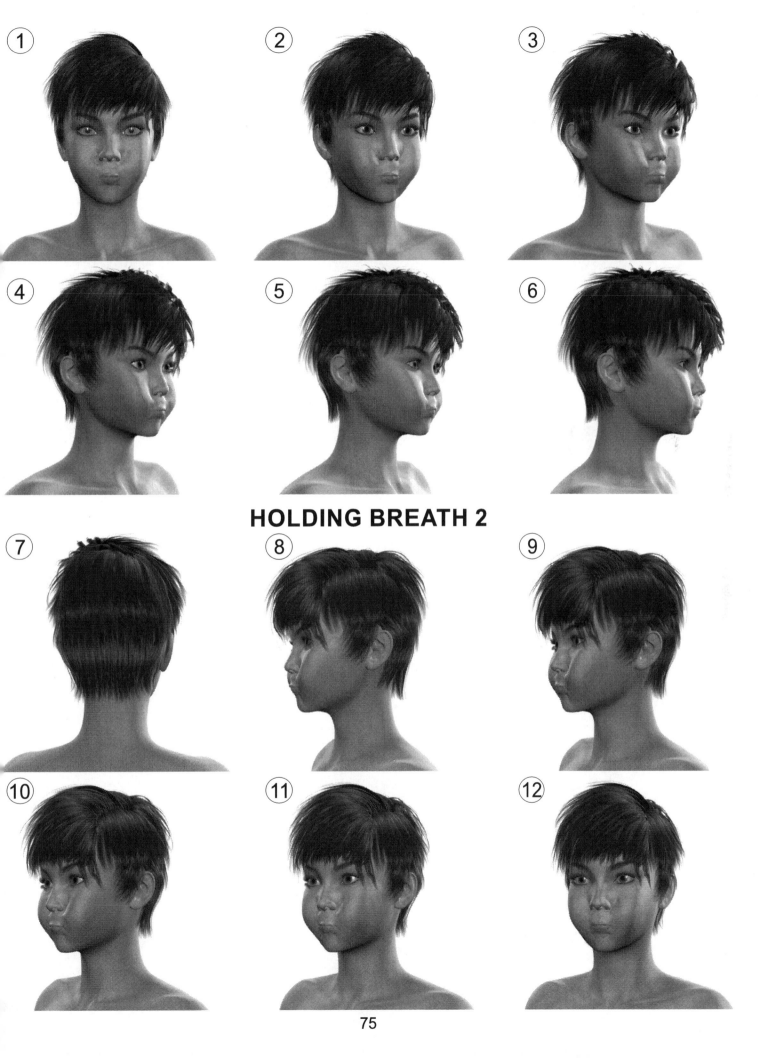

HOLDING BREATH 2

75

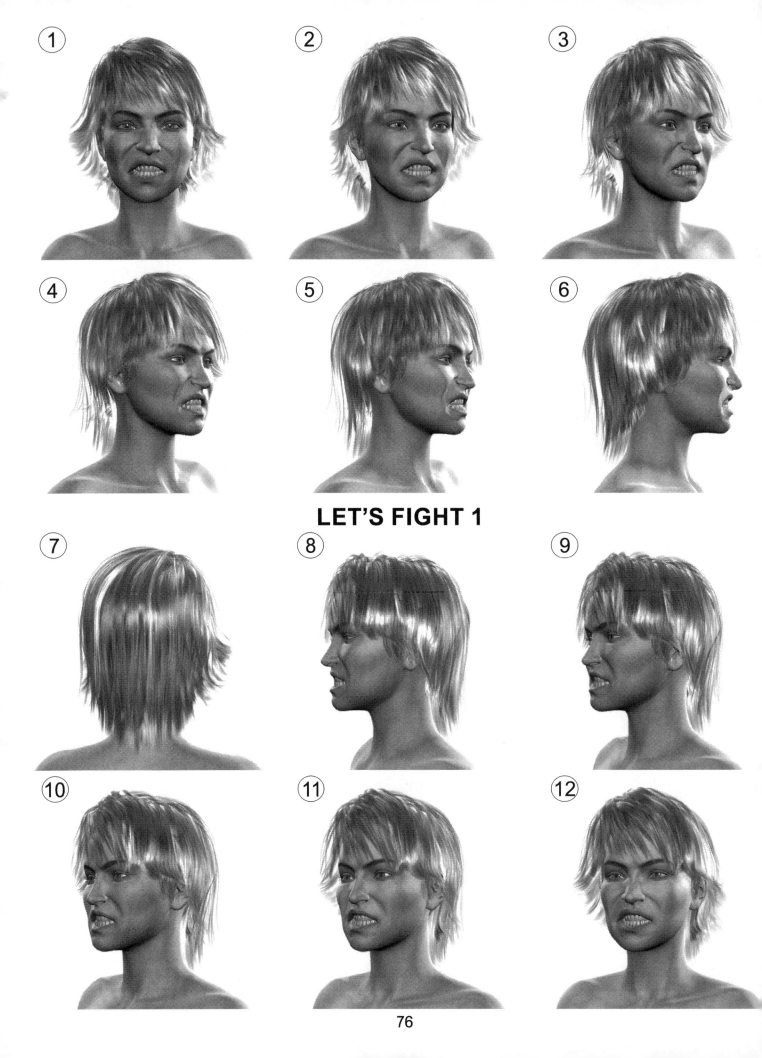

LET'S FIGHT 1

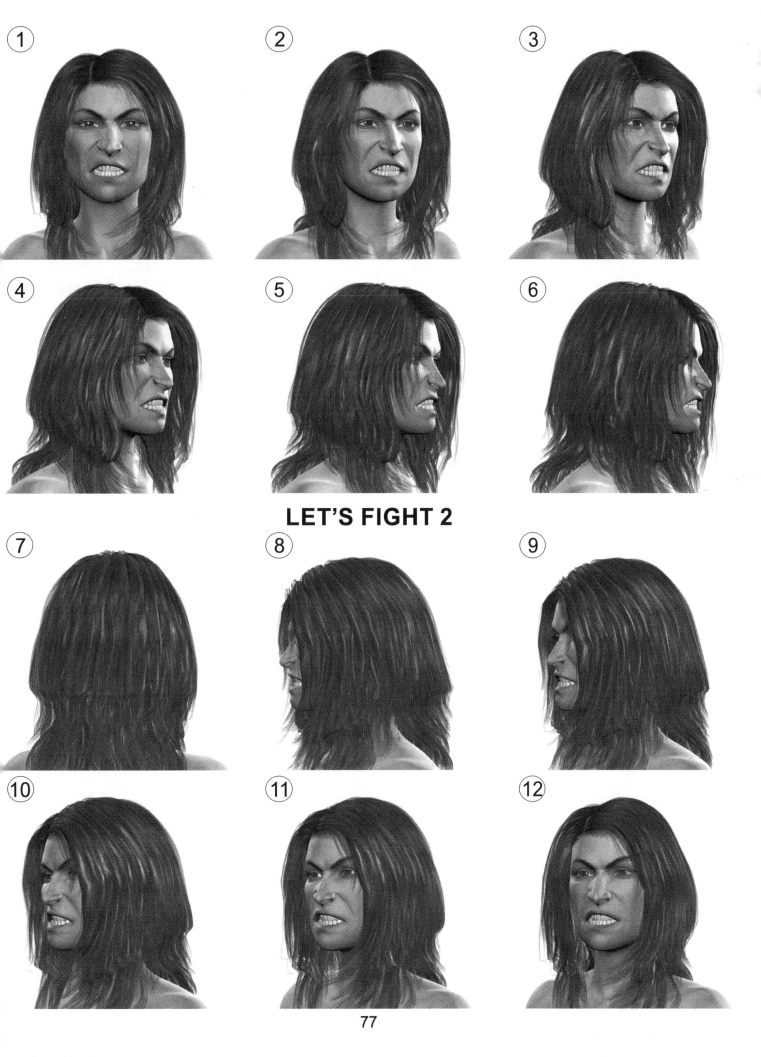

LET'S FIGHT 2

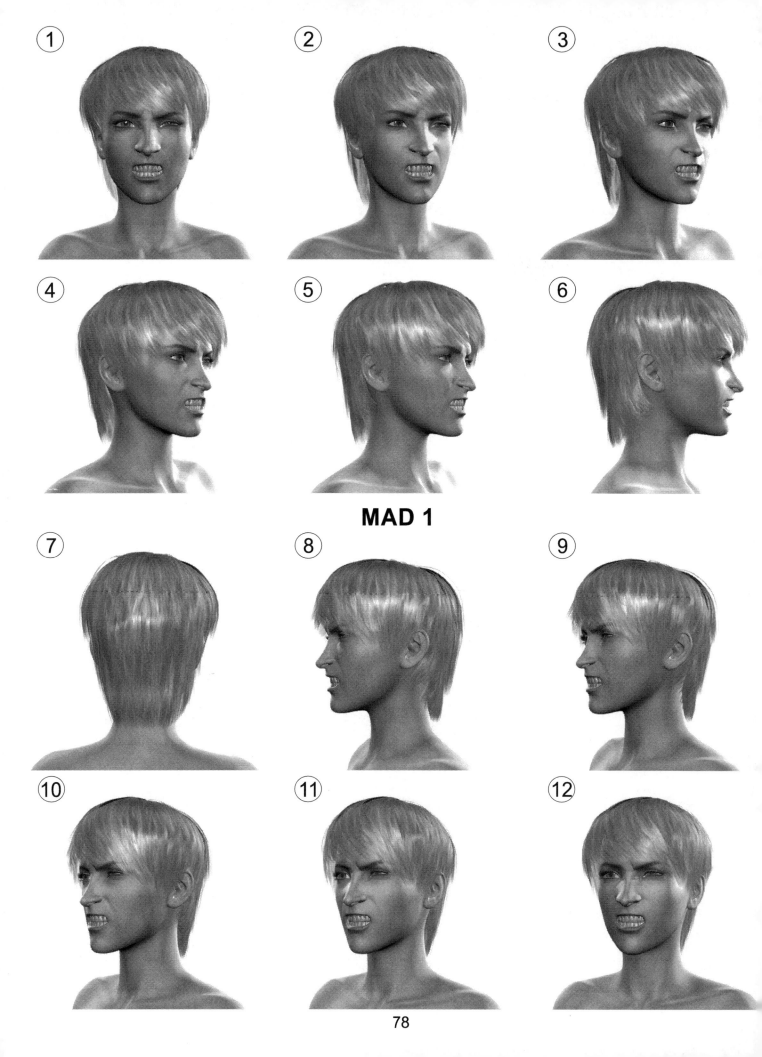

MAD 1

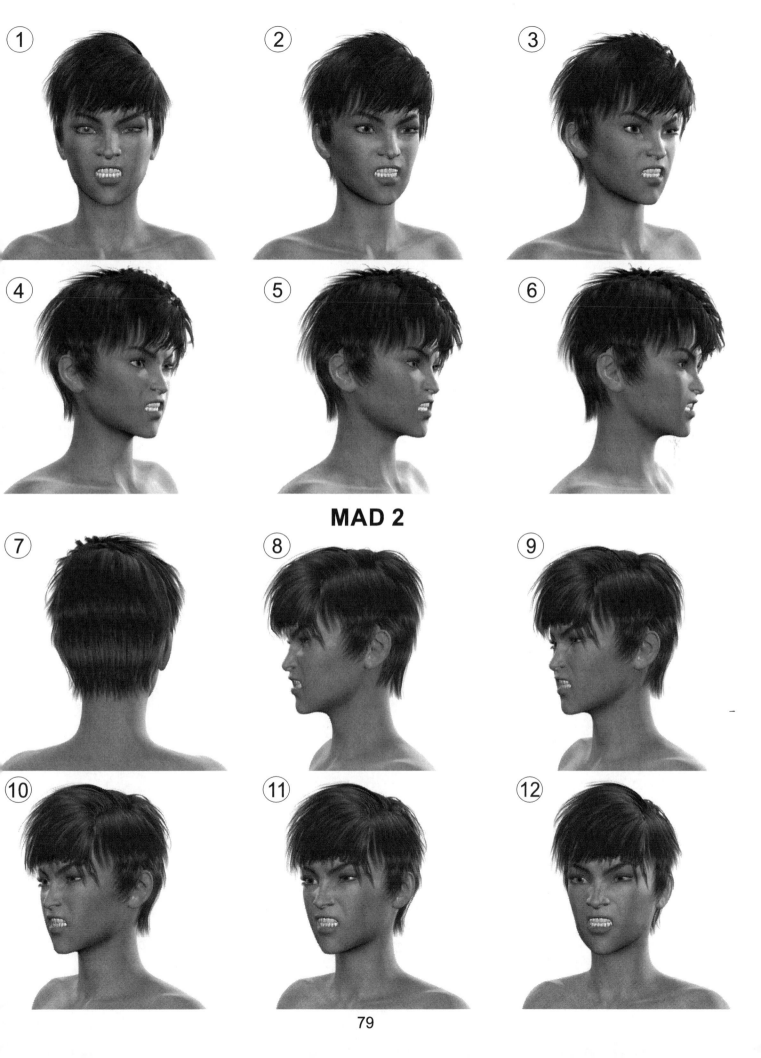

MAD 2

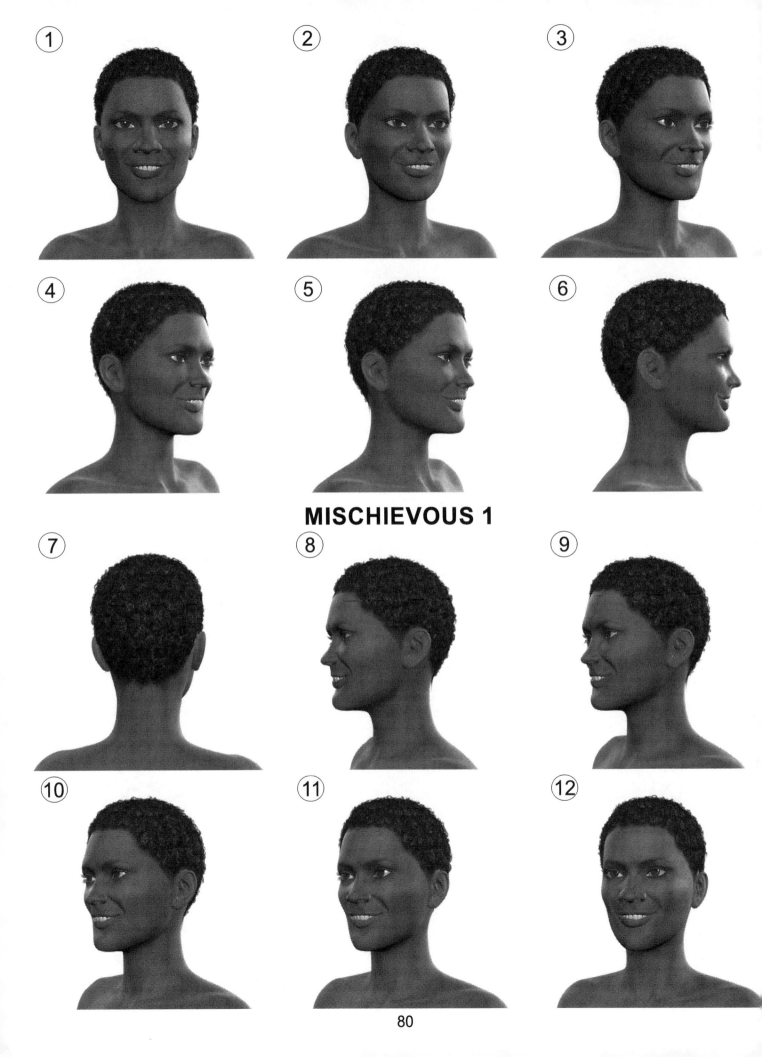

MISCHIEVOUS 1

80

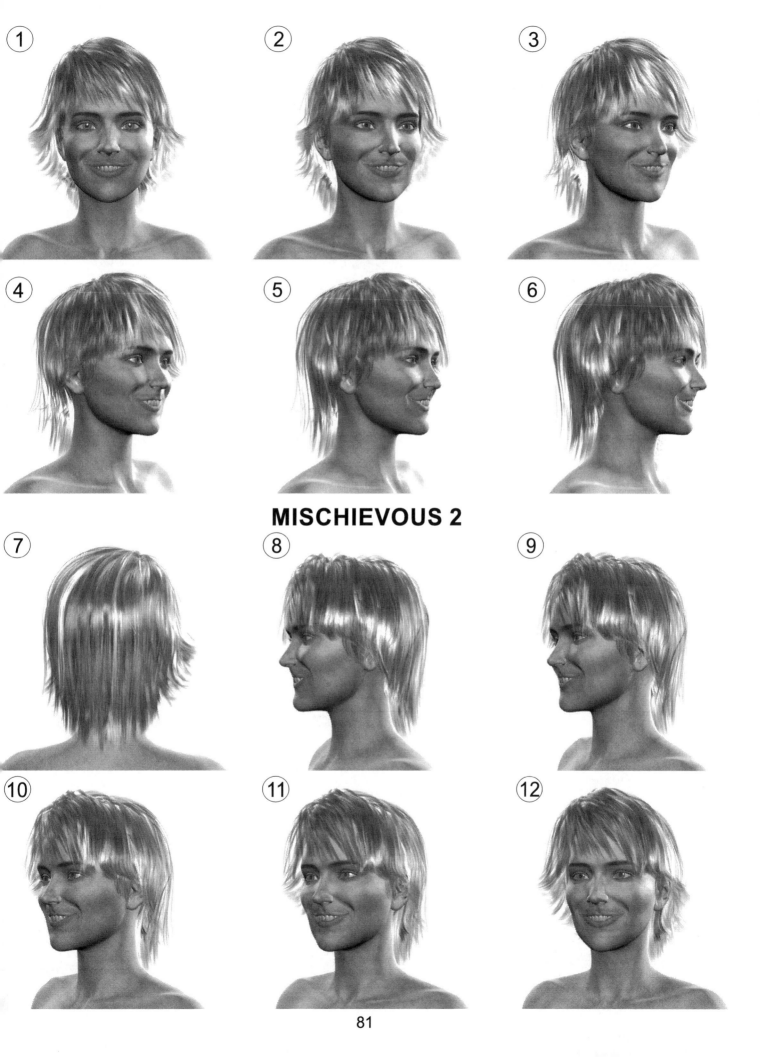

MISCHIEVOUS 2

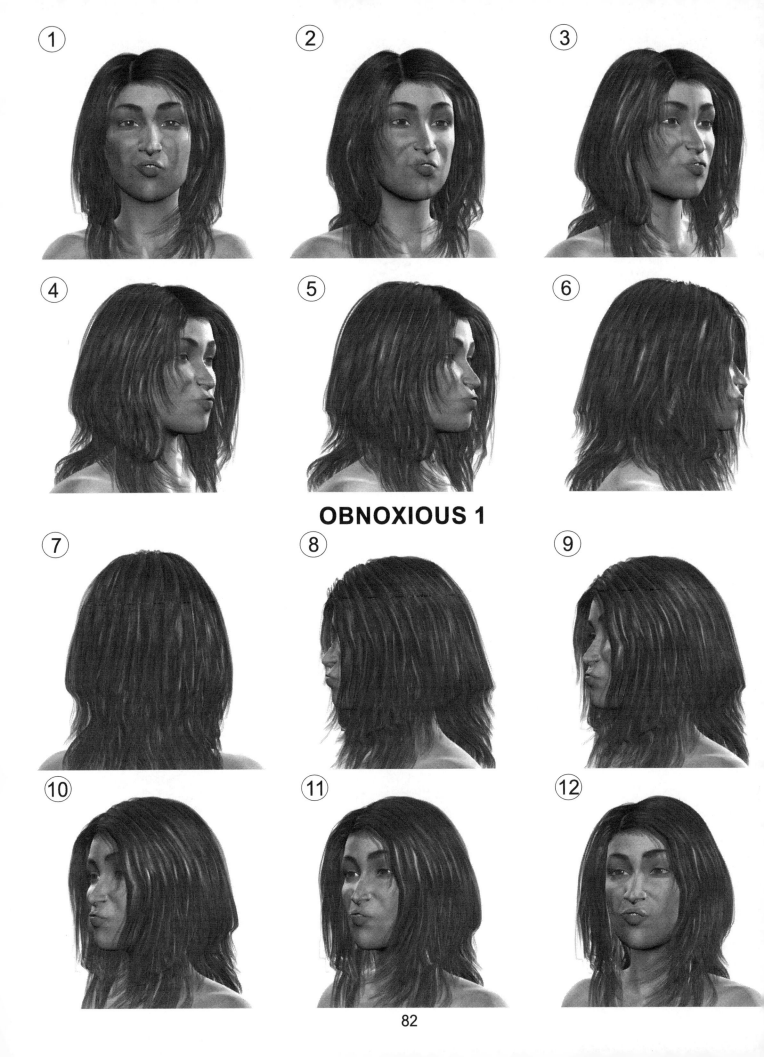

OBNOXIOUS 1

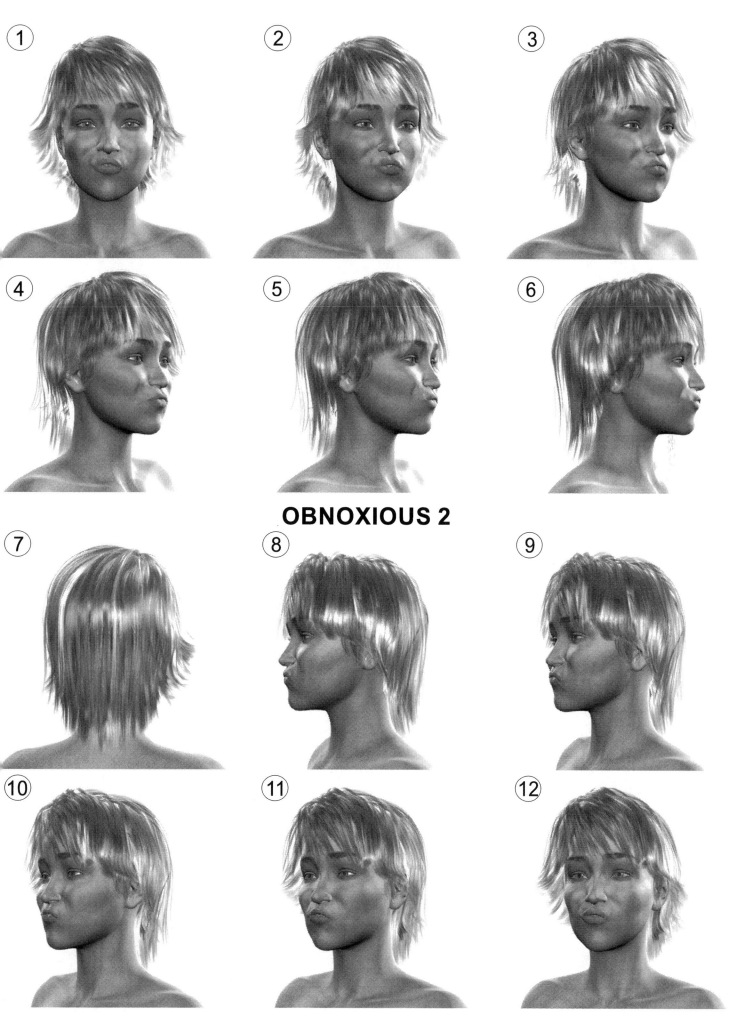

OBNOXIOUS 2

83

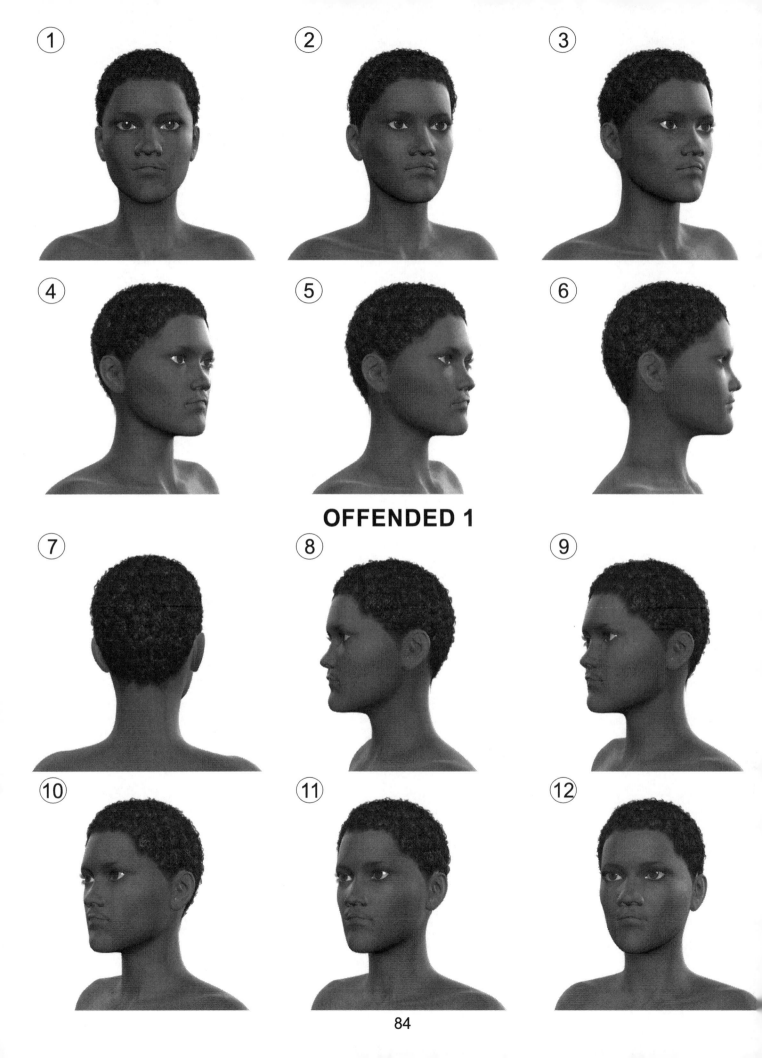

OFFENDED 1

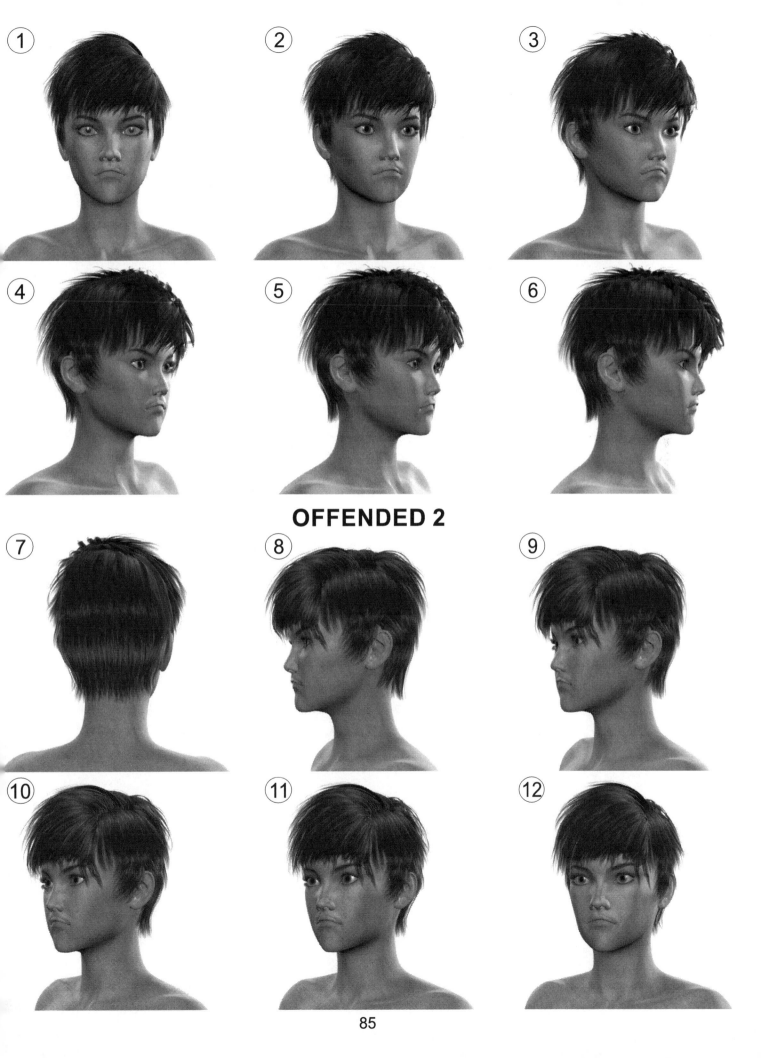

OFFENDED 2

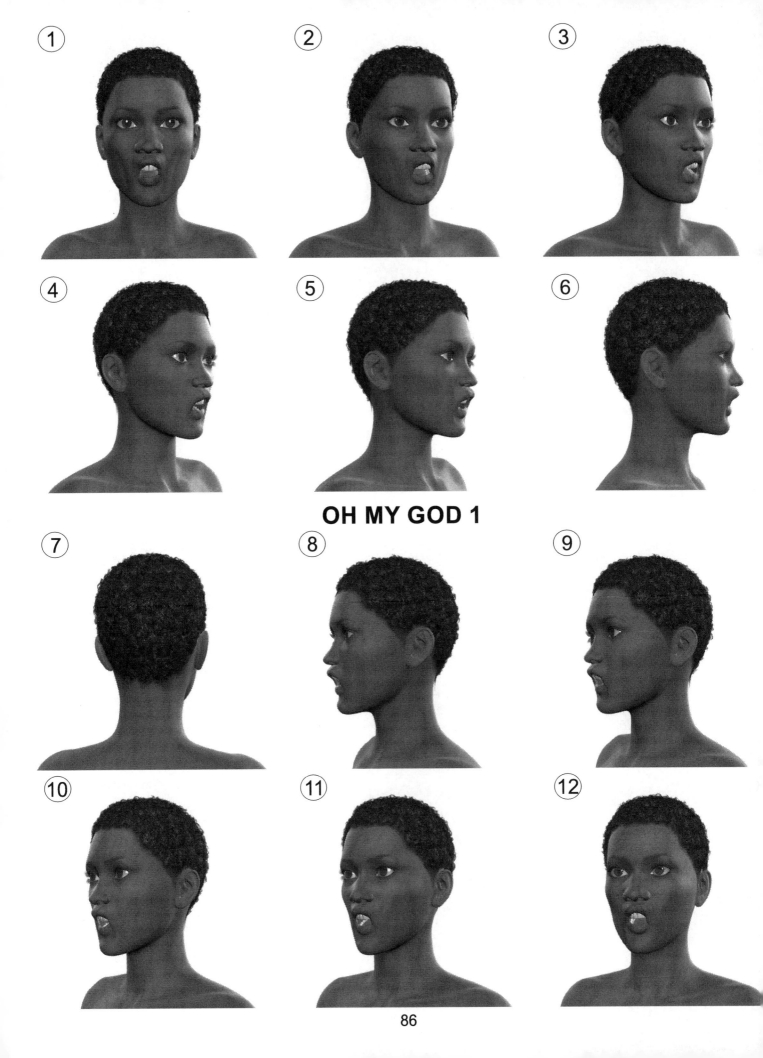

OH MY GOD 1

86

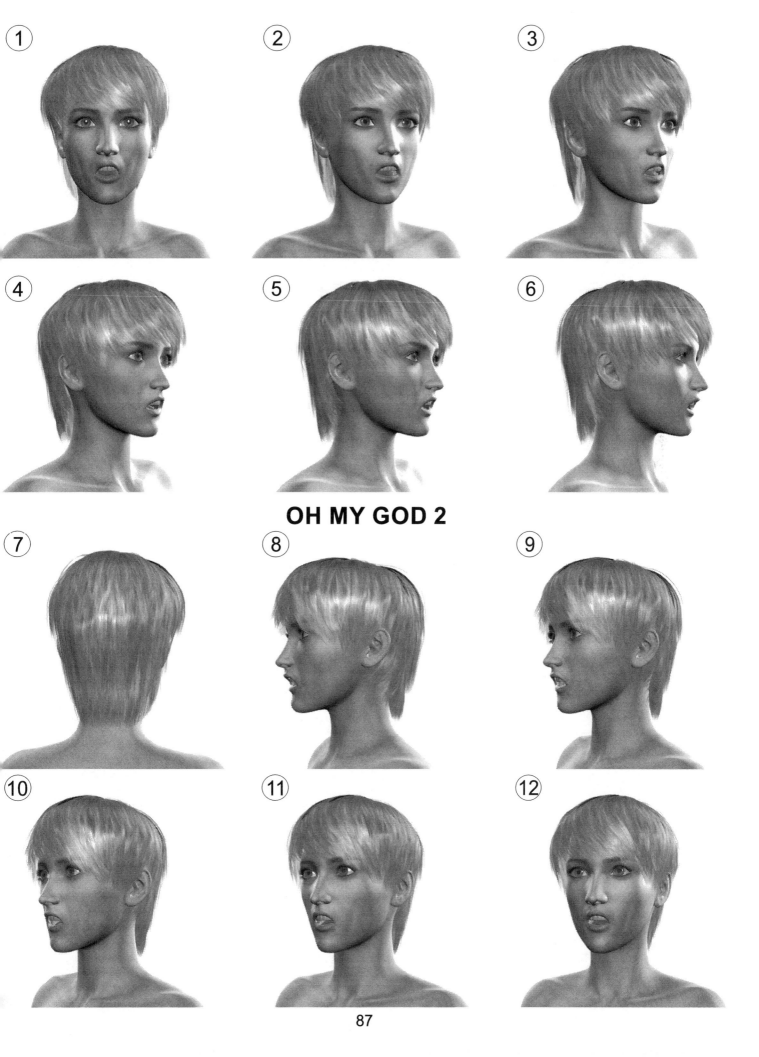

OH MY GOD 2

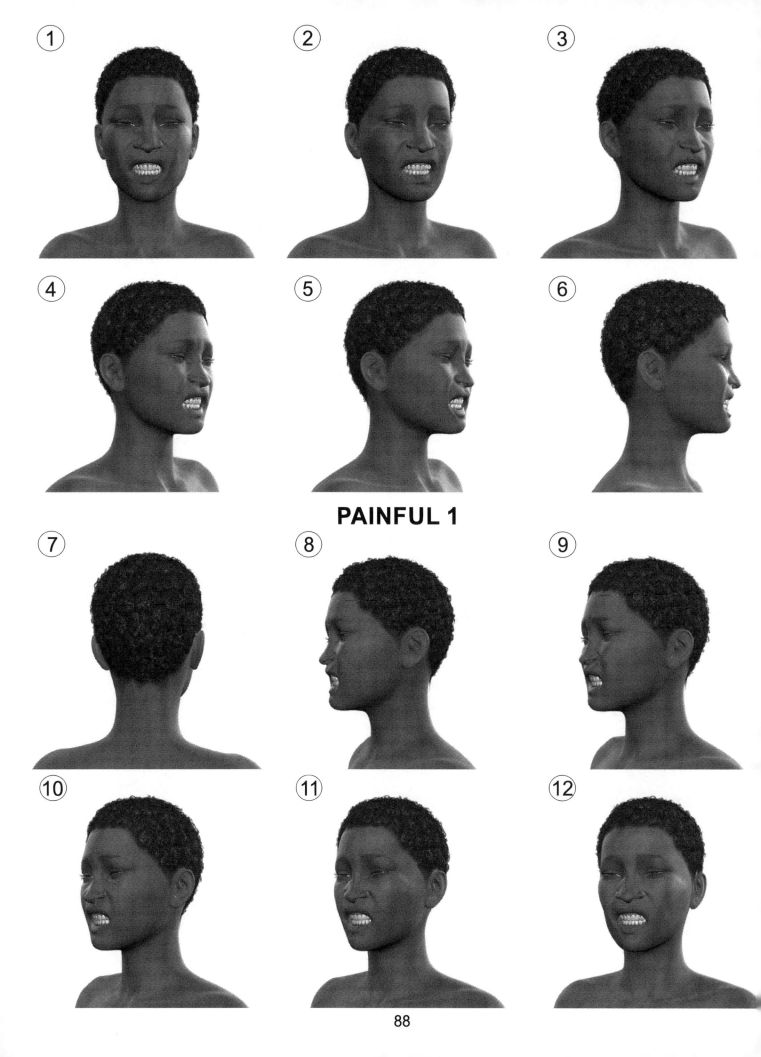

PAINFUL 1

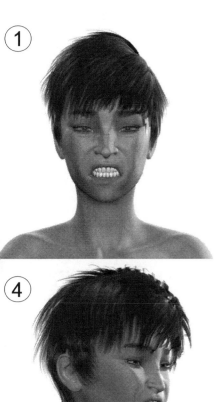

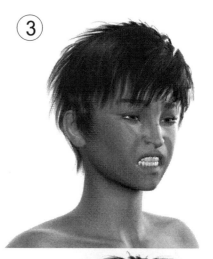

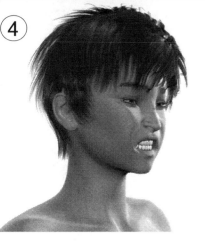

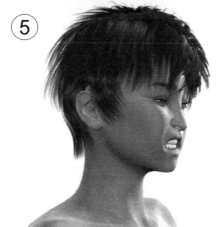

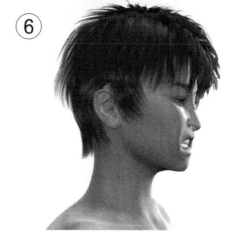

PAINFUL 2

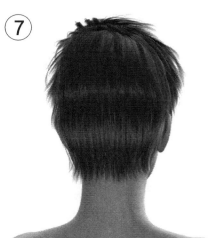

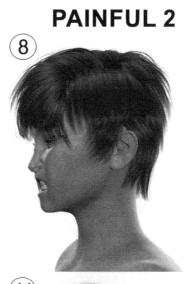

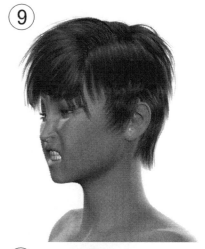

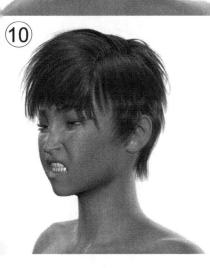

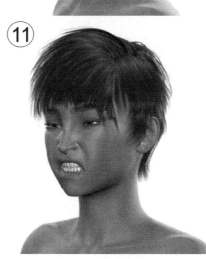

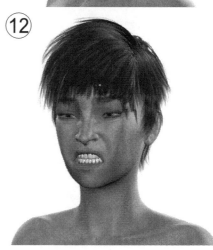

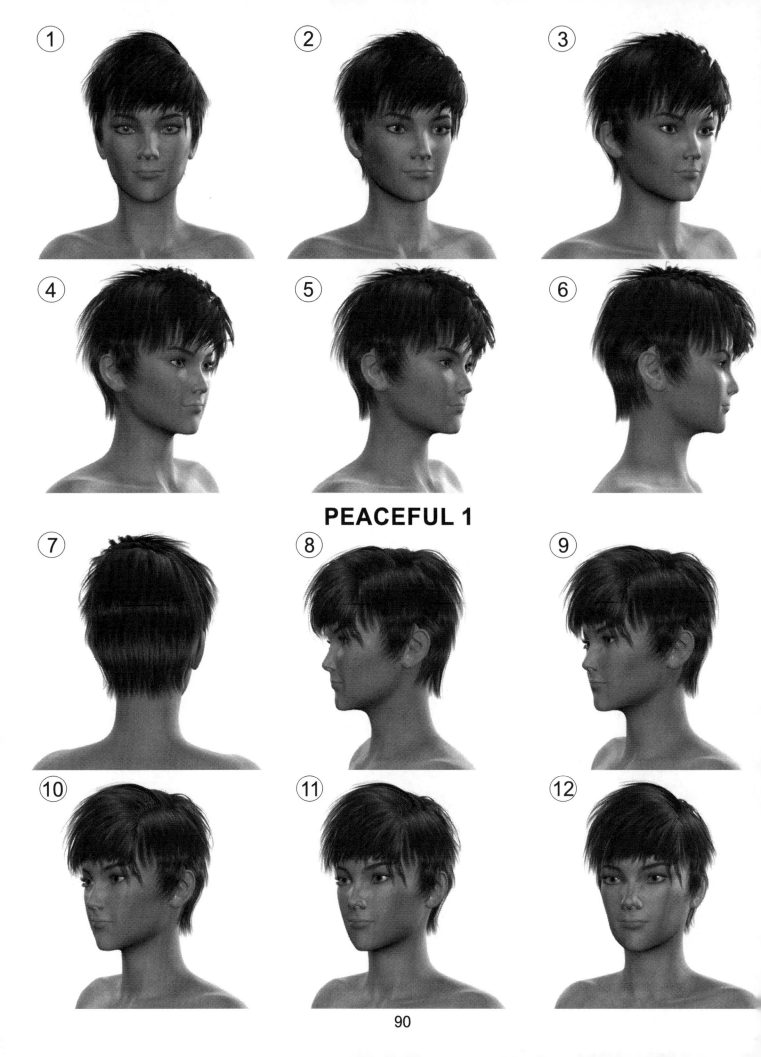

PEACEFUL 1

90

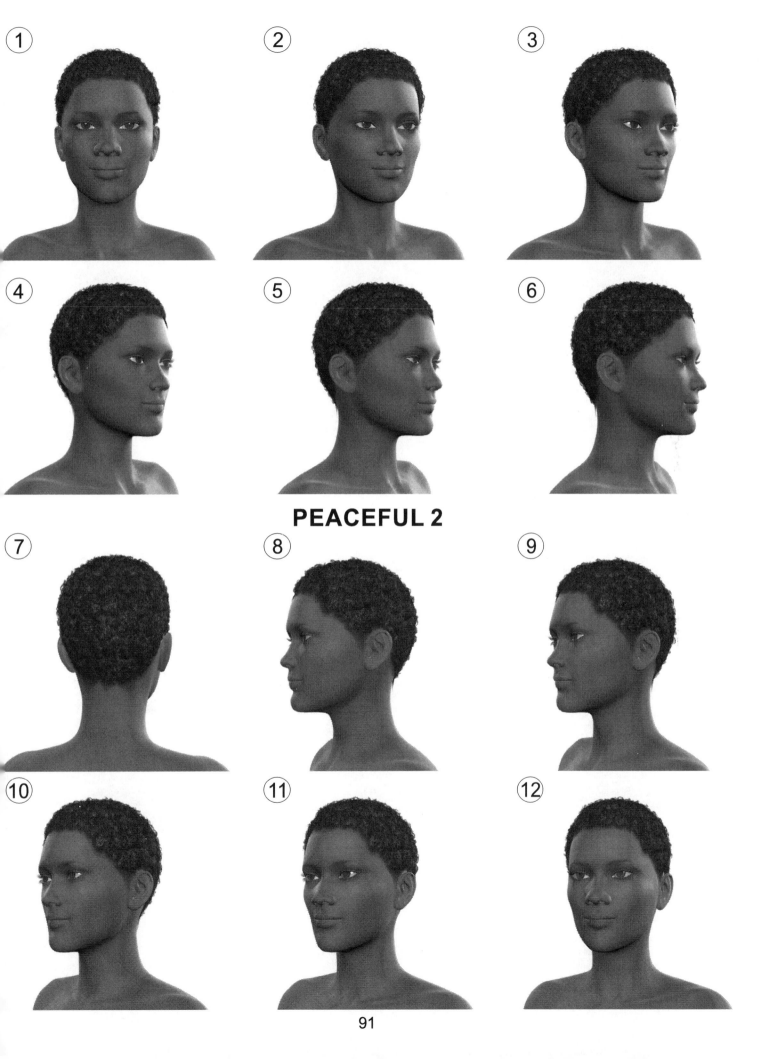

PEACEFUL 2

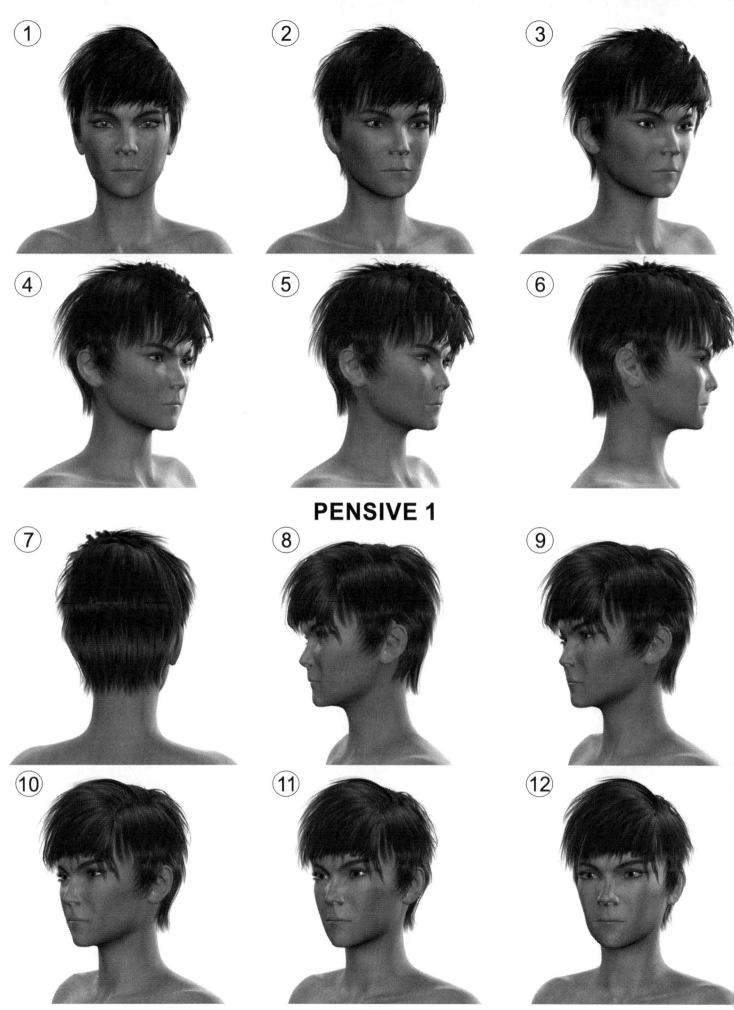

PENSIVE 1

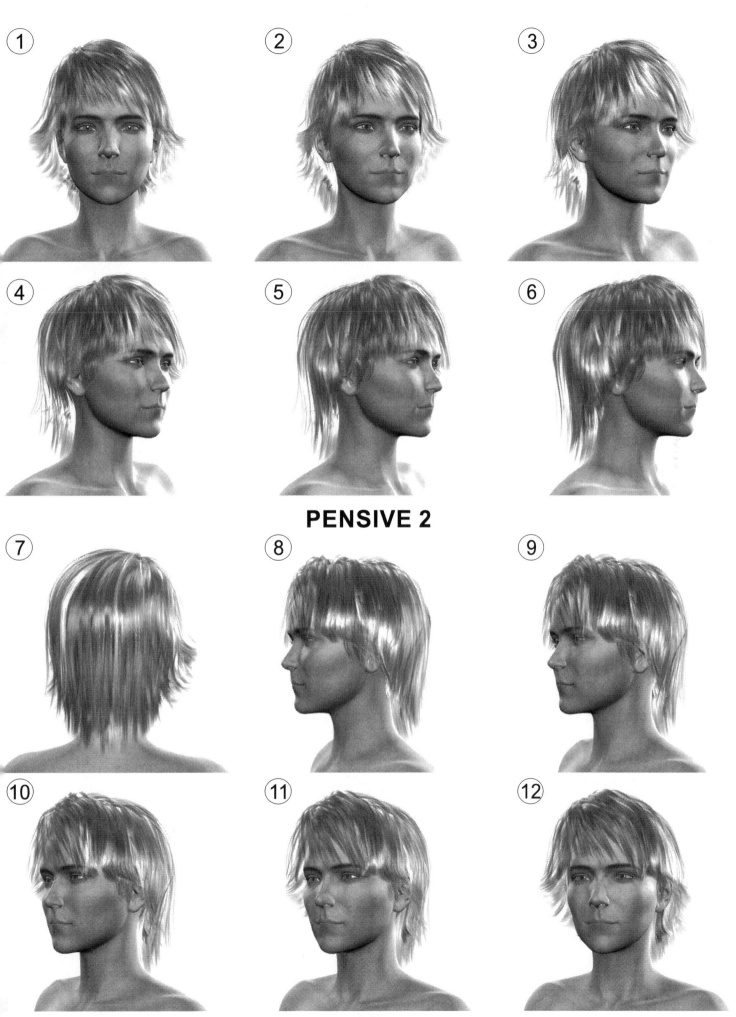

PENSIVE 2

93

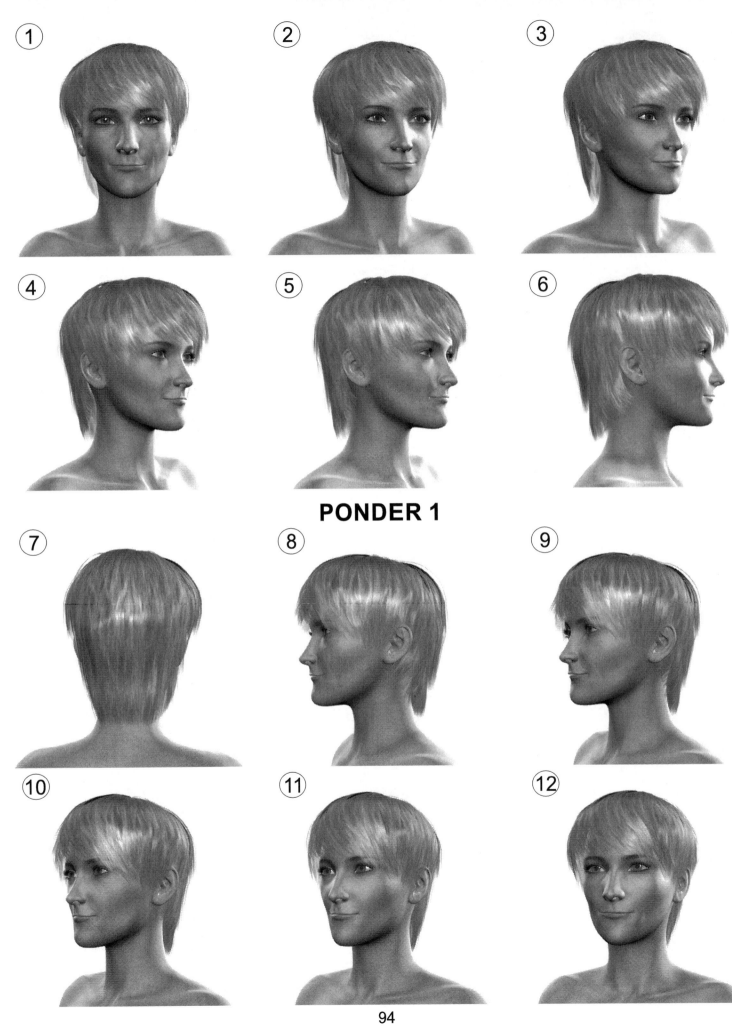

PONDER 1

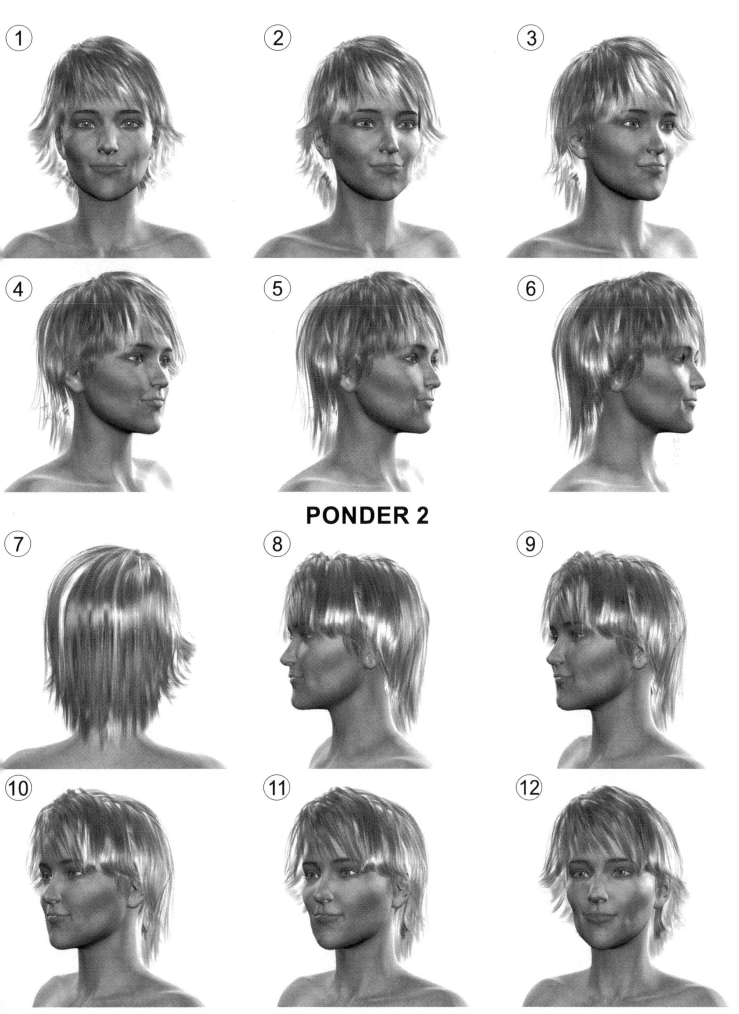

PONDER 2

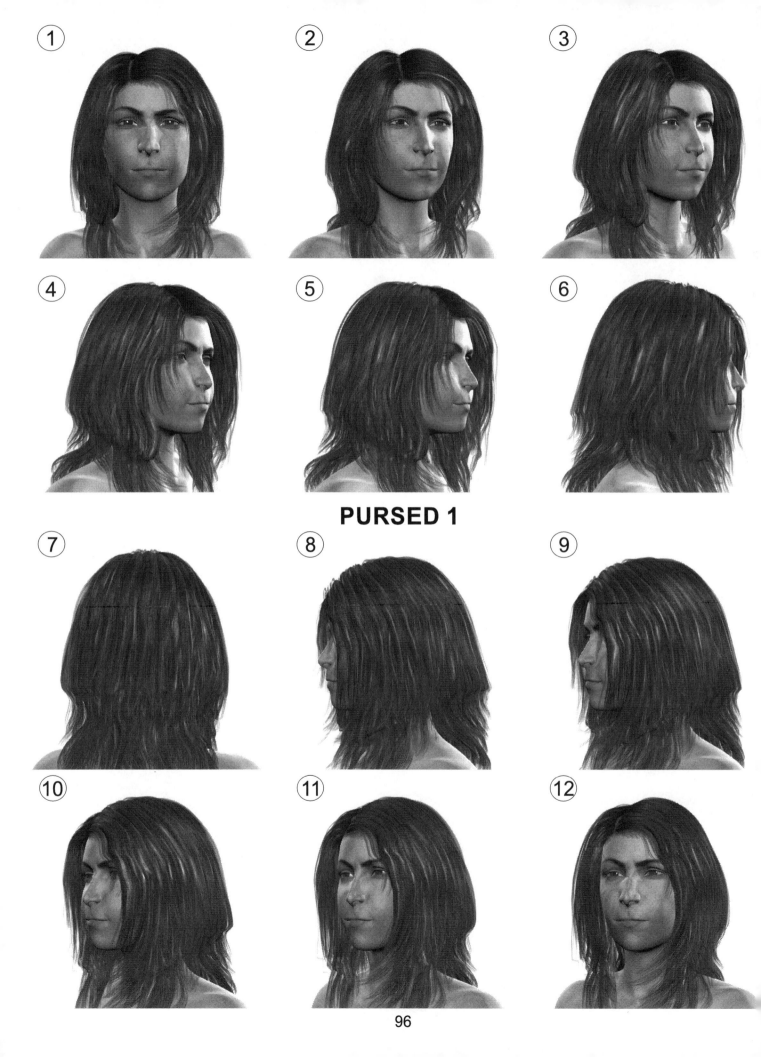

PURSED 1

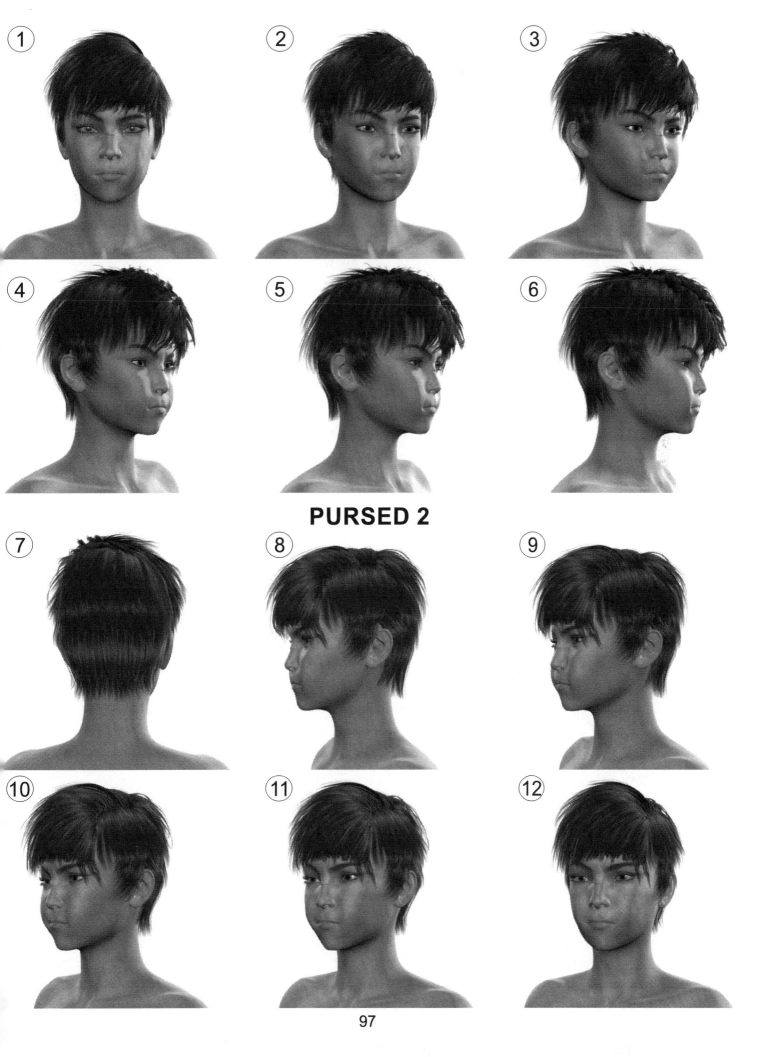

PURSED 2

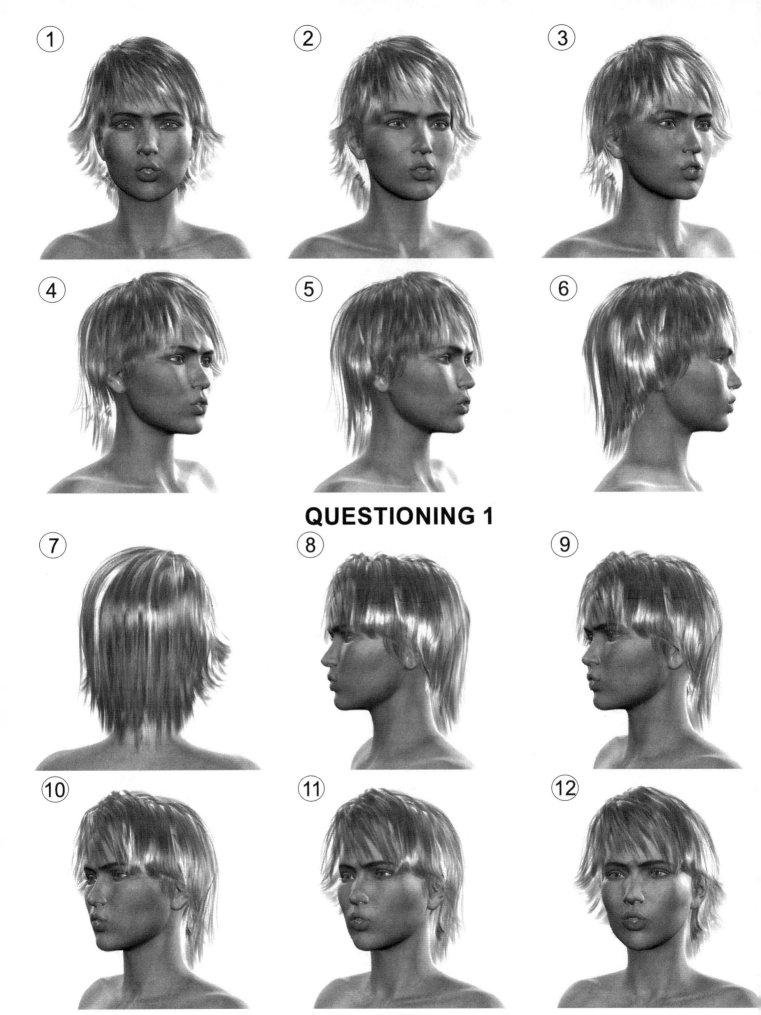

QUESTIONING 1

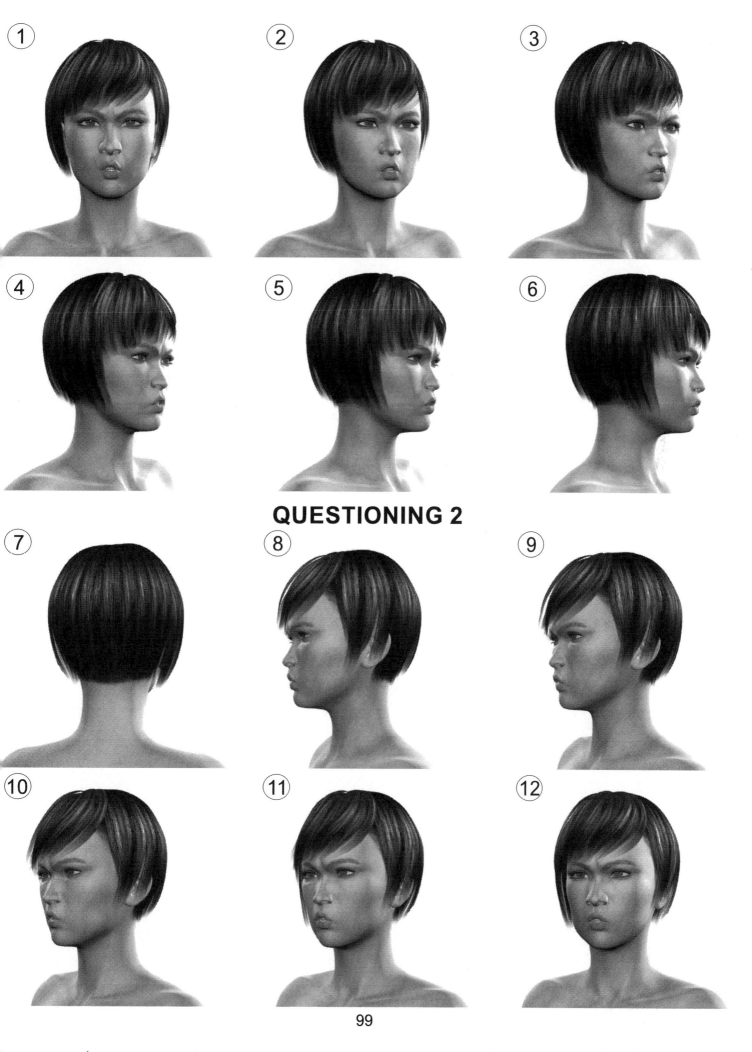

QUESTIONING 2

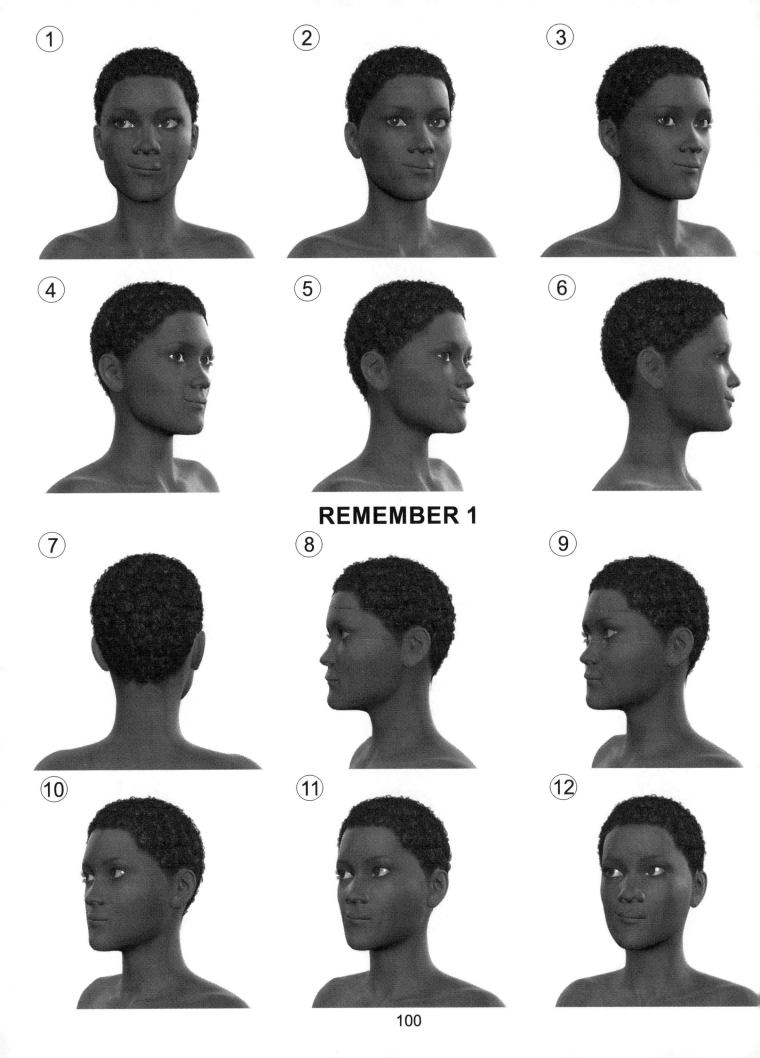

REMEMBER 1

100

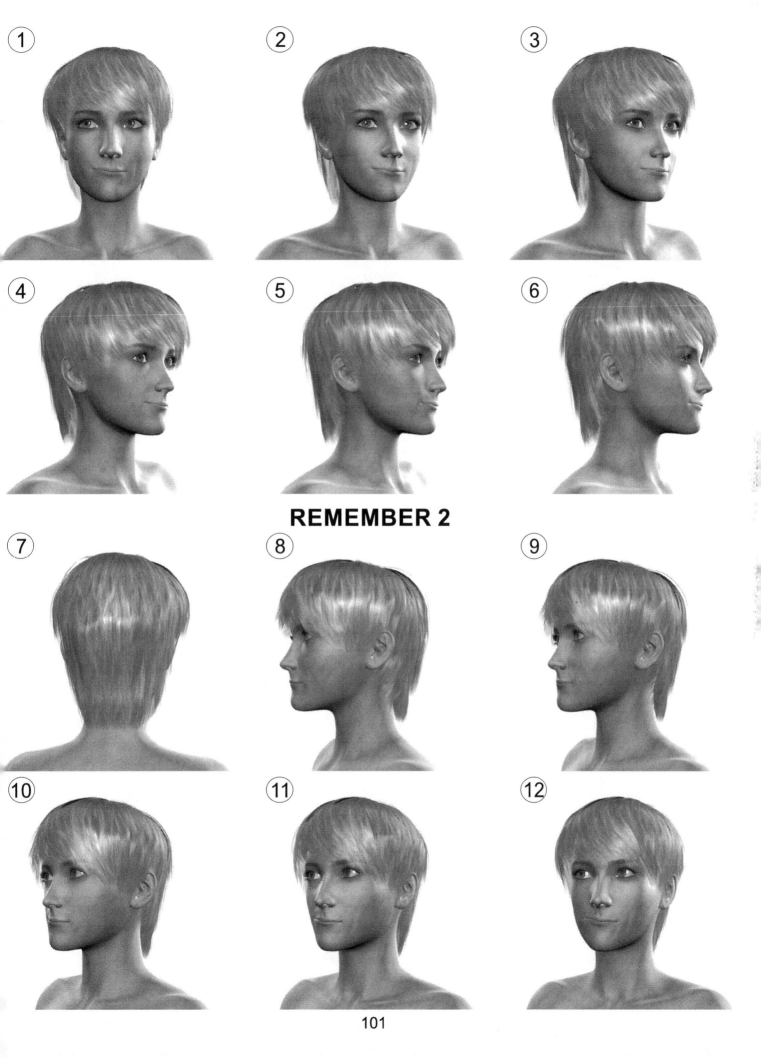

REMEMBER 2

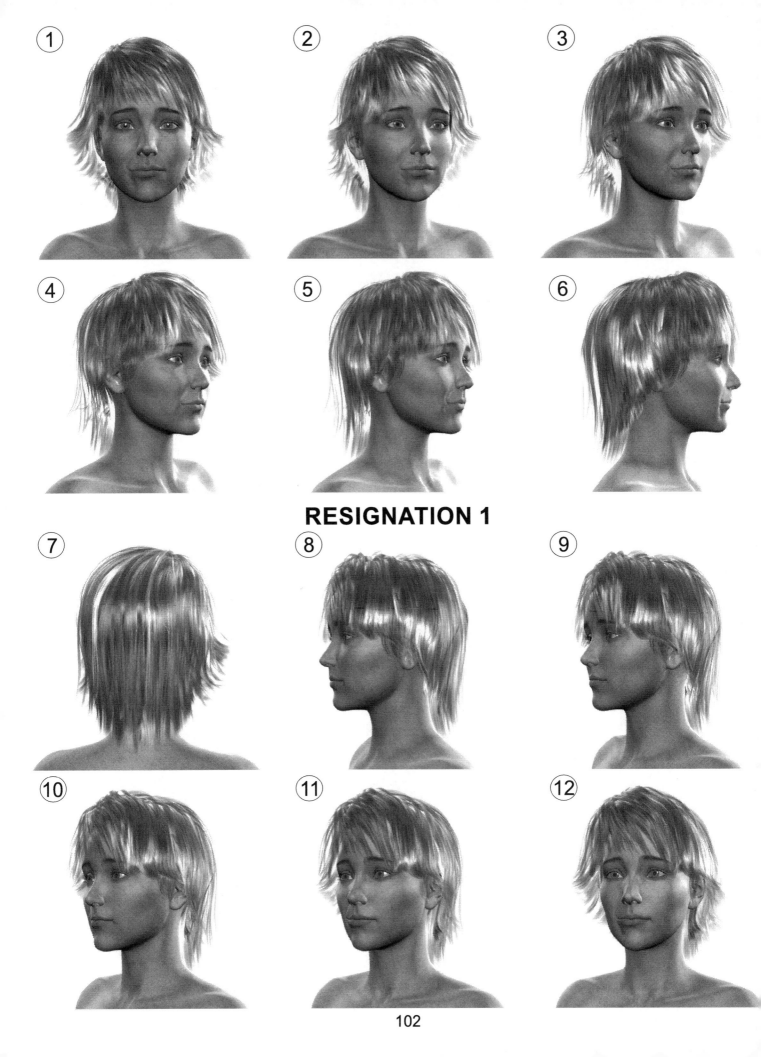

RESIGNATION 1

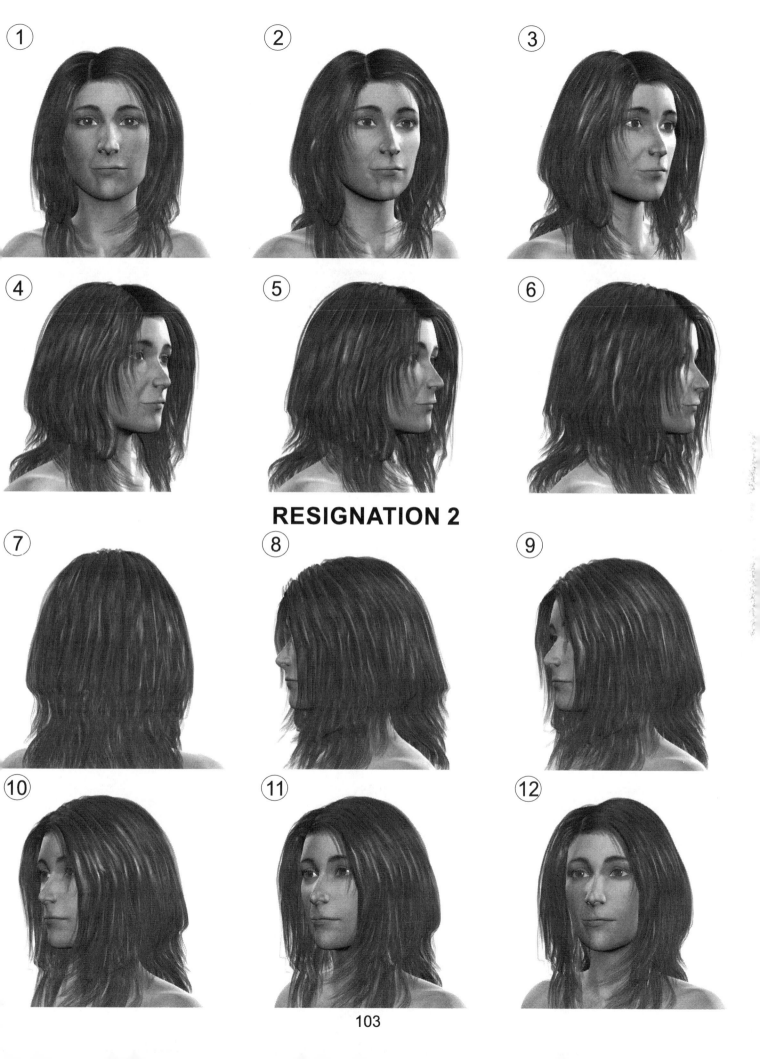

RESIGNATION 2

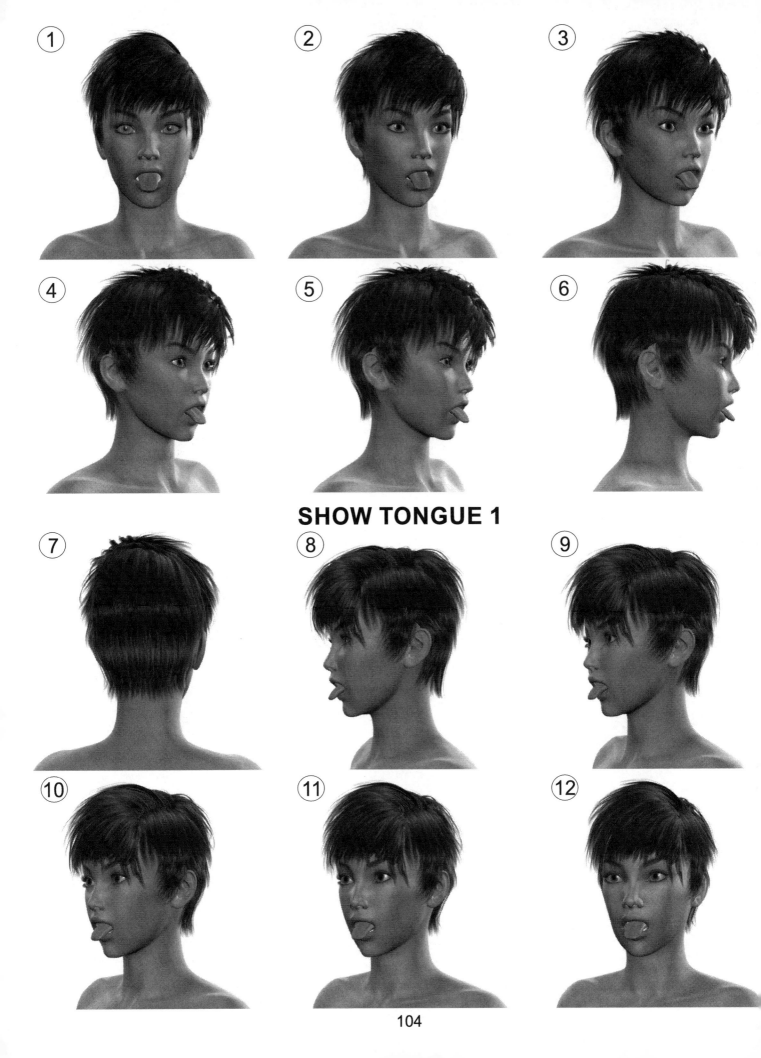

SHOW TONGUE 1

104

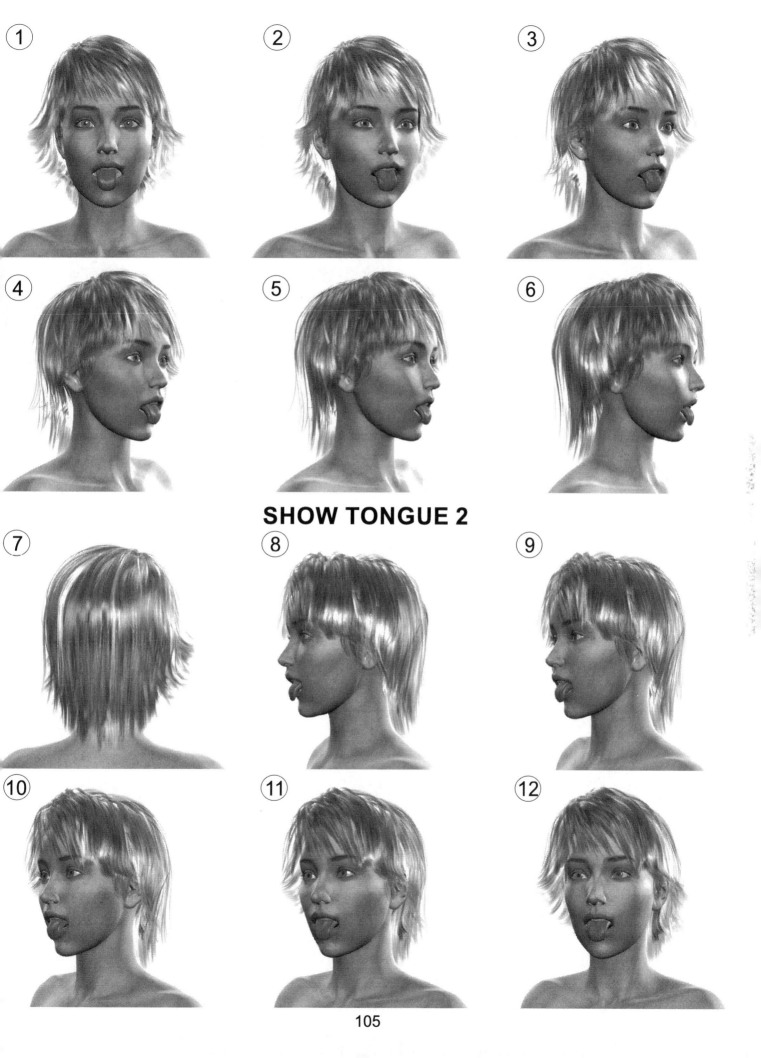

SHOW TONGUE 2

105

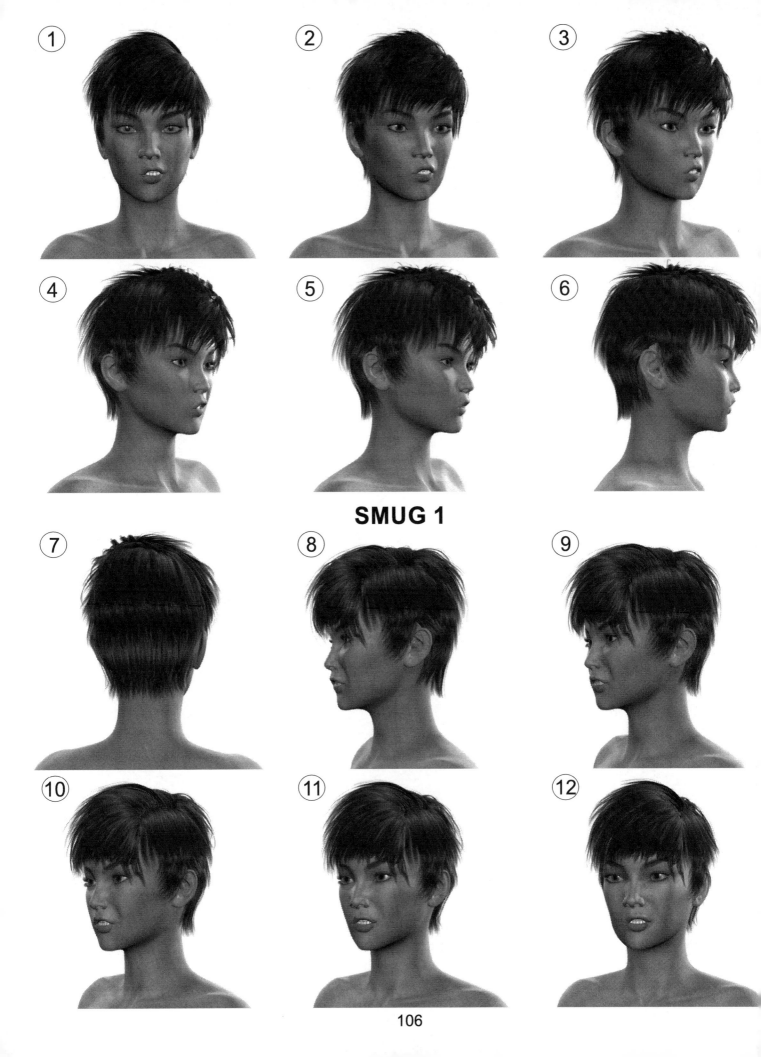

SMUG 1

106

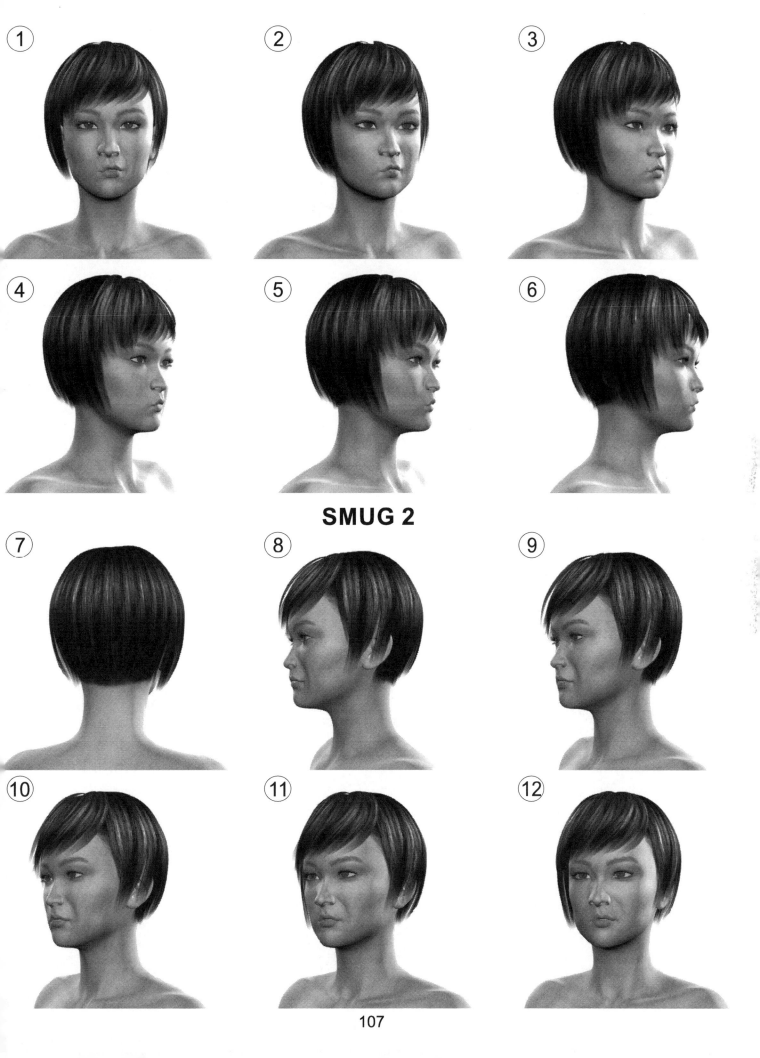

SMUG 2

107

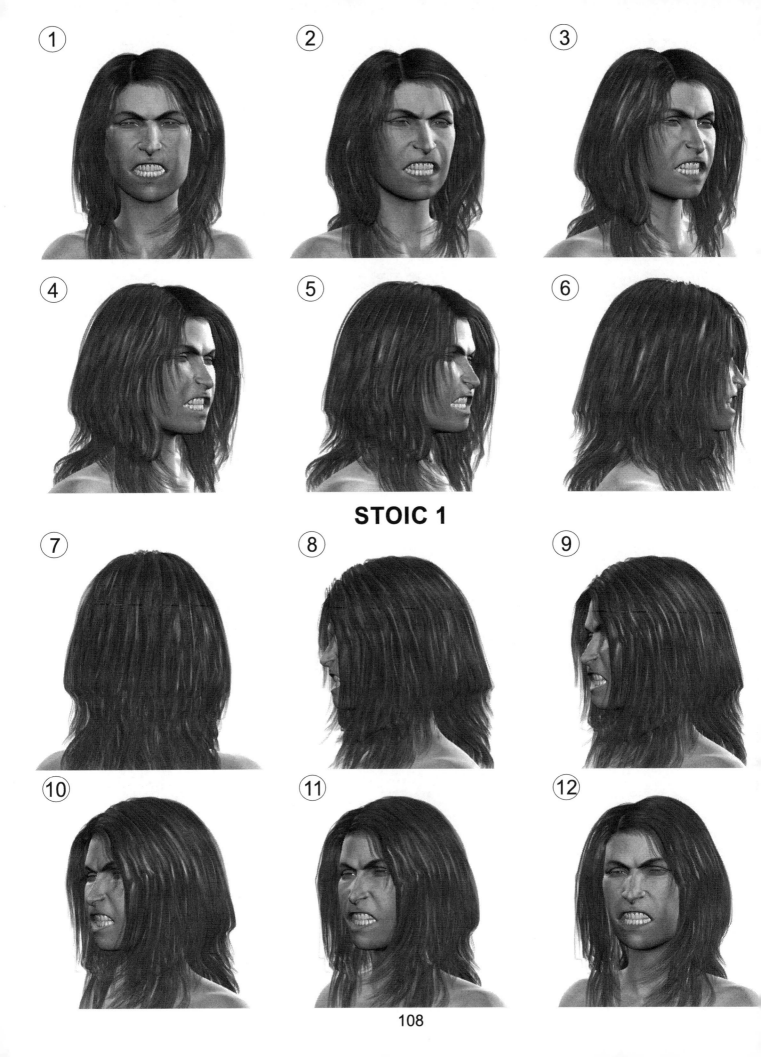

STOIC 1

108

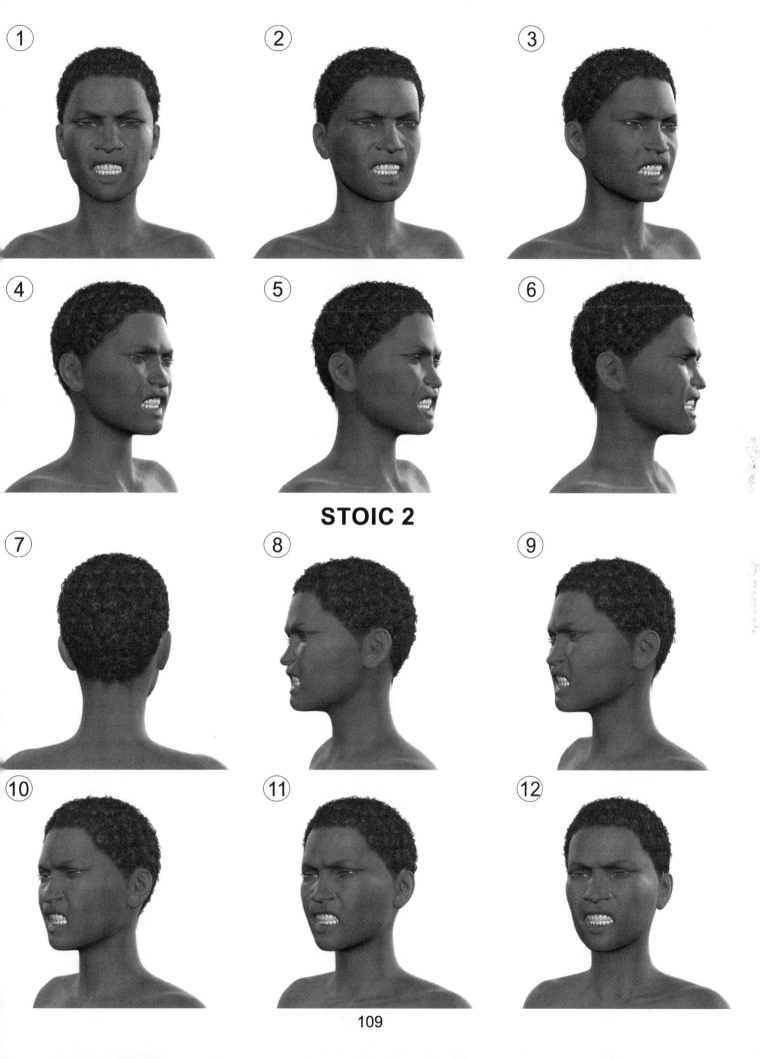

STOIC 2

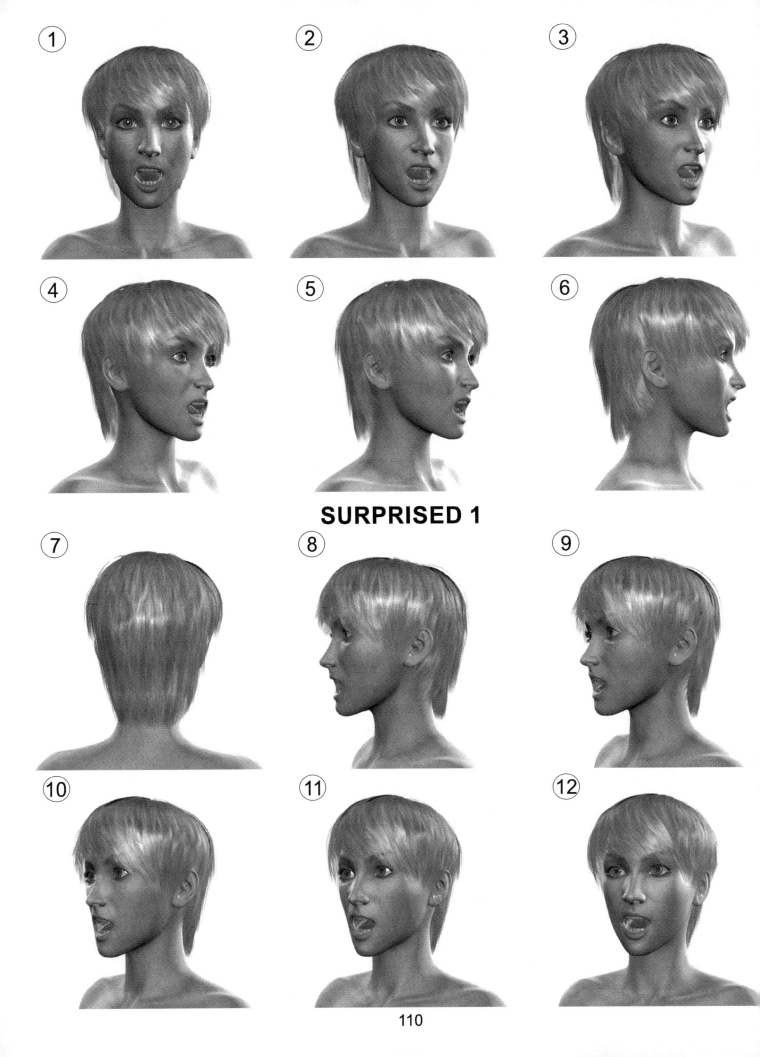

SURPRISED 1

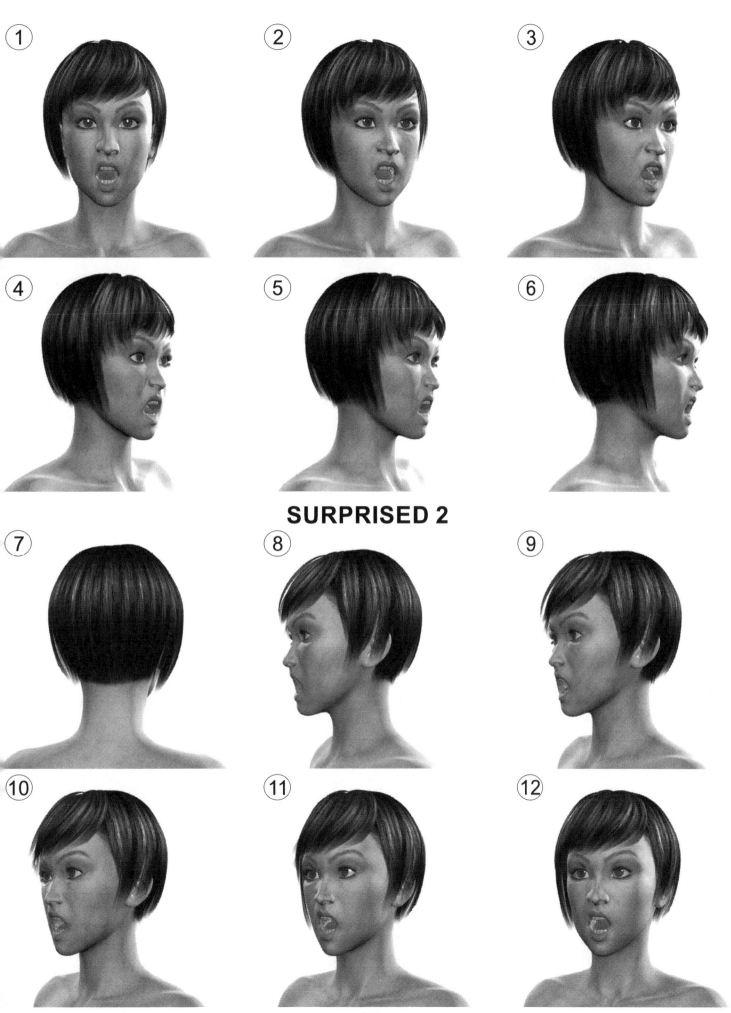

SURPRISED 2

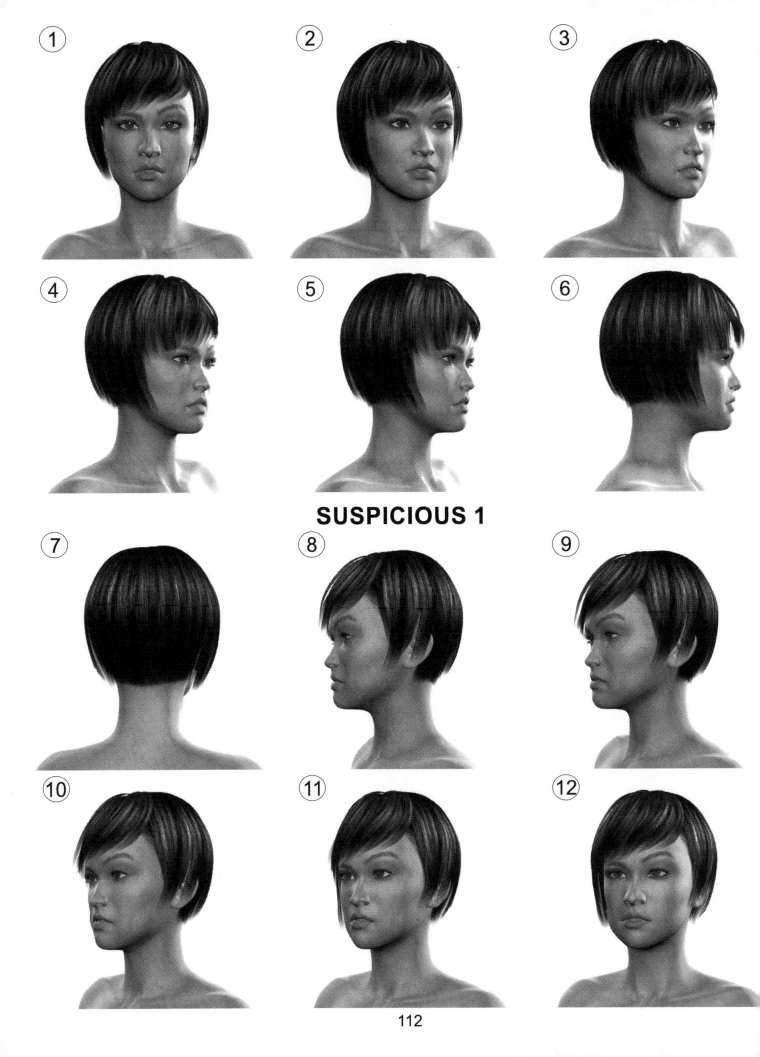

SUSPICIOUS 1

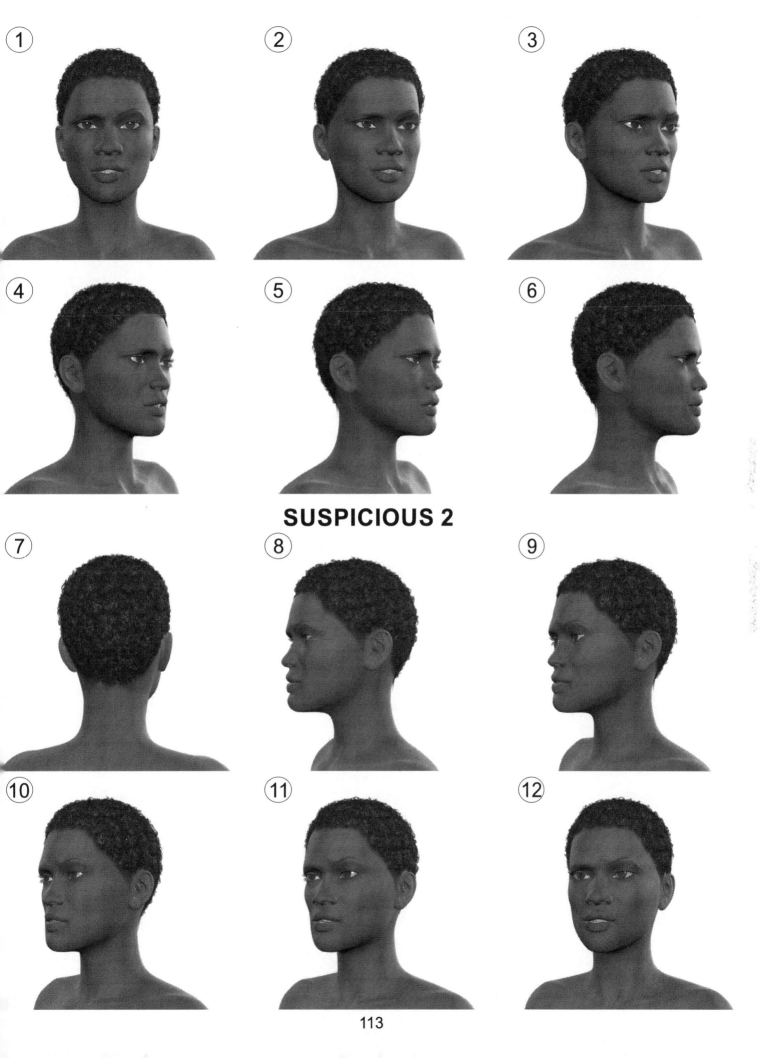

SUSPICIOUS 2

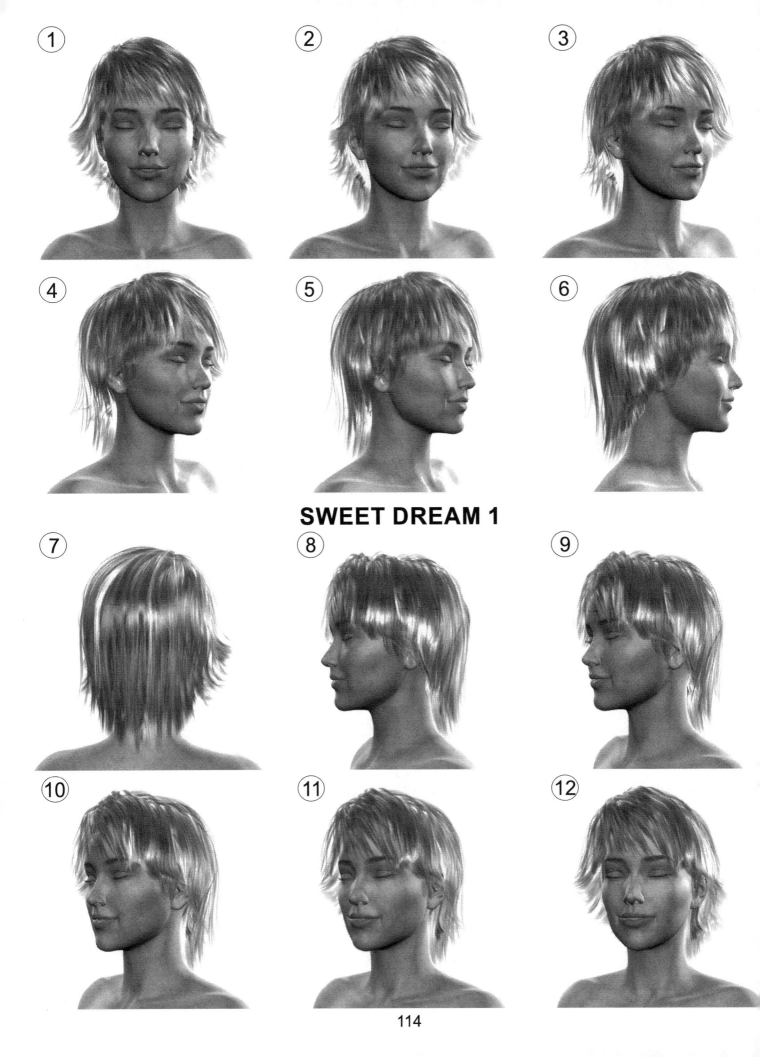

SWEET DREAM 1

1

2

3

4

5

6

SWEET DREAM 2

7

8

9

10

11

12

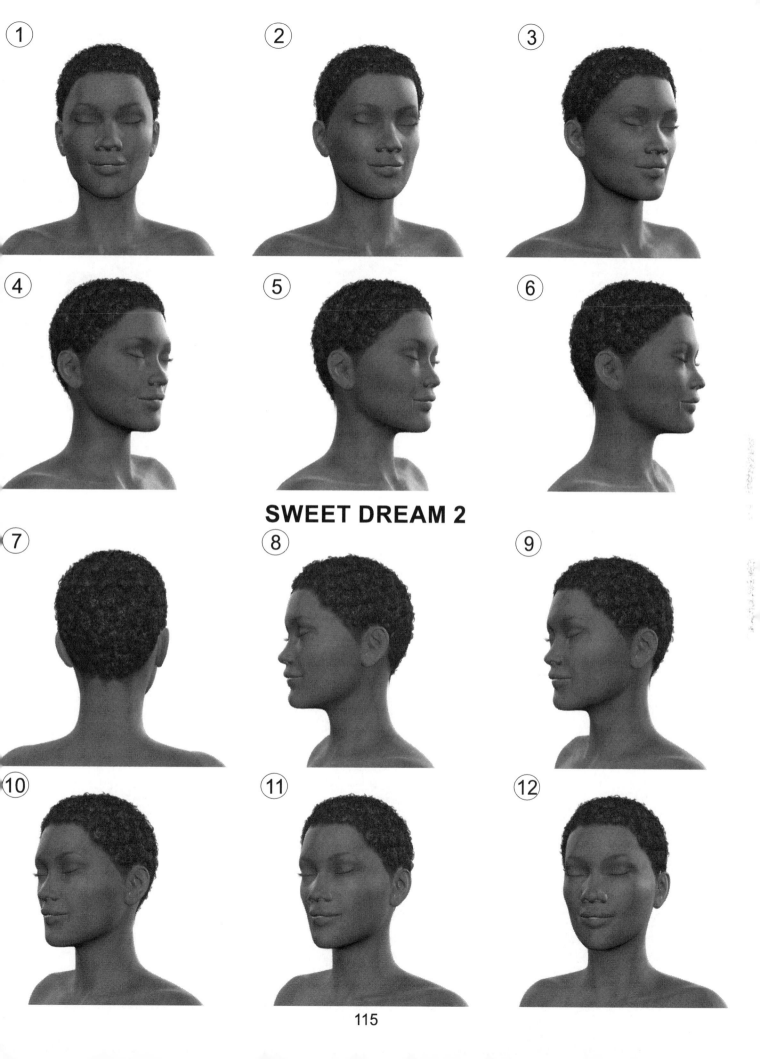

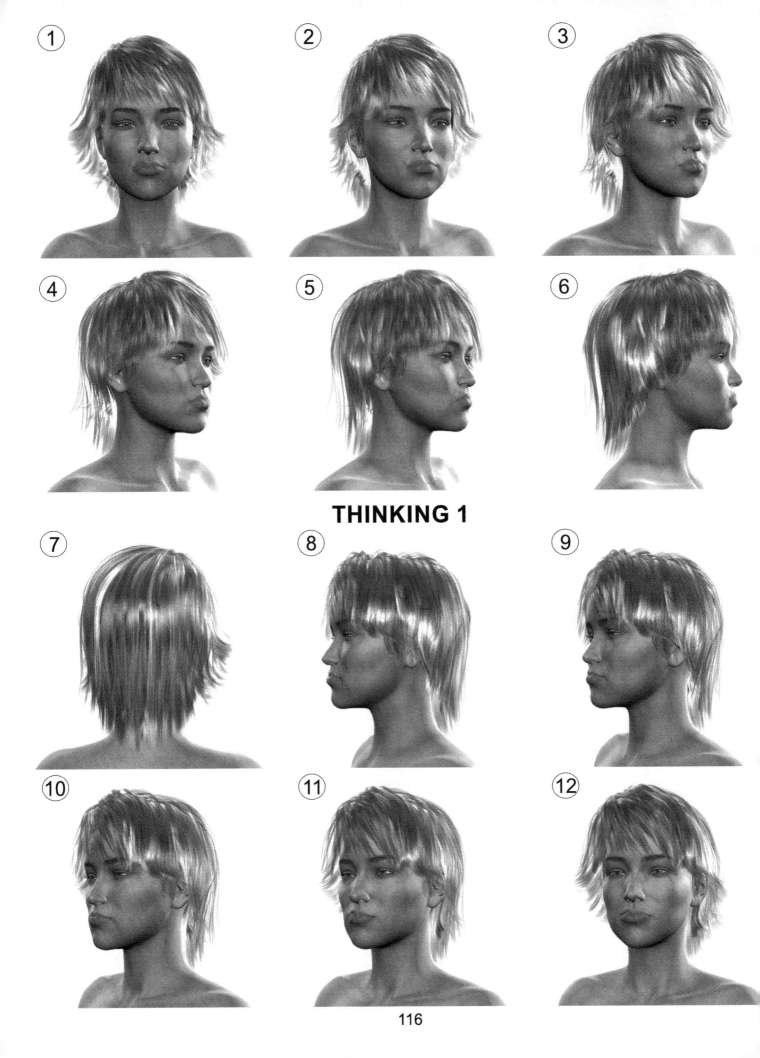

THINKING 1

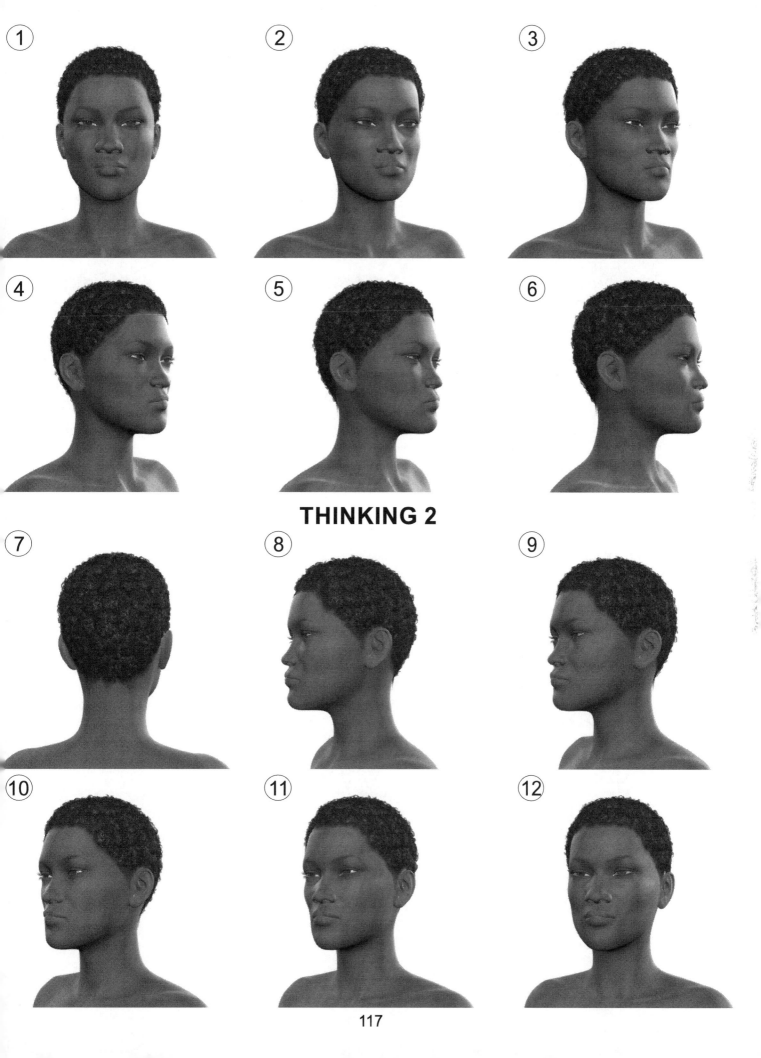

THINKING 2

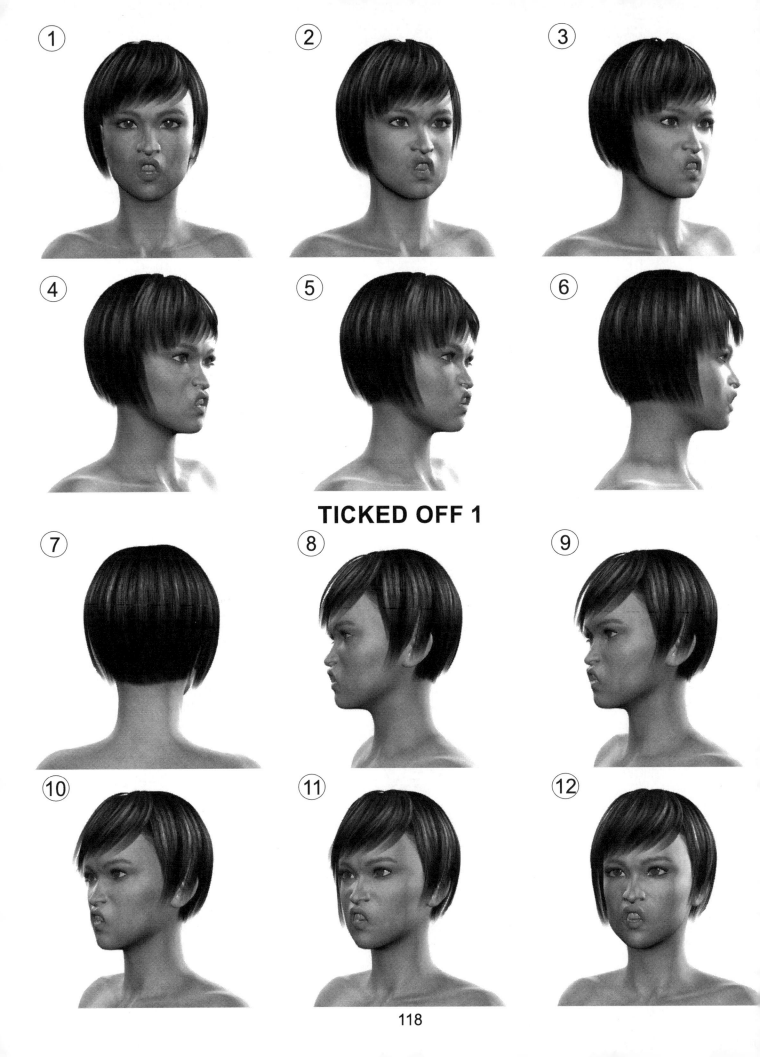

TICKED OFF 1

118

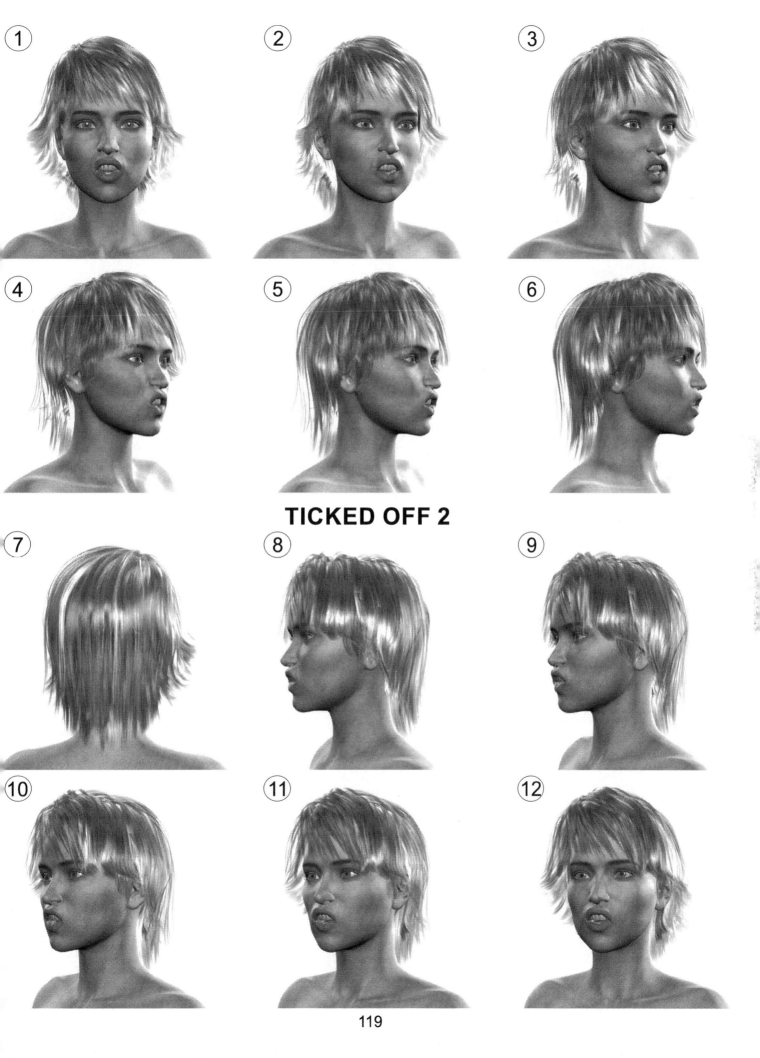

TICKED OFF 2

119

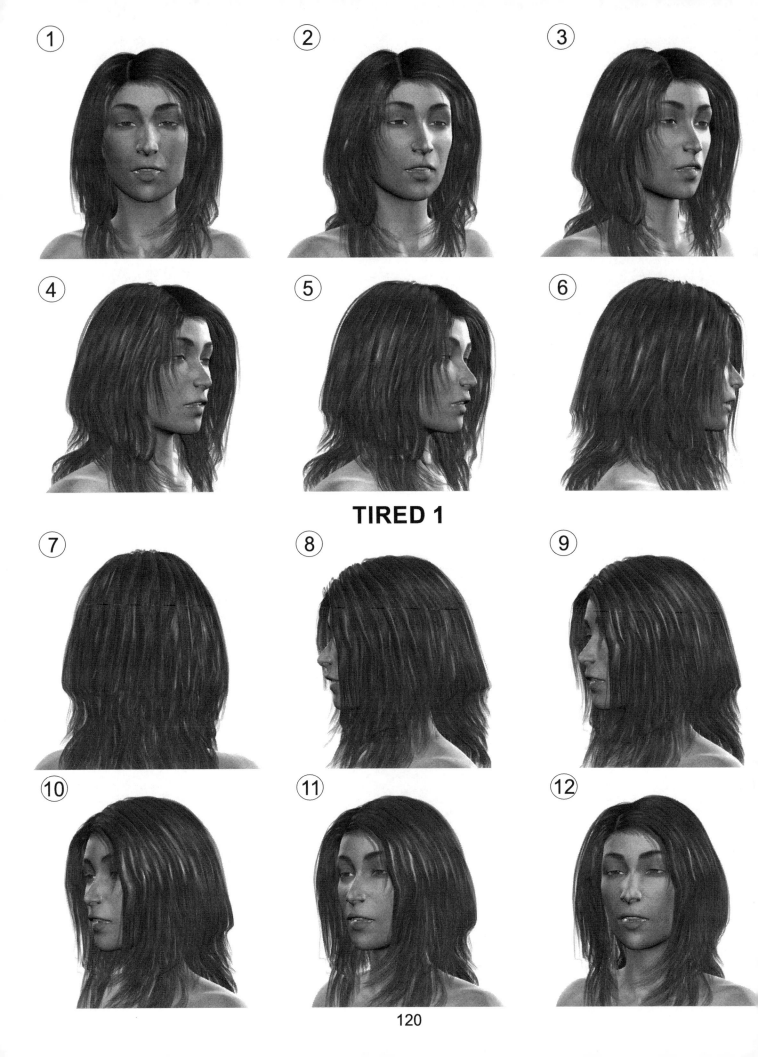

TIRED 1

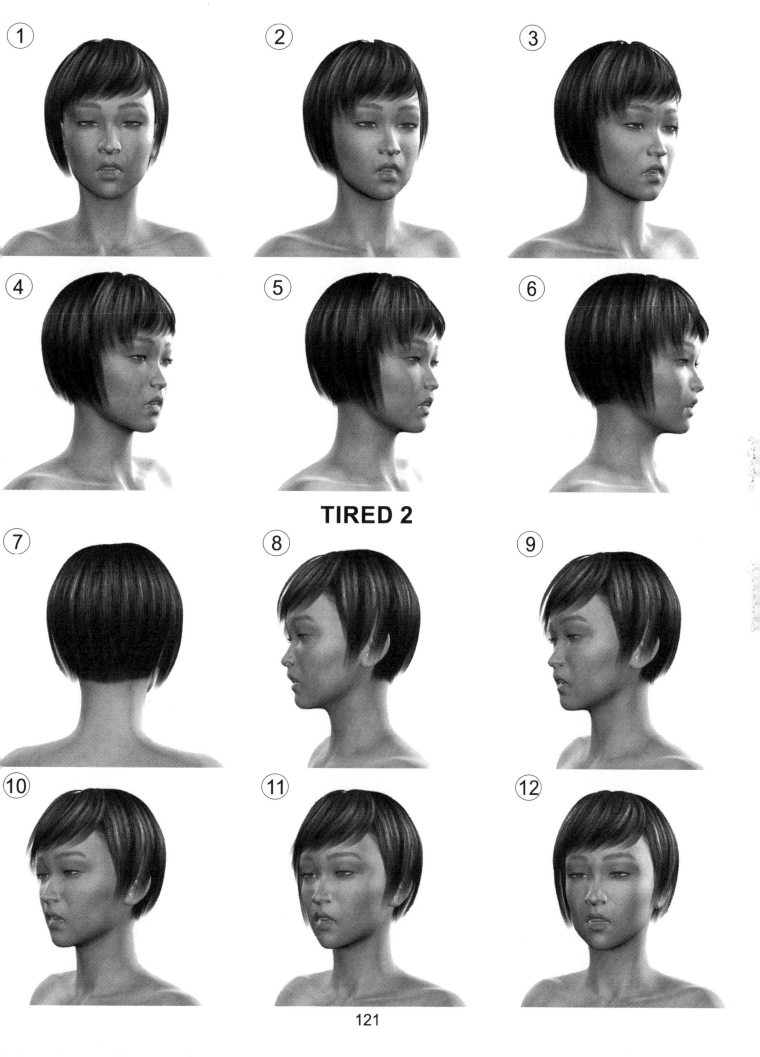

TIRED 2

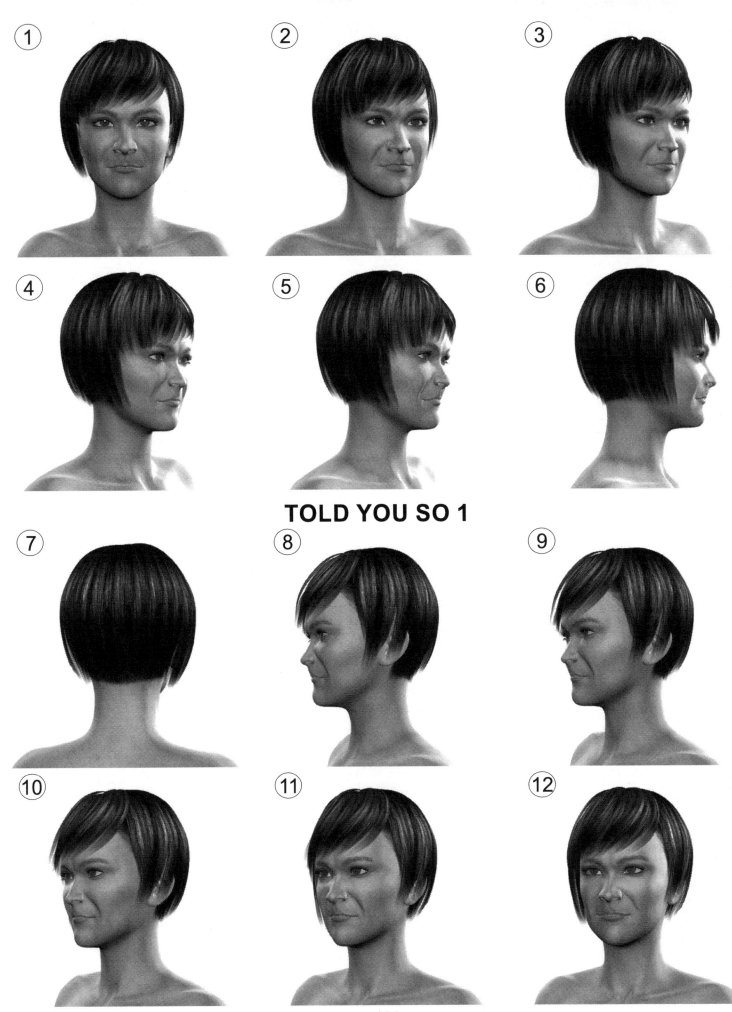

TOLD YOU SO 1

122

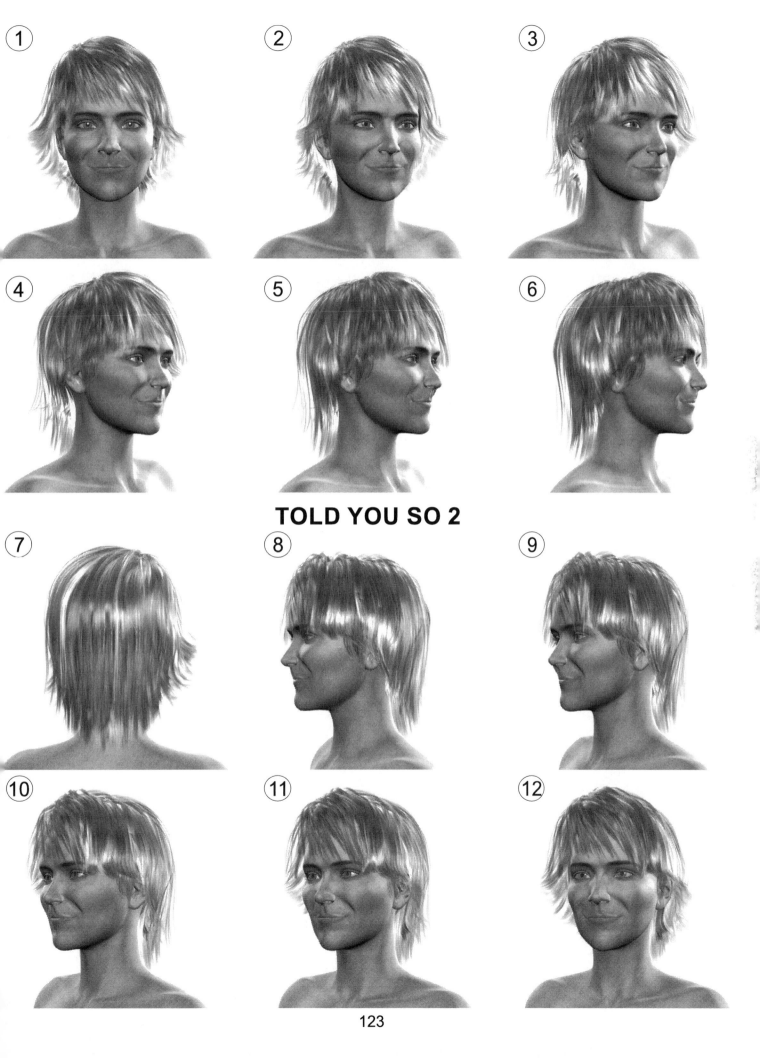

TOLD YOU SO 2

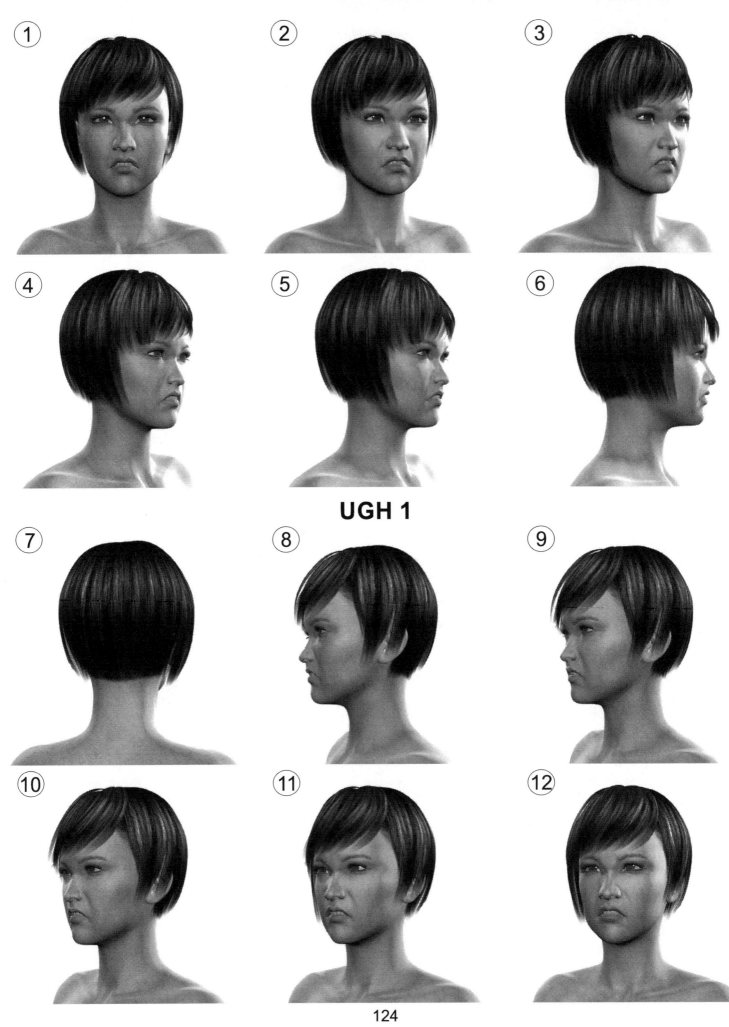

UGH 1

124

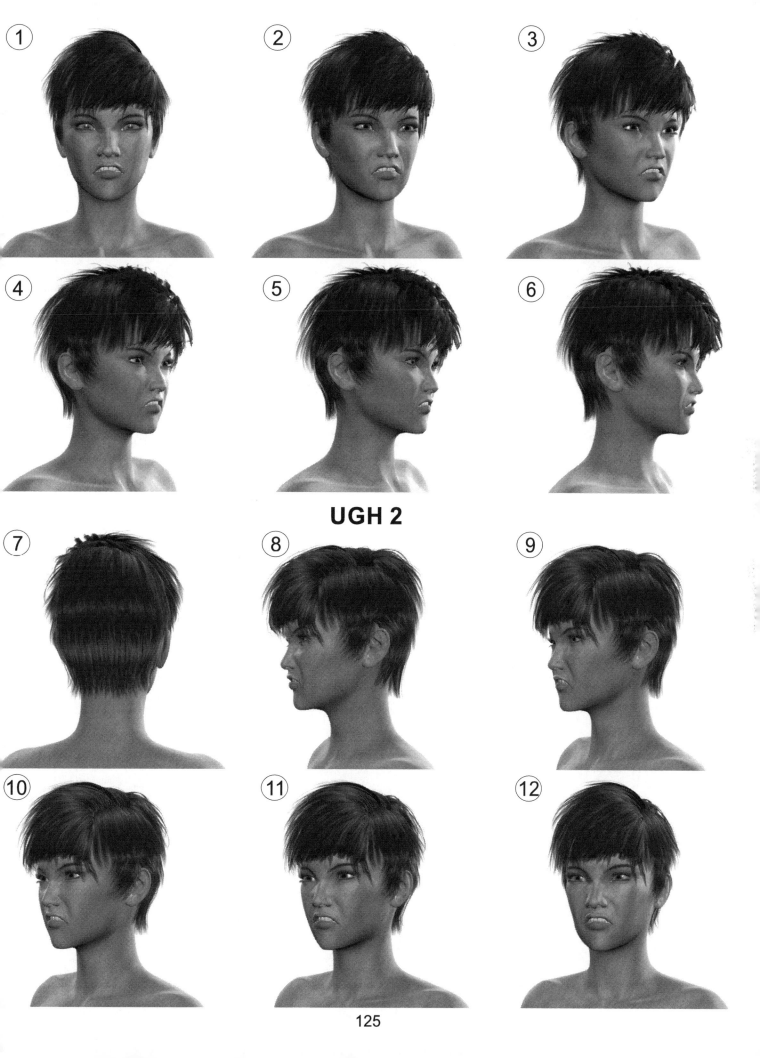

UGH 2

125

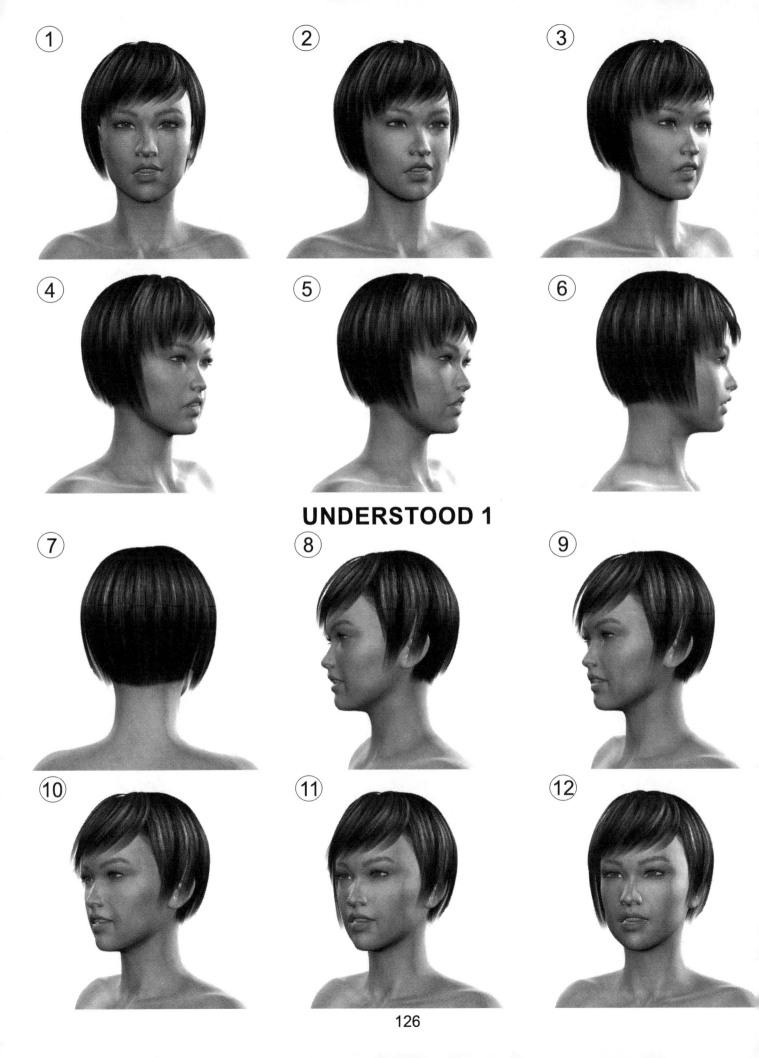

UNDERSTOOD 1

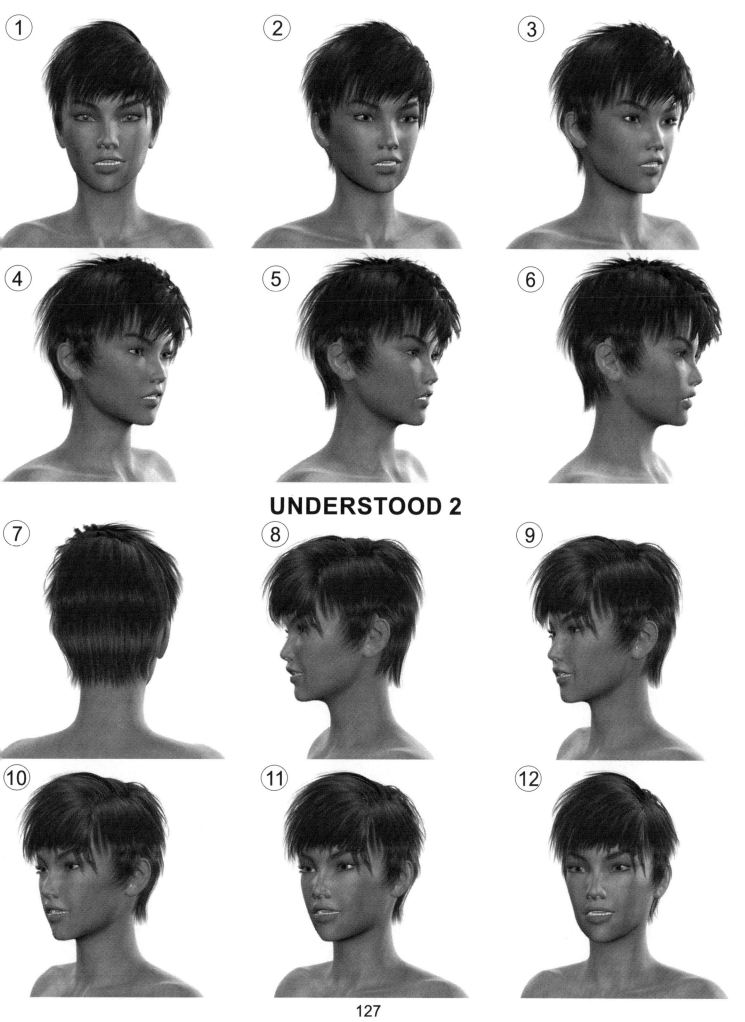

UNDERSTOOD 2

127

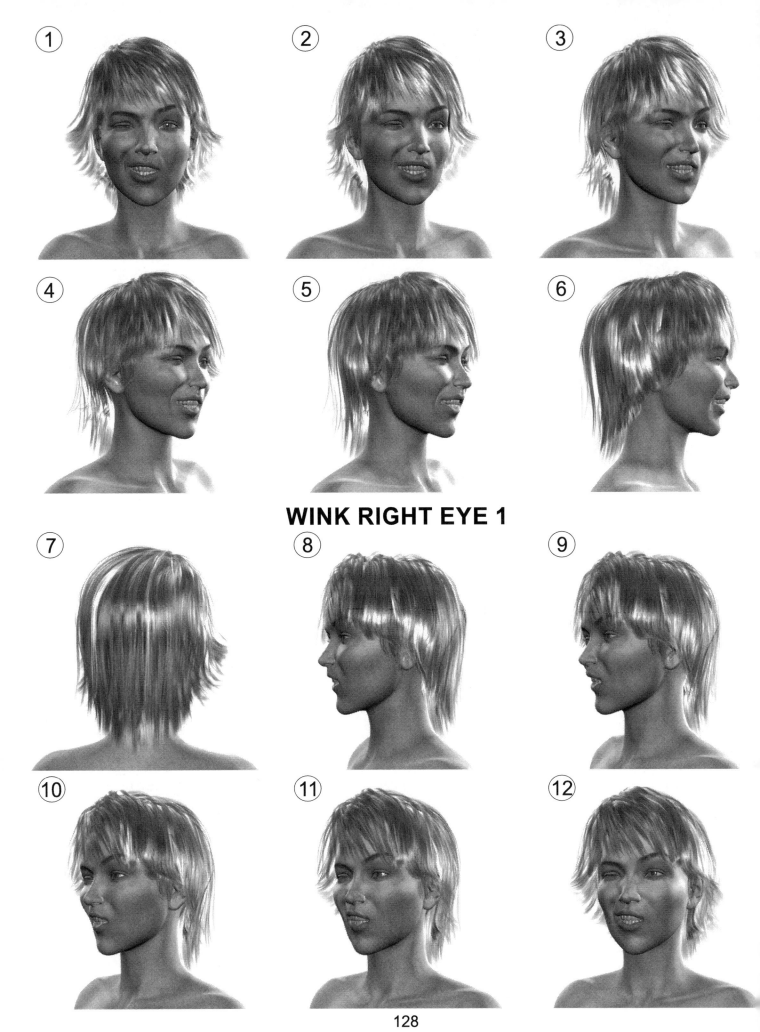

WINK RIGHT EYE 1

128

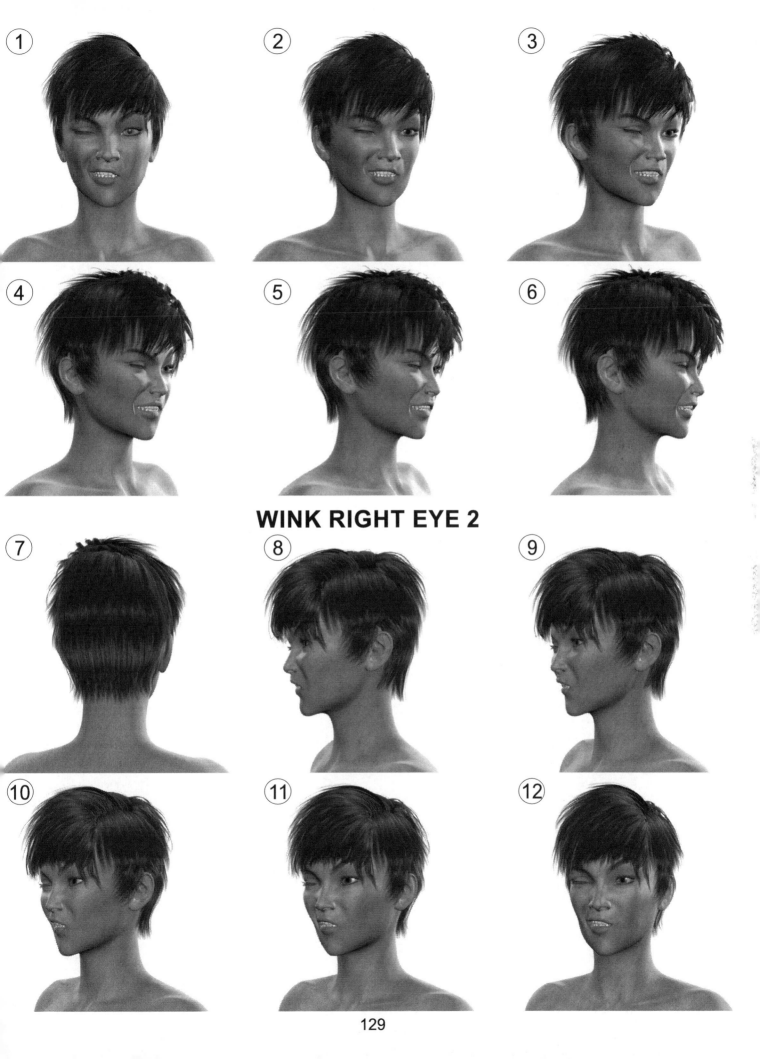

WINK RIGHT EYE 2

129

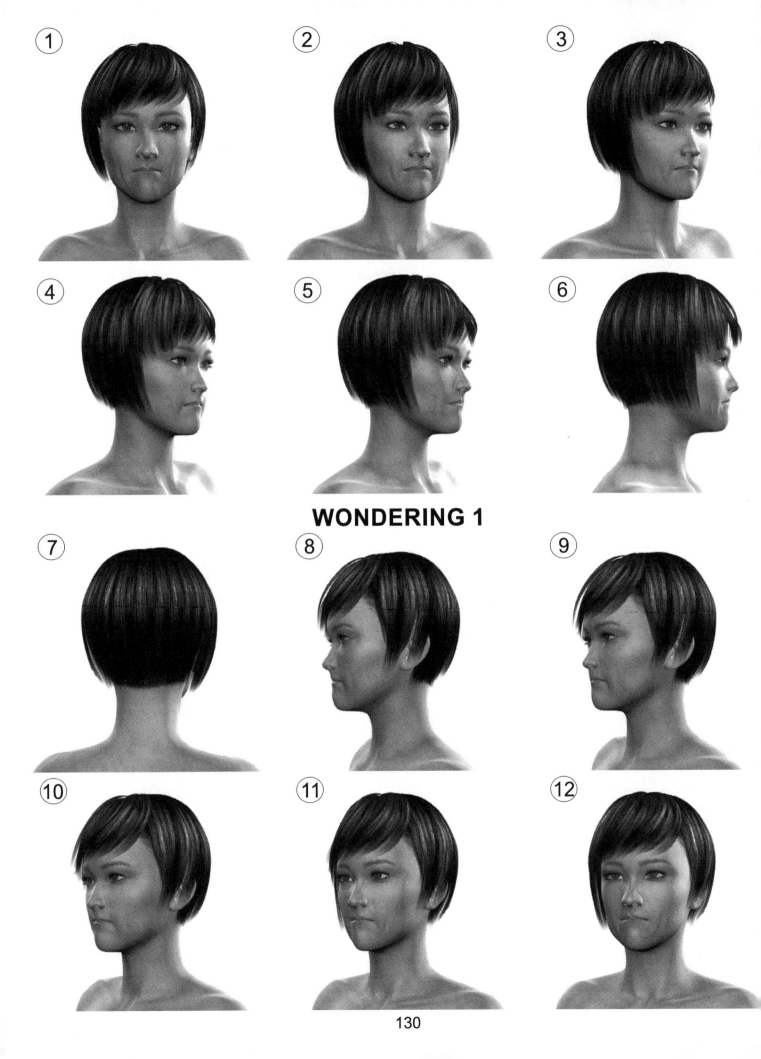

WONDERING 1

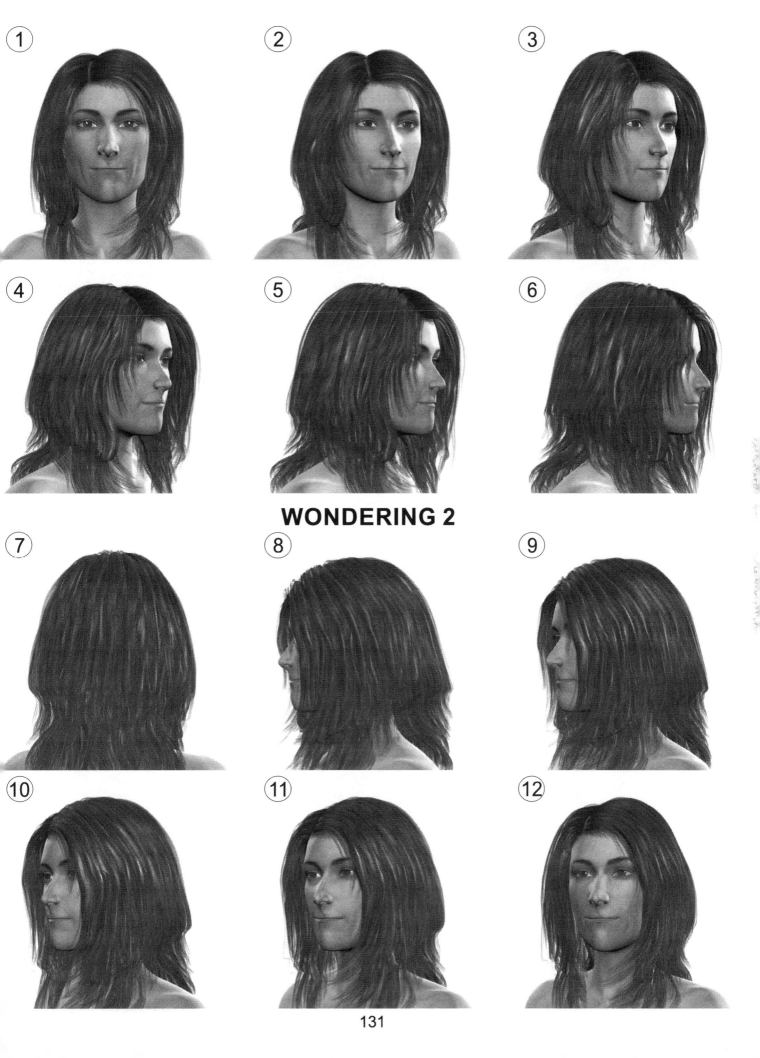

WONDERING 2

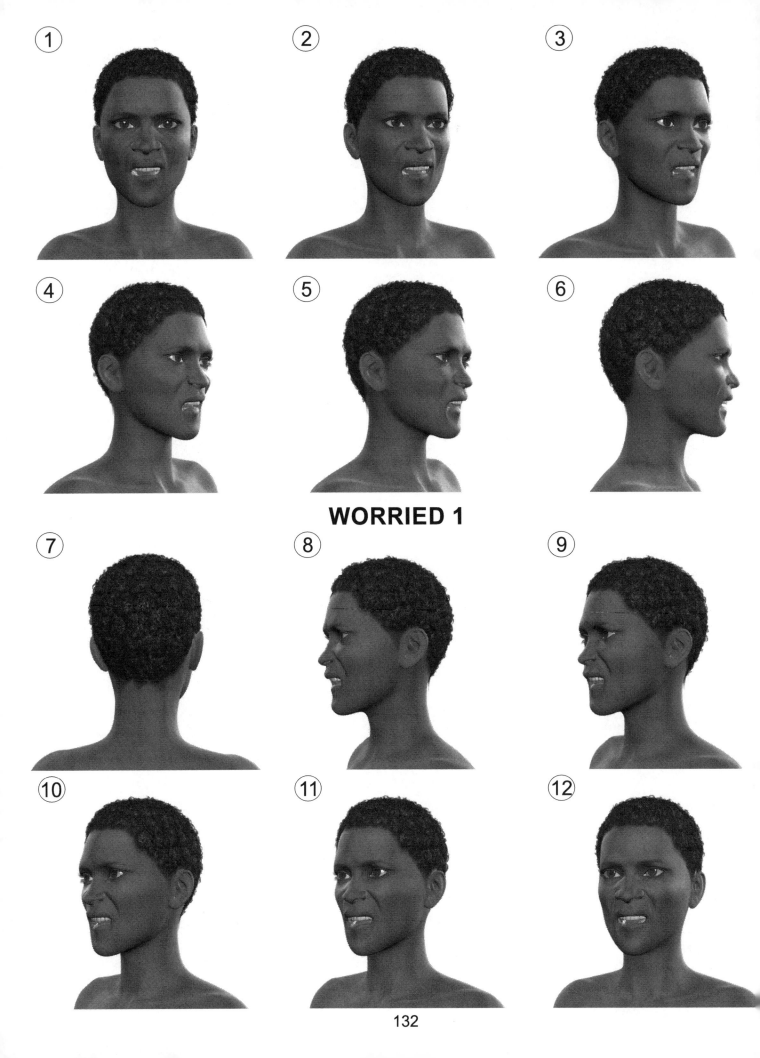

WORRIED 1

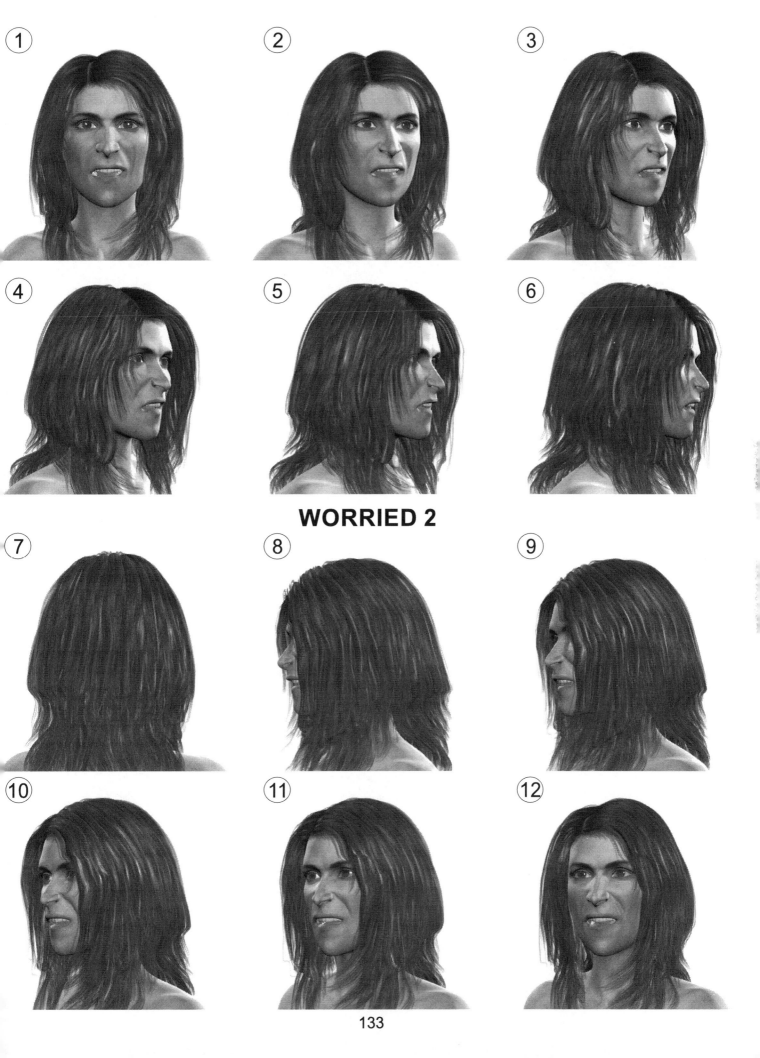

WORRIED 2

NOTES

Made in the USA
Middletown, DE
08 April 2020

88509709R00075